· A HISTORY LOVER'S ·

GUIDE TO

NEW YORK CITY

ALISON FORTIER

THE
History
PRESS

Published by The History Press
Charleston, SC
www.historypress.net

All images by James Maher.

First published 2016

Manufactured in the United States

ISBN 978.1.46711.903.0

Library of Congress Control Number: 2015959411

In memory of my mother, Sally B.

CONTENTS

PREFACE

Like many others whose stories are in this book, I came to New York from elsewhere. My own migration from the Midwest was relatively short. My parents moved to New York City when I was a teenager. Immediately, I fell in love with the city and its multitude of people and attractions. As an adult, work and family drew me to Washington, D.C. New York City became a special occasion place. This book represents my attempt to return to New York, to walk its streets, to integrate my life into its life and to revel in its every facet.

New York City, known for modernity and change, boasts nine National Monuments, Memorials and Sites, more than any other city in the United States. Only presidents and the United States Congress can designate a site as a National Monument in consideration of its extraordinary place in American history. A National Historic Landmark designation indicates that the secretary of the interior and the National Park Service regard the site as important to American heritage.

For this book to exist, I am deeply indebted to Banks Smither, my editor at Arcadia/The History Press. Dr. Thomas Keaney, Dr. Jeffrey Kelman and Ann Sauer kindly read drafts of the book, and each made very helpful comments. I would like to thank them for their support and contributions. James Maher, the photographer of all the beautiful images, has succeeded in conveying the majesty and vitality of New York City and its citizens.

The visit to sites in each chapter's "Your Guide to History" section is organized by general topic and geographic location from Lower Manhattan to Inwood in Manhattan, followed by Brooklyn, Queens, the Bronx and Staten Island.

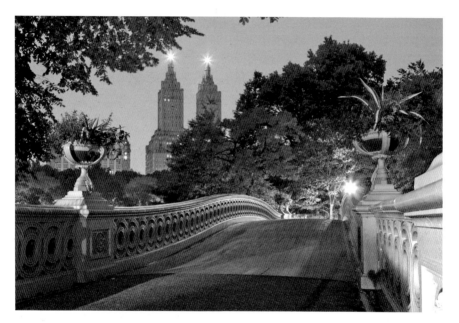

The New York City skyline from Central Park. *Courtesy of James Maher.*

SUPERLATIVE CITY

THE BIGGEST AND BEST OF THEM ALL

New Year's Eve in Times Square, Thanksgiving Day parades and Santa Claus, skyscrapers and the Statue of Liberty—these are celebrations and symbols of America that bring smiles to our faces. They are a gift to us from New York City. New York redefined itself in the nineteenth and twentieth centuries. In so doing, it redefined our country.

New York was the most populous city in the United States by 1825. It quickly became the preeminent American city. New York City has owned every superlative: it was the wealthiest, the most innovative and diverse and the most splendid in the country. In the early twentieth century, the longest bridge, the tallest skyscraper, the largest public park and the most extensive subway system in the world were all in New York City. New York was the first city anywhere to be electrified and the first to have telephone service. Its concert halls, theaters and museums became the arbiters of taste and distinction in this country.

With its obvious attractions, nineteenth-century New York became a magnet to many. Those who made vast fortunes elsewhere came to New York City to make their mark. And so John D. Rockefeller, Andrew Carnegie, Henry Clay Frick, James Duke and Joseph Pulitzer left Cleveland, Pittsburgh, North Carolina and St. Louis to reside in New York and make their contributions to the city. The first two millionaires in the United States lived in New York City in 1850. By the end of that century, there were scores of millionaires here—so many that a stretch of 5th Avenue became known as "Millionaires' Row."

New York also attracted the poor, the outcast and the persecuted. They came in large numbers. Between 1824 and 1924, thirty-four million immigrants entered this country. Twenty million arrived at the Port of New York. The majority of those who entered each year by way of New York stayed. Little Italy, Chinatown and Kleindeutchland grew up within the city. The Irish, Germans, Italians, Russian Jews, Polish, Chinese and countless others joined in and enriched the life of New York. Many immigrants quickly established themselves here and did well. Others suffered, finding misery and poverty where they had expected opportunity.

However grand and complex, New York City did not exist as we understand it today until 1898. Through most of the nineteenth century, Manhattan, Brooklyn, Queens, the Bronx and Staten Island were five separate entities. New York City was Manhattan alone. Brooklyn was a city in its own right. In fact, it was the third-largest city in the United States after New York and Chicago.

Some with vision recognized that combining five different entities into one city would help solve the area's increasingly vexing problems of transportation, water supply and sanitation. They promoted unification. A popular referendum on creating a Greater New York passed in 1894. It took a few more years to realize what this would mean in practical terms. On January 1, 1898, Manhattan, Brooklyn, Queens, the Bronx and Staten Island became the five boroughs, or administrative units, of one New York City. By a "stroke of a pen," New York's population increased to three million, making it the second-largest city in the world after London.

The Brooklyn Bridge deserves much credit for generating public support for a Greater New York. The Brooklyn Bridge opened in 1883, linking more closely together those two great rivals, Brooklyn and Manhattan. To cross this bridge today is a routine commute between Brooklyn and Lower Manhattan, but the bridge itself is far from common. It is an engineering marvel. Although it is no longer the longest span in the world, the Brooklyn Bridge remains one of our most beautiful American bridges. And it offers unrivaled views of New York.

Through much of the nineteenth century, millions relied on ferryboats to shuttle them across the East River between Brooklyn and Manhattan. There was, however, always the dream of a bridge to facilitate travel. But the East River was wide and deep; the challenge of building a bridge across the river was daunting. Then, an engineer named John Roebling, an immigrant from Germany, conceived of a suspension bridge that would employ the latest technology, including steel cable wiring and enormous sunken supports, called caissons.

Work began on the Brooklyn Bridge in 1869; it took $16 million and fourteen years to complete. It also took the lives of twenty workers through

accidents, including the life of John Roebling himself. Roebling's son, Washington, took over supervision of the construction of the bridge but later suffered from what was called "caisson disease." Today, we call this "the bends." It was actually during construction of the Brooklyn Bridge, when workers were submerged deep under water to work on the enormous supports, that this terrible and painful killer affliction became understood. Washington Roebling's wife, Emily, assisted him in finishing the work on the bridge.

The Brooklyn Bridge opened on May 24, 1883, widely acclaimed as a modern marvel. With a central span of 1,595 feet, the Brooklyn Bridge was the longest suspension bridge in the world. The entire structure is over one mile long. Its 272-foot-high double-arch Gothic towers rise at each end, and caissons extend 78 feet below the water level. President Chester Arthur (1881–85) and members of his cabinet attended the opening ceremonies for the Brooklyn Bridge. Fireworks added to the excitement.

Some, however, were skeptical. A week after the bridge opened, a large crowd of people crossing the bridge grew fearful that it would collapse under their weight. Panic ensued. Twelve people were crushed to death in the pandemonium. To reassure New Yorkers that the Brooklyn Bridge was safe, P.T. Barnum, the great circus showman, walked a herd of his elephants across the bridge. The herd included his most famous elephant, Jumbo. It was good publicity for both bridge and elephant. *Jumbo*, an Asian Indian word for "very large," soon came into common English-language usage.

New Yorkers quickly realized they could not live without this bridge and indeed needed more. They constructed three additional bridges over the East River: the Williamsburg Bridge in 1903, the Queensboro Bridge in 1909 and the Manhattan Bridge in 1912. The George Washington Bridge, the only bridge connecting Manhattan to New Jersey across the Hudson River, was completed in 1931. The Triborough Bridge—really a complex of spans and roadways connecting Manhattan, Queens and the Bronx—opened in 1936. In 2008, the Triborough officially became the Robert F. Kennedy Bridge. The last major bridge built in New York City is the 1964 Verrazano-Narrows Bridge, which has the longest span of any bridge in the United States.

One hundred years after New York became the most populous city in the United States, it became the most populous in the world. In 1925, it took this title from London and held it for forty years. Today, New York City, with a population of 8.5 million people, ranks nineteenth in the world. With a population greater than all but eleven of the fifty American states, New York remains the most populous city in the United States.

YOUR GUIDE TO HISTORY

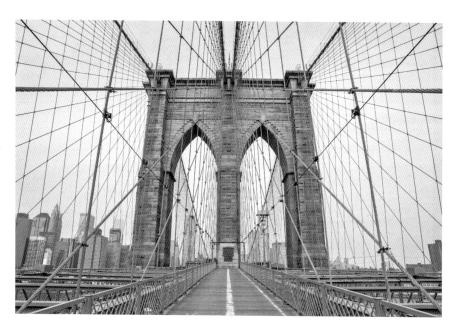

The Brooklyn Bridge. *Courtesy of James Maher.*

Official New York City Information Centers
www.nycgo.com

This website helpfully provides the location of the official New York City Information Centers. The website also has maps, guides, lists of tours and popular attractions. It also has information on citywide tourist passes that offer money-saving opportunities.

Website of the City of New York
www.nyc.gov

This website of the City of New York, the official name of the city, provides up-to-date information on attractions, museums and cultural events. New York City is the most visited tourist destination in the United States.

Subway and Bus Maps and Information
www.mta.info

This website provides a full range of information on the New York subway and bus system with maps, fares and schedule updates.

New-York Historical Society Museum and Library
170 Central Park West at 77th Street • Manhattan/Upper West Side
212-873-3400 • www.nyhistory.org • Admission Fee

This is New York City's oldest museum. The society was founded in 1804 and continues to use the hyphenated version of New-York that was common early in the nineteenth century. The museum is in a beautiful 1908 Beaux-Arts building designed by York and Sawyer. The collection is extensive and includes ones of the best repositories of the Hudson River School of Painting. The Robert H. and Clarice Smith New York Gallery of American History showcases themes in American history reflected in the New York City experience. The gallery highlights the role of New York City in the young United States. Included in the admission fee is an eighteen-minute film, *The New York Story*, and guided tours of the museum. The museum makes a serious attempt to encourage children to think about history in

the Dimenna Children's History Museum and in history camps for middle school students.

Museum of the City of New York
1220 5th Avenue at East 103rd • Manhattan/Upper East Side
212-534-1672 • www.mcny.org • Admission Fee

The mission of the Museum of the City of New York is to explore the past, the present and the future of New York City. The museum takes advantage of its broad mandate and its extensive collection of 750,000 objects to create exhibits that help visitors understand the city today and to imagine it as it continues to evolve. A permanent exhibit, Gilded New York, displays the portraits, porcelain, dresses and jewels of the very wealthy at the end of the nineteenth century. Not to be missed is the twenty-karat gold, diamond, pearl and turquoise Tiffany dog collar. At the other end of the spectrum are the late nineteenth-century photographs by Jacob A. Riis documenting the lives of the very poor in New York City. *Timescapes* is a twenty-minute movie on the history of New York. The museum is planning a new permanent exhibit on the history of the City of New York, scheduled to open in 2016.

Like so much of New York City, the museum was the vision of an immigrant. The founder, in 1923, was Henry Collins Brown, a writer born in Scotland who made New York his adopted home. Architect Joseph H. Freedlander designed the splendid 1932 Georgian Revival–style building for the museum.

Brooklyn Historical Society
128 Pierrepont Street at Clinton Street • Brooklyn
718-222-4111 • www.brooklynhistoricalsociety.org • Admission Fee

Founded in 1863, the Brooklyn Historical Society studies and displays artifacts from the four-hundred-year history of Brooklyn. It also has a mission to engage the community in a dialogue of the contemporary issues facing Brooklyn. It offers considerable educational outreach to teachers and students. The Brooklyn Historical Society also has extensive holdings of genealogy reference materials for those seeking to trace their family roots in Brooklyn. Changing exhibits often explore the neighborhoods and citizens of Brooklyn today. One exhibit on display through 2018 is In Pursuit of

Freedom, which focuses on Brooklyn's antislavery movement from the eighteenth to the nineteenth centuries. The building itself, a National Historic Landmark, is worth a visit. The architect, George Browne Post, greatly admired the engineering behind the Brooklyn Bridge and used iron trusses in the building's roof for support.

THE BROOKLYN BRIDGE
In Manhattan, access the pedestrian walkway behind City Hall in Lower Manhattan.
In Brooklyn, access the pedestrian walkway at the intersection of Tillary Street
and Boernam Place.
www.nyc.gov • Free

More than 120,000 vehicles cross the East River each day on the Brooklyn Bridge, which is a National Historic Landmark. In addition, 4,000 pedestrians and 3,100 bicyclists make the daily trip. There is a walkway on the Brooklyn Bridge above the traffic for pedestrians and bicyclists. The views of Lower Manhattan from the bridge are spectacular. They generate the same excitement felt by those crossing the bridge in 1883. Not far from the bridge on the Brooklyn side are the Brooklyn Heights Promenade and Brooklyn Bridge Park, both with beautiful views of Lower Manhattan.

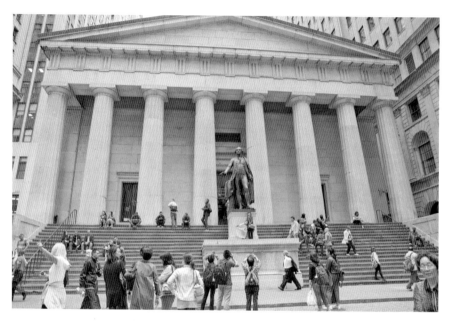
George Washington at Federal Hall. *Courtesy of James Maher.*

FIRST CAPITAL OF THE COUNTRY

GEORGE WASHINGTON SLEPT HERE

Contrast the New York City of 1898 with the New York of one hundred years earlier. In the late eighteenth century, New York occupied only the tip of Manhattan Island. The street map reveals the geography of early New York. Lower Manhattan is a jumble of streets that twist and turn and bear distinctive names like Hanover, Beaver, Water, Houston and Pearl.

Many of these street names provide insights into seventeenth- and eighteenth-century New York. Pearl Street is named for the seashells once found there. Pearl Street ran along the shore of the East River before landfill extended Manhattan to South Street in 1800. There once was a wall along the outer edge of the city to protect the earliest European settlers in New York, the Dutch, from their enemy, the English. This explains the name "Wall" Street. Beaver Street was the center of the very important fur trade that created fashionable hats and large fortunes in the late eighteenth century. Notably, the seal of the City of New York includes the image of a beaver.

Early European exploration of New York was a precursor of the future city's cultural mix. In 1524, Italian Giovanni da Verrazano, sailing for the French, was the first European to lay eyes on Manhattan. The Verrazano-Narrows Bridge, which connects Brooklyn and Staten Island, is named in his honor. Today, if you arrive in New York City by ship, you will most likely go under the Verrazano-Narrows Bridge. Henry Hudson, an Englishman sailing for the Netherlands, became, in 1609, the first European to explore what would be named the Hudson River along the west side of Manhattan.

Hudson named Staten Island for the governing body of the Netherlands: the *staten*, or states general.

The Netherlands, the greatest sea power in the world in the early seventeenth century, grasped the potential of New York for trade. A small group of Dutch colonists landed on Governors Island in 1624. Officials of the Dutch West India Company established a trading outpost at the mouth of the Hudson River and called it New Amsterdam after their country's capital city. They named the broader area New Netherlands. In 1648, the Dutch built the first wharf to handle the shipping trade on the East River. One hundred years later, there would be multiple wharfs with one-third of the world's trade shipped out of New York City.

But the Dutch were not the first to inhabit the land. About fifteen thousand Lenape Indians lived here, moving from shore to inland in different seasons. To ensure the establishment of successful trade routes, the leader of New Amsterdam, Peter Minuit, sought a peaceful accommodation with the local inhabitants. The story is that Minuit bought Manhattan from the Lenape in 1626 for approximately twenty-four dollars' worth of beads and utensils. It is probable that the Lenape had a different approach to property rights than the Europeans, not intending to relinquish the land completely. Whatever their intentions, the Lenape legacy lives on in the name Manhattan; it derives from a Lenape word meaning "island of many hills."

The Dutch continued their advances in the area, settling Brooklyn, named for Breuklelen, a town in the Netherlands, in 1636. The name for another borough, the Bronx, also has Dutch origins. Jonas Bronck settled the area for the Dutch in 1639. Bronck, however, was born in Sweden. Other Dutch naming rights extended to Haarlem after the city in the Netherlands of the same name. Later, the spelling was changed to Harlem. The Bowery on the Lower West Side of Manhattan takes its name from the Dutch word for farm: *bouwerij*. And Coney Island derives from the Dutch name for rabbit—*conyne*—once plentiful in the area.

Though Dutch control of Manhattan was short-lived—about forty years—their contributions to what would become New York and the United States have been long lasting. Unlike English settlers in New England, the Dutch did not attempt to impose a state religion on New Amsterdam. They practiced a tolerance that was a feature of their seventeenth-century homeland. Eager to expand the trading post's economic output, New Amsterdam accepted French Protestants, English Roman Catholics, Quakers and those fleeing the strictures of New England Puritanism.

Eighteen languages were spoken in New Amsterdam. Diversity was as much a characteristic of early Manhattan as it is now.

Jews first arrived in Manhattan in 1654, fleeing from Brazil, where Portuguese victories over the Dutch and ensuing intolerance made their existence untenable. The director general of New Amsterdam, Peter Stuyvesant, initially objected to their presence, but his bosses at the Dutch West India Company in Amsterdam overruled him. The Jewish population in Manhattan became an integral part of the town.

Freedom and tolerance did not, however, extend to those of African origin. The slave trade was robust. Slaves worked in the fields and at the port. The Dutch began bringing Africans into New Amsterdam in the 1620s. At first, they seized them from Portuguese ships. Later, the Dutch brought them directly from Africa. At a time when there were fewer than two thousand people living in New Amsterdam, the slave population numbered three hundred.

By the mid-seventeenth century, the balance of power had shifted in Europe with major consequences for the Americas. The English surpassed the Dutch as the dominant sea power. In North America, the British had already defeated the French in the French-Indian War of 1754 to 1763, becoming the continent's powerhouse. The English had colonies in Massachusetts, Connecticut, Pennsylvania and Virginia. The Dutch New Amsterdam stuck out like a great interruption of the extended English control. The English eyed New Amsterdam and wanted it. England was looking not only at opportunities in trade; it also needed outlets for its booming and underemployed population. Overseas settlement provided a great escape hatch for too many people with too few jobs who otherwise might become disruptive at home.

In 1664, King Charles II dispatched a naval force of four war ships and two thousand men under the command of Richard Nicolls to take the Dutch New Amsterdam outpost for England. Peter Stuyvesant, with only a small garrison to defend the town, saw reason and surrendered. The English took over, and Nicholls became governor. The English extended to the Dutch inhabitants of Manhattan their policy of freedom of religion and trade—two cornerstones of continued New York growth and development.

Though Stuyvesant returned to the Netherlands, he later resumed his life in New York and died here. He is interred at St. Mark's Church in-the-Bowery on land he once owned. There is a 1915 statue of Stuyvesant at the church. He is also immortalized in Stuyvesant Street, Stuyvesant Square and Stuyvesant High School in Manhattan and the Bedford-Stuyvesant area of Brooklyn.

English possession provided naming rights. Instead of New Amsterdam and New Netherlands, New York became the name for the settlement and

territory. The important Dutch outpost of Fort Orange became Albany. All were named in honor of the younger brother of King Charles II, who was the Duke of York and also the Duke of Albany. He later became King James II of England. The English named Queens, the largest of the five New York boroughs, for the wife of King Charles II of England, who ruled from 1660 to 1685. Queen Catherine of Braganza was originally from Portugal.

English control of New York continued from 1664 until 1783, with a brief interruption in 1673, when the Dutch returned and took over Manhattan for fifteen months before permanently losing it to the English. The English made New York a royal colony in 1685 and retained sovereignty until the American Revolution brought independence. Ironically, in 1688, in the Glorious Revolution, the Dutch army landed on the coast of England, marched toward London and installed the Protestant daughter of Catholic King James II on the throne of England. Her husband was the Dutch William of Orange. They ruled jointly as King William and Queen Mary. Their rule was notable in that it established the supremacy of Parliament over the throne in England. This, in turn, would greatly influence American views of how government should operate.

Under British rule, New York continued the African slave trade. By the mid-eighteenth century, 20 percent of the eleven thousand people living in Manhattan were slaves. Of all the towns in North America, only Charleston, South Carolina, had a greater slave population. Slaves performed household labor, worked in the growing shipbuilding industry and served as apprentices in various trades. Under Dutch rule, some slaves had worked to earn their freedom. The English stopped this practice. They also precluded slaves from burial in churchyards, such as the one at Trinity Church. The important ceremony of individual burial would occur in the African burial grounds north of the city and away from the population center.

While little concerned about freedom for African slaves, New Yorkers became increasingly focused on their own personal liberty. New York played host to the first organized American resistance to British taxation. In October 1765, representatives of all thirteen of the American colonies gathered for the Stamp Act Congress at New York City Hall. They were there to protest "taxation without representation," which London had proposed to do in the Stamp Act. The Stamp Act Congress resulted in the Declaration of Rights and Grievances, which helped achieve the desired result: British Parliament repealed the Stamp Act.

The Sons of Liberty of New York had organized in response to the Stamp Act. They were principled defenders of freedom and, when they thought

necessary, public agitators. To celebrate the repeal of the Stamp Act, they erected a "Liberty Pole" in 1766 near the British military barracks in what is now City Hall Park. British soldiers took it down, and the Sons of Liberty erected another. This back and forth continued a few more times. Today, a symbolic Liberty Pole stands close to City Hall. As in Boston, there was a tea party in New York Harbor to dump tea into the sea to protest the taxation of this important commodity.

With tensions between England and the colonies propelling them toward conflict, George Washington became commander in chief of the Continental army in June 1775. Washington successfully drove the British from Boston after the Battle of Bunker Hill. Both Washington and the British immediately recognized that New York City was the next big prize.

Political momentum reinforced the action on the battlefield when the American Patriots meeting in Philadelphia in the Second Continental Congress issued the Declaration of Independence on July 4, 1776. When the declaration was read to the public in New York City on July 9, the New York Sons of Liberty rushed to Bowling Green and toppled the large equestrian statue of King George III that had stood there since 1770.

The largest land battle of the Revolutionary War was the Battle of Long Island, also known as the Battle of Brooklyn. In this military engagement on August 27, 1776, British commander Sir William Howe defeated General George Washington and his Continental army. Not only were there twice as many British as American forces—twenty thousand compared to ten thousand—but Howe also surprised Washington in a nighttime flanking maneuver and nearly managed to surround the Continental army. Sensing a hopeless situation, George Washington rushed to evacuate the remaining nine thousand American troops from Brooklyn to Manhattan. A dense fog helped conceal their escape from the British. There are annual reenactments of the Battle of Long Island on its August anniversary in Green-Wood Cemetery, Brooklyn, where the battle occurred.

While Washington did win a battlefield victory against the British at Harlem Heights shortly thereafter, he recognized the peril his soldiers faced when up against the far superior British forces. George Washington and the Continental army evacuated New York on November 16, 1776, not to return for seven years. Washington led his troops north into Westchester County, New York, then into New Jersey and on into Pennsylvania. New York City remained under British control for the duration of the Revolutionary War. British admiral of the fleet Richard Howe, also known as Lord Howe, and his brother Sir William Howe, general of the British army, made New York

their North American headquarters. Under British rule, many New Yorkers remained loyal to the Crown.

George Washington, eager to learn about British war plans, deployed spies to the Loyalist stronghold of Manhattan. One of the most famous American spies was Nathan Hale, a former schoolteacher from Connecticut. Hale was on a mission to New York City when the British captured him and hanged him on September 22, 1776. The brave twenty-one-year-old is remembered for his inspiring last words: "I only regret that I have but one life to give for my country." An American hero, he is remembered in a statue by Frederick MacMonnies in City Hall Park.

While there were no more battles in New York City, a great fire in September destroyed a quarter of Manhattan. Both the British and the Americans accused each other of arson. And American casualties in New York exceed those in all the Revolutionary War battles combined. From 1776 to 1781, over ten thousand captured Patriots died on British prison ships moored in the East River, succumbing to neglect, disease and malnutrition. These Americans are memorialized and some of their remains interred at the Prison Ship Martyrs' Monument in Fort Greene Park, Brooklyn.

As the Revolutionary War continued, George Washington and the Continental army, persevering without adequate arms, food or pay, kept the British at bay. King George III saw many battlefield wins but no victory. This was enough for the government of France to increase support for the American Revolution. The American-French victory over the British at Yorktown in 1781 was the final battle of the American Revolution. On September 3, 1783, a war-weary Britain signed the Treaty of Paris and relinquished its thirteen American colonies and all lands to the Mississippi River.

New York would be the last American territory the British left. On November 25, 1783, British forces under Sir Guy Carleton evacuated New York City. That same afternoon, General George Washington and his Continental army made a triumphant return. For many years, Evacuation Day, November 25, remained a day of great celebration in New York City. Its importance diminished after President Abraham Lincoln proclaimed in 1863 a national day of Thanksgiving set for the third Thursday of November. Later, Congress changed Thanksgiving to the fourth Thursday in November. After World War I and the United States' alliance with Great Britain, the evacuation commemoration disappeared altogether.

In appreciation of the American victory and the November 25 return to New York City, George Clinton, the first governor of New York, hosted a dinner in honor of George Washington at Fraunces Tavern in Manhattan.

George Washington dined again at Fraunces Tavern on December 4, 1783, and said goodbye to his officers in the Continental army. Immensely popular, Washington could have stayed on indefinitely as general. He would have held great sway over the young country. With his farewell, Washington helped create a true American democracy under civilian, not military, control.

George Washington retained a special place in the hearts of grateful New Yorkers. New York City's Common Council, a precursor of today's city council, honored him in 1785 with "the Freedom of the City." In response, George Washington wrote the council a letter and referred to New York State as the seat of the empire. Some historians point to this letter as the first reference to New York as "the Empire State." Today, New York State is commonly known as the Empire State, and "Empire State" is written on New York automobile license plates. The most famous building in New York City is the Empire State Building.

During the Revolutionary War, a national government had been formed under the Articles of Confederation, adopted in 1777 and ratified by the states in 1781. Under this form of government, individual states held power. The federal government could not raise taxes, pay the army or effectively conduct foreign policy. There was no president, only a Confederation Congress that periodically met but accomplished little. From 1785 to 1789, the Confederation Congress met in New York City.

Recognizing the shortcomings of the Articles of Confederation, some pushed for the Constitutional Convention that convened in Philadelphia in the summer of 1787. The result was a constitution that framed a new, stronger federal government. With the ratification of the Constitution in 1788, New York City became the first capital of the United States. Pierre L'Enfant, a French engineer who had left his homeland to support the American side in the Revolutionary War, remodeled the former British colonial City Hall on Wall Street to house Congress and the executive and judicial branches of the new federal government. City Hall became Federal Hall. The first session of the First United States Congress convened on March 4, 1789, at Federal Hall in New York City. It was in New York City in the summer of 1789 that James Madison, serving as a representative from Virginia, introduced twelve amendments to the Constitution. The states would ratify ten of these amendments that define the basic rights and liberties of Americans. These first ten amendments to the United States Constitution are known as the Bill of Rights.

By the terms set forth in the Constitution, the Electoral College voted for the first president of the United States and unanimously chose George Washington. Informed of its decision at his Virginia plantation, Mount

Vernon, Washington made his way to New York City for an inauguration originally set for March 4 but delayed by bad weather until April 30.

April 30, 1789, was clear and cool as George Washington stepped onto the second-floor balcony of Federal Hall to take the oath of office of president of the United States. Robert Livingston, chancellor of New York, administered the oath. John Adams, vice president, stood at Washington's side. On this solemn occasion, George Washington spoke the words laid out in the United States Constitution. He also added his own touches to the ceremony: he swore the oath on a Bible. In closing, Washington added, "So help me God." Every president since 1789 has sworn the oath on the Bible and added the words "So help me God." Today, a large bronze statue of George Washington stands where he took the oath of office as our first president. The statue by sculptor John Quincy Adams Ward has been in this location since 1882.

After his inauguration, George Washington delivered his inaugural address in the Senate chambers in Federal Hall to the assembled members of Congress. He then walked to St. Paul's Chapel to worship. Later, President Washington would return to his residence, a rented home at 1 Cherry Street that also served as his office. This home was demolished in the nineteenth century. There is a plaque on Pearl Street under the Brooklyn Bridge to remember the first presidential mansion.

In New York City, in Federal Hall, Congress created the United States government of today and the first four departments of the executive branch: Treasury, State, War and Justice. For secretary of the treasury, George Washington chose New Yorker Alexander Hamilton, an ardent advocate of the new federal form of government. Thomas Jefferson became secretary of state, Henry Knox became secretary of war and Edmund Randolph became attorney general. Washington nominated John Jay, a New Yorker, to be the first Supreme Court chief justice.

New York City remained the federal capital until 1790. The decision to relocate the United States capital out of New York City was part of a grand compromise that resolved several difficult issues threatening to tear the young country apart. Over dinner in New York City in 1789, Alexander Hamilton, Thomas Jefferson and James Madison agreed that the northern states, with their much heavier Revolutionary War debt, would gain relief through the federal government's assuming the debt. In return, the southern states would realize their goal of seeing the United States capital move to a more geographically central location. President George Washington had the authority to select the location. He chose a site on the banks of the Potomac

River near Georgetown, Maryland. It was here that a new district would be created to house the federal government.

Pierre L'Enfant, who had successfully remodeled New York City's Federal Hall, would prepare the plan for this new United States capital city: Washington, named for George Washington, in the federal District of Columbia, named for Christopher Columbus. The national government would move to Washington, D.C., in 1800. Until then, Philadelphia would serve as the temporary capital of the United States. Moving the federal capital out of New York City in 1789 reassured many Americans who felt that concentrating political as well as economic power in a single city would threaten the young democracy.

As the United States approached the nineteenth century, New York City would no longer be the political capital of the young nation. However, New York City would increasingly become the nation's financial, commercial and cultural capital.

Your Guide to History

National Museum of the American Indian New York
1 Bowling Green, across from Battery Park • Lower Manhattan
212-514-3700 • www.nmai.si.edu • Free

This New York branch of the Smithsonian Institution's National Museum of the American Indian, the George Gustav Heye Center, is housed in the Alexander Hamilton U.S. Custom House. This museum has an important and extensive permanent collection of archeological items, modern and contemporary art, photographs and video from tribes across the United States and also from Canada and South and Central America. Rotating exhibits, musical and dance presentations and significant educational outreach create a museum that provides stimulating insight into Native American life and artistic endeavors.

The Alexander Hamilton U.S. Custom House building is an important part of the visit. On the site where the Dutch Fort Amsterdam once stood, it is one of the most beautiful Beaux-Arts buildings in New York City. Dating to 1907, it is the work of famed architect Cass Gilbert. Sculptor Daniel Chester French designed the massive exterior statues representing the continents of America, Africa, Asia and Europe. The building is named for Alexander Hamilton, a New Yorker. He was the first secretary of the treasury of the United States, serving under President George Washington. Hamilton is credited with creating the national banking system.

The National Archives at New York are also in the building. There is a small welcome center and exhibit gallery of original United States documents. The Alexander Hamilton U.S. Custom House is a National Historic Landmark.

Bowling Green
Broadway at Whitehall Street • Lower Manhattan
www.nycgovparks.org

At this location, Peter Minuit negotiated with the Lenape Indians for the sale of Manhattan to the Dutch in 1626. This is the oldest public park in New York City. It was built in 1733 next to the original location of the Dutch Fort of New Amsterdam. The original eighteenth-century fence is still in place. For a while in colonial times, the locals enjoyed the popular sport of lawn bowling here. The Sons of Liberty tore down the 1770 equestrian statue of King George III after the July 9, 1776 reading in New York City of the

Declaration of Independence. Today, the statue on Bowling Green is the *Charging Bull* described in Chapter 14.

THE BATTERY
Lower Manhattan
www.thebattery.org

This twenty-five-acre park is built on landfill that has extended the tip of Manhattan since the mid-nineteenth century. Its name derives from the artillery batteries the original Dutch residents placed here to protect the city. Today, it is a lovely park with many pleasant features, gardens and memorials. The Battery Conservancy, a nonprofit organized in 1994, maintains this New York City park.

There is a lovely waterfront promenade with views of the Statue of Liberty and of Lower Manhattan. The gardens include the Bosque Gardens, designed by Piet Oudolf. *Bosque* means "grove of trees" in Spanish. The Gardens of Remembrance flower in tribute to those who died on September 11, 2001. The Labyrinth, a path for reflection, has been a feature of the Battery since September 11, 2002.

Historical references are strong and numerous. They are captured in a totally modern and artistic way at the Peter Minuit Plaza near the Staten Island Ferry Terminal in the New Amsterdam Pavilion. The pavilion was designed by UNStudio to look like a flower. At midnight, the pavilion flashes different colors in honor of Peter Minuit, whose name translates to "midnight" in English. A very recent addition, the Seaglass Carousel is a contemporary version of the popular merry-go-round. In this case, luminescent fish rather than horses move through light projections that give the rider the feeling of being under water. The carousel acknowledges the former presence in the Battery of the New York Aquarium, housed in Castle Clinton from 1896 to 1941.

The East Coast Memorial remembers the 4,601 American servicemen who died in World War II combat in the Atlantic Ocean. The Sphere, originally at the World Trade Center and severely damaged on September 11, 2001, is here, at least temporarily, to remember those who lost their lives that terrible day. There are memorials to Korean War veterans, the American Merchant Marines and the Coast Guard, and also there is the Marine Flagstaff.

Americans of many nationalities have sought to honor their distinguished countrymen in statues and memorials that include: the Statue of Giovanni

da Verrazzano, the Netherland Memorial, the John Ericsson Statue, the Walloon Settlers Memorial, the Peter Caesar Alberti Marker, the Norwegian Maritime Monument and the John Wolfe Ambrose Memorial. A statue, *The Immigrants*, remembers those who entered this country through Castle Clinton. The visit to Castle Clinton is described in Chapter 7. Markers in the Battery honor Emma Lazarus and Admiral George Dewey.

GOVERNORS ISLAND

10 South Street at Whitehall Street • Lower Manhattan
www.batterymaritimebuilding.com • www.govisland.com • www.nps.gov/gois •
Admission Fee

The ferry to Governors Island departs from the Battery Maritime Building. The island is open to visitors from May to September, with ferries operating during those months. Governors Island is the joint responsibility of the Trust for Governors Island and the National Park Service.

The 172-acre island off the southern tip of Manhattan is a gem, offering entertainment as well as a large green park to provide respite from the concrete of the city. A series of events is planned for the warm weather season, including concerts and art installations, often with an international flavor. A relatively new addition to the island's attractions is the "Hills." Four separate hills of varying heights provide visitors with beautiful panoramic views of Lower Manhattan and the Statue of Liberty.

The name Governors Island dates to the colonial period when the island was the preserve of the British governors who ruled the city. After the 1783 Treaty of Paris that ended the Revolutionary War and the British military's departure from New York, the island hosted part of the system of fortifications built to protect the city from the British in the event of renewed conflict. Although the United States and Great Britain again took up arms against each other in the War of 1812, no fighting occurred here.

The National Park Service staffs and offers free tours of the two military forts built after the end of the Revolutionary War and before the War of 1812. The classic star-shaped Fort Jay, dating to 1798, was named for John Jay, then governor of New York and the first Supreme Court chief justice. Castle Williams is named for Colonel Jonathan Williams of the Army Corps of Engineers, who designed the fort in 1811. The United States Army had a major post on Governors Island from 1794 until 1966. The site is a National Monument.

Battery Maritime Building
10 South Street at Whitehall Street • Lower Manhattan
www.batterymaritimebuilding.com

Before your ferry departure for Governors Island, take a moment to look around the 1909 Beaux-Arts Battery Maritime Building of cast iron with lovely, decorative ceramic tile. It is the work of the Walker & Morris architectural firm. The ferry runs in the summer months.

James Watson House
7 State Street • Lower Manhattan
Exterior Only

This 1793 home, enlarged in 1806 by architect John McComb Jr., was originally built for James Watson, the first Speaker of the New York Assembly and a United States senator representing New York. Today, it serves as the rectory of the Shrine of Saint Elizabeth Seton. For many years in the nineteenth century, the building served as a hostel for young Irish women immigrating alone to the United States who were at great risk as they landed in New York. The building is on the National Register of Historic Places.

African American Burial Ground National Monument
290 Broadway at Duane Street • Lower Manhattan
212-637-2019 • www.nps.gov/afbg • Free

Begin at the visitor center located in the Ted Weiss Federal Building on Broadway. This National Park Service site provides informative exhibits on the lives of Africans brought to New York as slaves during the colonial period. Although New York City served as the host to the first United States Congress, which wrote the Bill of Rights detailing our most fundamental rights as United States citizens, slavery continued here. New York State passed a law in 1799 that provided for the gradual emancipation of slaves. Slavery in New York State was finally abolished on July 4, 1827.

After the British banned burying Africans in public cemeteries, they provided a burial ground for them beyond the limits of Manhattan. Africans and their descendants followed sacred rites for more than fifteen thousand individual burials in the six-acre grounds that existed here in the eighteenth

century. City growth and development overtook the burial ground. Excavations in 1991 for the Ted Weiss Building uncovered the forgotten human remains.

Walk around the corner from the visitor center to the monument on Duane Street for a moment of reflection. The Circle of Diaspora signifies the cultural diversity of the Africans who arrived in this country. The Ancestral Chamber not only represents the soaring African spirit, but it also symbolizes the ship holds in which so many slaves were brought against their will to America. The Ancestral Reinternment Ground is where 419 human remains uncovered during the excavation are now buried. The remains were reburied in a 2003 traditional African ceremony attended by many luminaries, including Maya Angelou. The site is a National Monument.

FRAUNCES TAVERN
54 Pearl Street at Broad Street • Lower Manhattan
212-425-1778 • www.frauncestavernmuseum.org • Admission Fee

The museum, four joined buildings taking up a city block, opened in 1907. The tavern building dates to 1719. It became a popular tavern after 1762 under proprietor Samuel Fraunces. Today, the museum offers lectures, concerts and special events, as well as tours and displays. Its focus is the history of the tavern and New York City during the colonial era, the Revolutionary War and the early days of the United States. The guided tour includes the Long Room, where George Washington said farewell to his Continental army officers on December 4, 1783, as he prepared to resign his military commission after the conclusion of the Revolutionary War. The Clinton Room, where George Washington dined to celebrate Evacuation Day, is also part of the tour. Several galleries on the upper floor of the museum display American memorabilia, including early flags. When New York City served as the first capital of the United States, the building provided office space for the Departments of Foreign Affairs, Treasury and War.

FEDERAL HALL NATIONAL MEMORIAL
26 Wall Street • Lower Manhattan
212-825-6990 • www.nps.gov/feha • Free

Park Rangers provide guided tours of the building, which is a memorial to George Washington and to the creation of the American government.

Federal Hall became City Hall after the United States capital departed New York and moved to Philadelphia in 1790. The original building where George Washington took the oath of office as first president of the United States was demolished in 1812. The current building dates to 1842, when it was the New York City Custom House. John Frazee was the architect.

The Bible on which George Washington swore his presidential oath in his 1789 inauguration is on display. This Bible was printed in 1767. It is known as the St. John's Bible, as it belongs to St. John's Masonic Lodge 1. Other presidents who took the oath of office on this Bible were President Warren B. Harding in 1921, President Dwight D. Eisenhower in 1953, President Jimmy Carter in 1977 and President George H.W. Bush in 1989. The large bronze statue of George Washington by sculptor John Quincy Adams Ward has been in this location since 1882. The statue stands on the approximate spot where Washington took the oath of office as our first president. The statue is a popular venue for visitors who seek to have their photographs taken with the father of our country. In addition to this statue of George Washington at Federal Hall, there are statues of Washington in Washington Square Park, which was named for the first president, and in Union Square.

There were several events that occurred in the original Federal Hall that were important to American democracy. In 1735, a newspaperman named John Peter Zenger was tried for writing articles critical of the royal governor of New York. The trial found Zenger innocent of libel, setting a precedent for the important principle of freedom of the press. The royal governor lost another fight when he failed to prevent the Stamp Act Congress from meeting in the hall in 1765, thus ensuring the promotion of freedom of assembly. These and other basic rights were codified when James Madison introduced the amendments to the Constitution that would become known as the Bill of Rights when Congress was meeting in Federal Hall in 1789. Federal Hall housed the offices of the Senate, the House of Representatives and the president.

It is notable that Congress convened a session in Federal Hall on September 11, 2002, one year after 9/11, to demonstrate the American commitment to democracy in the face of terrorism. This was only the second time in history after the federal government moved to Washington, D.C., in 1800 that Congress met outside of the United States capital. The site is a National Memorial.

Nathan Hale Statue in City Hall Park
City Hall Park • Lower Manhattan

An American hero, Nathan Hale is remembered in a statue by Frederick MacMonnies in City Hall Park. The statue has stood here since 1893, the centennial of the British evacuation of New York City at the end of the Revolutionary War. At one point, experts believed that this was where the British hanged Nathan Hale, but that location is in dispute. The body of Nathan Hale was never recovered. The best way to see the statue is to take a tour of City Hall as described in Chapter 9.

Trinity Church
75 Broadway at Wall Street • Lower Manhattan
212-602-0800 • www.trinitywallstreet.org • Donation

Trinity Church first opened for worship on this site in 1698. However, the original building burned in the Great Fire of 1776. A second building was later demolished for structural reasons. This church edifice, a beautiful Gothic Revival–style building designed by Richard Upjohn, dates to 1846. The church tower, at 280 feet, was once the highest spire in New York City—an early skyscraper. Trinity has one of only two complete sets of twelve change-ringing bells in North America. Volunteers pull the ropes that make the bells peal on Sundays and for special occasions. The churchyard is also important. It is the final resting place of several notable Americans: Alexander Hamilton, Robert Fulton and Albert Gallatin. Within the churchyard there is also the Society of the Cincinnati Plaque in honor of the nation's oldest patriotic organization, founded in 1783. Trinity is an active Episcopal church with regular services. Together with St. Paul's Chapel, it operates as Trinity Wall Street.

St. Paul's Chapel and Cemetery
209 Broadway at Fulton • Lower Manhattan
212-602-0800 • www.trinitywallstreet.org • Donation

After his inauguration as president of the United States on April 30, 1789, George Washington walked to St. Paul's Chapel to worship. Within the chapel is a replica of the pew box where Washington sat. The Great Seal

of the United States hangs above the pew box. Among the notable objects within the chapel is the "Glory" altarpiece designed by Pierre L'Enfant, architect of the remodeled 1789 New York Federal Hall and of the plan for Washington, D.C. L'Enfant also helped restore St. Paul's Chapel while he was in New York City.

St. Paul's Chapel, built in the Georgian Classic Revival style, opened for worship in 1766. This building, a National Historic Landmark, survived the Great Fire of 1776. Even more remarkably, it survived the terrorist attack of September 11, 2001, that destroyed the nearby Twin Towers and many surrounding buildings. Because of this, it is now affectionately called "the little chapel that stood." Within the chapel are many remembrances of 9/11 and of the thousands of volunteers who used St. Paul's as a base of operations in the aftermath of the attack. St. Paul's Chapel is an active place of worship. Together with Trinity Church, it is Trinity Wall Street.

St. Mark's Church in-the-Bowery
131 East 10th Street, 10003 • Manhattan/East Village
212-674-6377 • www.stmarksbowery.org • Donation

This is the oldest site of continuous worship in New York. The church building is more recent, dating to 1799. This church, which is within the St. Mark's Historic Village, is on land that once belonged to Peter Stuyvesant. Peter Stuyvesant is buried here. The statue of Stuyvesant dates to 1915.

Columbus Circle
8th Avenue, Broadway, Central Park South and Central Park West •
Manhattan/Midtown

There are several statues of Christopher Columbus in New York City. The most notable is the one by Italian sculptor Gaetano Russo, erected in 1892 to commemorate the 400th anniversary of the Italian explorer's discovery of the New World. In the nineteenth century, Italian Americans, growing in number and influence in New York City, supported this statue as recognition of their presence. All official distances to and from New York City are measured at Columbus Circle.

The Mount Vernon Hotel Museum & Garden
421 East 61st Street • Manhattan/Upper East Side
212-838-6878 • www.mvhm.org • Admission Fee

Constructed in 1799 as a carriage house for Mount Vernon, an estate in New York named for George Washington's Virginia plantation, the building became the Mount Vernon Hotel in 1826. In 1833, the owners converted it to a family home until early in the twentieth century. It opened as a museum in 1939. The Colonial Dames of America own and operate the museum. The museum was formerly known as the Abigail Adams Smith Museum, named for the daughter of President John Adams who owned land here with her husband, Colonel William Stephens Smith.

The building is restored to its time as a hotel. New Yorkers would travel up from the city, which ended around 14th Street, to this location, then in the countryside. Interpreters offer guided tours of the eight furnished rooms that represent comfortable New York life in the 1820s and '30s. There are many public events, including summer concerts in the lovely garden.

Hamilton Grange National Memorial
414 West 141st Street • Manhattan/Harlem
212-668-2208 • www.nps.gov/hagr • Free

This is a National Park Service site with ranger-guided tours of the period rooms. Alexander Hamilton was one of the most influential of the Founding Fathers. Born in the West Indies, he came to New York in 1772 as a teenager. Educated at King's College, now Columbia University, he became an advocate of American independence and of a strong federal government. Hamilton served as aide-de-camp to General George Washington. He fought at Yorktown.

Hamilton was the first United States secretary of the treasury in President George Washington's cabinet. In many ways, Hamilton was the creator of the modern American banking system. In honor of all that Hamilton did for the young country, his image is on the ten-dollar bill. This will change, however, in 2020, when a woman, to be selected in voting by the American public, will appear on the ten-dollar bill.

Alexander Hamilton spent the last two years of his life in this 1802 home. Although the home has been relocated several times in an effort to preserve it, it is on land that Hamilton once owned. Sadly, Hamilton would

engage in a duel with Thomas Jefferson's vice president, Aaron Burr, in 1804—a duel he lost. Hamilton was able only briefly to enjoy this beautiful Federal-style home designed by architect John McComb Jr. The building is a National Memorial.

MORRIS-JUMEL MANSION
65 Jumel Terrace at West 160th and 162nd Streets • Manhattan/Washington Heights
212-923-8008 • www.morrisjumel.org • Admission Fee

Tours of the Palladian-style mansion, a National Historic Landmark, are self-guided or guided. Morris-Jumel has been a museum since 1904. It hosts frequent musical and other events. Built by British colonel Roger Morris, this 1765 home and 130-acre estate was originally known as Mount Morris. George Washington, general of the Continental army, used the home as his military headquarters in the fall of 1776. He was staying here when he defeated the British at the Battle of Harlem Heights. As president, George Washington would return to the home. In July 1790, the president and Vice President John Adams, as well as Secretary of State Thomas Jefferson, Secretary of the Treasury Alexander Hamilton and Secretary of War Henry Knox, enjoyed a memorable dinner here. In 1810, Stephen and Eliza Jumel bought the estate. Stephen died in 1832 from pneumonia. Eliza remarried in the home in 1833 to Aaron Burr. Their marriage was short lived, lasting only ten months. They divorced the day of Aaron Burr's death. It was Aaron Burr who killed Alexander Hamilton in an 1804 duel.

DYCKMAN FARMHOUSE
4881 Broadway at 204th Street • Manhattan/Inwood
212-304-9422 • www.dyckmanfarmhouse.org • Admission Fee

Where there were once many farmhouses in a rural, agricultural area, now there is only the Dyckman Farmhouse, built around 1784. The Dutch colonial home opened as a museum in 1916 to help visitors understand eighteenth-century New York. A small formal garden surrounds the house. It is a National Historic Landmark.

BUILDING 92 AT THE BROOKLYN NAVY YARD
63 Flushing Avenue • Brooklyn
718-907-5992 • www.bldg92.org • Exhibits Are Free/Fee for Tours

During the Revolutionary War, the British prison ships where many Americans died anchored here. Commissioned as a naval yard in 1801, it remained one of the most important naval shipbuilding facilities until its closure in 1966. Building 92, the former residence of the marine commandant, was designed by Thomas U. Walter, one of the architects of the United States Capitol in Washington, D.C. Built in 1857, Building 92 now hosts rotating exhibits. Tours of the Brooklyn Navy Yard explore the history of the industrial park that produced some of the most legendary United States Navy ships in the history of our country. This includes the USS *Maine*, the USS *Arizona* and the USS *Missouri*. A menu of tours includes bike tours of the facility, photography tours and one of the most popular: the World War II tour. Today, the yard is home to many small artisans and crafts industries.

GREEN-WOOD CEMETERY
500 25th Street • Brooklyn
718-210-3080 • www.green-wood.com • Free

Founded in 1838, this 478-acre cemetery also serves as a park. The beautiful landscape and impressive array of statuary helped make it a major tourist destination by the mid-nineteenth century. It offers magnificent views of New York City. DeWitt Clinton, Boss Tweed, conductor Leonard Bernstein and artist Jean-Michel Basquiat are among the many notables buried here. The cemetery's historical importance includes the fact that the Revolutionary War Battle of Long Island, also known as the Battle of Brooklyn, was fought on this land. There are annual reenactments of the battle in August. Visitors may prefer a self-guided tour or a guided Historic Trolley Tour. The site is a National Historic Landmark.

LEFFERTS HISTORIC HOUSE
In Prospect Park • Brooklyn
718-789-2822 • www.historichousetrust.org • Free

Pieter Lefferts built this house in 1783. Of Dutch ancestry, Lefferts served in the Continental army during the Revolutionary War. The home was

moved from its original site to Prospect Park to preserve it from encroaching development in the early twentieth century. Today, Lefferts House is a museum of the life of an agricultural family in Brooklyn during the 1820s.

Prison Ship Martyrs' Monument
Fort Greene Park • Brooklyn
www.nycgovparks.org/parks/fort-greene-park/monuments

President-elect William Howard Taft attended the November 1908 dedication of this monument to remember the more than 11,500 men and women who died on the British prison ships anchored in the East River during the Revolutionary War. The monument, consisting of a simple, tall column with one hundred steps leading up to it, was the work of famed New York architect Stanford White. The bronze ornamentation is by sculptor Adolph Alexander Weinman. Under the monument is a vault containing the remains of a small number of those who died on the ships.

Fort Greene Park is named for American Continental army general Nathanael Greene, who was responsible for constructing Fort Putnam to defend New York from the British. Fort Putnam once stood in this park. After the Americans lost to the British in the Battle of Long Island, they surrendered Fort Putnam and retreated to Manhattan.

Wyckoff House
5816 Clarendon Road • Brooklyn
718-629-5400 • www.wyckoffmuseum.org • Admission Fee

Visiting Brooklyn today and experiencing its very urban vibes, it is difficult to appreciate that this area was once one of the most productive farmlands in the United States. The Wyckoff House Museum provides an opportunity to remember those earlier times. This is the oldest existing house in New York State. Pieter Claesen came to New Netherlands in 1637 from what is today part of Germany. Claesen worked off his indenture, married and bought a farm and one-room house where he and his wife raised eleven children. He would later add the surname Wyckoff. His descendants would remain on the farm until 1901. The museum opened in 1982. It offers tours of the house and gardens and educational outreach programs that include "Colonial Life" and "African American Life." The house is a National Historic Landmark.

Kingsland Homestead at Queens Historical Society
143–35 37th Avenue, Flushing • Queens
718-939-0647 • www.queenshistoricalsociety.org • Free

Built between 1774 and 1785, after 1801 this home belonged to Joseph King and his descendants until well into the twentieth century. The house, home to the Queens Historical Society, has been open to the public since 1973.

The Van Cortlandt House Museum
Broadway at West 246th Street • The Bronx
718-543-3344 • www.historichousetrust.org • Admission Fee

This is a beautiful 1748 Georgian-style home with exquisite eighteenth-century furnishings. The land was a large wheat plantation developed by merchant Jacobus Van Cortlandt, a wealthy and distinguished New Yorker of Dutch descent. His son Frederick built the home. George Washington used the home as his temporary headquarters during the Revolutionary War before he evacuated New York. The National Society of the Colonial Dames in the State of New York operates the home, which is owned by the New York City Department of Parks & Recreation. The House Museum provides educational tours for students and frequent lectures on period history. The site is a National Historic Landmark.

Van Cortlandt Park
Broadway and Vancortlandt Park South • The Bronx
718-430-1890 • www.vcpark.org • Admission Fee/Free

The 1,100-acre park, New York City's fourth largest, is on what was once the Van Cortlandt farm. It provides the setting for the Van Cortlandt house. The park has considerable amenities, including Van Cortlandt Lake, the nature center, a pool and running trails. Van Cortlandt Golf Course, which dates to 1895, was the first municipal golf course in the country.

BARTOW-PELL MANSION MUSEUM
895 Shore Road • The Bronx
718-885-1461 • www.bartowpellmansionmuseum.org • Admission Fee

Robert Bartow bought land that had belonged to Thomas Pell and his heirs since the mid-seventeenth century. Bartow built this gray stone mansion with Greek Revival interiors, moving in with his family in 1842. The home opened as a museum in 1946. Its mid-nineteenth-century furniture and décor are on display; the museum also offers rotating exhibits. All tours of the home, which is a National Historic Landmark, are guided.

VALENTINE-VARIAN HOUSE
3266 Bainbridge Avenue • The Bronx
718-881-8900 • www.bronxhistoricalsociety.org • Admission Fee

This Fieldstone house, built by Isaac Valentine in 1758, became the property of the Varian family in 1791. In 1968, it opened as a museum of the history of the Bronx with exhibits and guided tours. It is the home of the Bronx Historical Society.

THE CONFERENCE HOUSE
298 Satterlee Street • Staten Island
718-984-6046 • www.conferencehouse.org • Admission Fee

On September 11, 1776, the leader of the British military forces in the colonies, Lord Howe, met in this house with three representatives of the rebellious Americans: Ben Franklin, John Adams and Edward Routledge. The purpose of the conference was to make a last effort at reconciliation. However, the British price—revocation of the Declaration of Independence—was too high. The Americans left the conference, and the Revolution continued. The house is now a museum. It is a National Historic Landmark.

Historic Richmond Town
441 Clarke Avenue • Staten Island
718-351-6057 • www.historicrichmondtown.org • Admission Fee

Historic Richmond Town today comprises of one hundred acres within four separate sites with thirty structures that date from the seventeenth to the twentieth centuries. This includes a tinsmith's shop, a carpenter's shop and a basket maker's house. Living history enactments provide a good look into the history of Staten Island and New York City. Voorleezer's House, a National Historic Landmark, in Richmond Town is the oldest surviving schoolhouse in the United States.

In 1661, a group of Dutch and French settlers led by Frenchman Pierre Billiou asked Dutch governor Peter Stuyvesant for land on Staten Island. This became the first permanent settlement on Staten Island. Billiou built a house there that still stands today. Subsequent descendants added to the structure so that today it is known as the Billiou-Stillwell-Perine House. The museum provides a good overview of the history of Richmond Town. The name "Richmond" comes from the Duke of Richmond, who was an illegitimate son of British king Charles II.

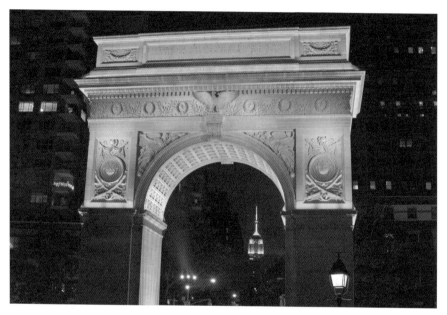

Washington Square Arch framing the Empire State Building. *Courtesy of James Maher.*

GOTHAM GAINS GROUND

A GRID FOR GROWTH

In 1811, the city fathers decided that the demands of doing business in New York dictated more efficient street patterns. They proposed the outline of the city to come: streets would form a grid with twelve broad avenues running the length of the island and numbered streets running across it. Part of the plan was to level the many hills for which the Lenape had named the island. The 1811 street plan went no higher than 155th Street. It was inconceivable to the city fathers that the town's development would ever extend beyond that boundary.

The only exception to this angular progression of blocks is the slight undulation of Broadway. As Route 9, the street runs all the way from Lower Manhattan to the New York State border with Canada. In time, a few of the numbered avenues would earn names: 4th Avenue became Park Avenue and 6th Avenue became Avenue of the Americas. Central Park West is the extension of 8th Avenue as it borders the park.

It was in this early nineteenth-century period that New York earned two nicknames. The same man, American author Washington Irving, gave both nicknames to the town. Irving referred to New York as "Gotham" in an 1807 publication. Gotham was a mythical English village full of crazy people. New Yorkers appreciated the humor; the name stuck.

Two years later, in an ironical history of New York, Washington Irving decided to poke fun at the town's Dutch forefathers. In early nineteenth-century New York, many of New York's most prominent citizens were of Dutch descent. This included the Roosevelts, the Schmerhorns, the

Van Cortlandts, the Beekmans and the Van Renssalaaers. Irving used a pseudonym, Diedrich Knickerbocker, when he published the 1809 book *The History of New York*. In the Dutch language, *knicker* is "to nod" and *boeken* is the word for "books." Irving was deriding those of Dutch descent for falling asleep over their books, casting doubt on their intellect.

Father Knickerbocker became a popular figure in New York lore. Soon, all New Yorkers were known as "knickerbockers." The city's professional basketball team, founded in 1946, is called the New York Knicks. Washington Irving lived at 3 Wall Street. The Irving Trust Building at 1 Wall Street, today the Bank of New York, took its name from Irving's residence on that site.

Water as much as land has been a contributing factor to New York's growth. Of the five boroughs of New York, four are islands or part of islands. The only borough connected to mainland New York State is the Bronx. Staten Island and Manhattan are islands. Queens and Brooklyn are part of Long Island. These islands form one of the great natural harbors in the world, facilitating trade and commerce. Into this harbor flows the Hudson River to the west and the East River to the east. Technically, though, the East River is not a river. It is actually a salt water tidal strait.

In the nineteenth century, New York governor DeWitt Clinton envisioned connecting this harbor with the American agricultural Midwest by building a canal from the Hudson River at Albany, New York, to Lake Erie at Buffalo, New York. Governor Clinton turned the first shovel of dirt for the Erie Canal on July 4, 1817. Construction of the canal was expensive and difficult. Ridicule met the governor's project. The canal became known as Clinton's Ditch. That is, until it opened. Connecting the Atlantic Ocean with the Great Lakes via the Hudson River, the Erie Canal had an enormous impact. New York grew to be the largest commercial port and city in the United States.

New technology took advantage of the waterways. In 1807, Robert Fulton's steamboat the *Clermont* made its first run on the Hudson River from New York City to Albany, generating excitement and opportunity. The steamboat vastly improved water transportation, which no longer had to depend on the vagaries of the wind. For both passengers and goods, it was a major step forward.

Growing trade and industrialization in New York City led to a push and pull between residential neighborhoods and commercial areas. The very wealthy continuously moved up the city grid in an attempt to put themselves beyond the geographic reach of industry and of the poor. However, factories

and stores soon overran even the finest neighborhoods. To escape the crowding of unconstrained development, those who could afford to would abandon one area of New York for another farther uptown.

When Washington Square became a park in 1826, it attracted the fashionable. As the century progressed, it was no longer as chic, but its elegant buildings drew to it the literati and the bohemians who gave Greenwich Village the special character it still retains. Novelists Mark Twain, Henry James, Edith Wharton and Theodore Dreiser; playwright Edward Albee; poets Edna St. Vincent Millay, John Masefield and E.E. Cummings; and painters including Edward Hopper and Rockwell Kent are among those who have lived in Greenwich Village.

In the mid-nineteenth century, the New York upper classes sought out real estate around four squares on the east side of Lower Manhattan: Union Square, Gramercy Park, Madison Square and Stuyvesant Square.

Union Square opened in 1839. Union Square is so named because two main roads, Broadway and an earlier version of 4^{th} Avenue, came together here. The neighborhood around the park attracted lovely residential homes in the 1840s and '50s. However, after the Civil War, the area became more commercial, and those who could afford it moved. Stuyvesant Square and Gramercy Park also opened as parks in the 1830s with a similar waxing and waning of the neighborhood's exclusive character.

Madison Square, named for President James Madison (1809–17), opened as a park in 1847. New York honored Madison with the park name because he wrote the Bill of Rights while he was serving in the first United States Congress in New York City. Madison Square, in turn, gave its name to Madison Square Garden, which once occupied a nearby site before moving uptown.

Eventually, in the latter part of the nineteenth century, 5^{th} Avenue became the artery of choice for the chic as the wealthy moved to the Upper East Side in New York City. Today, this process in Manhattan is in reverse, with upscale condominiums reclaiming buildings once used for commercial purposes. This is occurring in Manhattan in Tribeca, Soho, the Meatpacking District, Chelsea and, more recently, in the Bowery.

Tribeca, as a name for the area south of Canal Street, north of Chambers Street, east of West Street and west of Broadway, dates to the 1970s. Seeing the success of Soho as a neighborhood brand, artists in this area used the term "TriBeCa" or "Triangle below Canal." After World War II, as industry left New York City for less expensive locations in the American South or overseas, large commercial buildings went empty and deteriorated. This

area had been home to the once thriving textile business in New York City. It was, in many cases, artists who recognized that these spaces would make great places to live and work at a reasonable cost. Tribeca remains a very trendy area today, with many artists and actors as residents.

Soho is the area of New York bounded by Canal, East and West Houston, Crosby and West Broadway—an area south of Houston Street. Realtors coined the term in the 1970s to delineate a part of the city that had been recently rediscovered by artists. This district of warehouses, active from 1850 to 1950 but then abandoned and in disrepair, offered lofts that were low in rent and large in space that could accommodate giant canvases. Many of the buildings in this area are beautiful cast-iron structures, such as those on Greene and Prince Streets, that today offer elegant shopping and upscale housing.

The Meatpacking District includes the neighborhood from Gansevoort Street to West 14th Street, east of the Hudson River to Hudson Street. A commercial area since the mid-nineteenth century, in the twentieth century, there were more than two hundred slaughterhouses in this part of New York. As with other commercial and industrial districts in the city, the changing times of the post–World War II era took a toll on these businesses. The meat, poultry and food production companies moved out of New York, and the buildings fell empty. The slaughterhouses are long gone, replaced by high-end boutiques and condominiums.

One way to appreciate the Meatpacking District is to view it from the High Line that runs through this area, as described in Chapter 12. This neighborhood still retains the feel of warehouses and large commercial establishments that are often only a few stories high. The streets are wide to facilitate trucks and commerce. Today, the buildings house the stores of couturiers such as Diane von Furstenberg, Stella McCartney and Christian Louboutin. The new Whitney Museum on Gansevoort Street provides an exciting addition to the neighborhood.

In the mid-eighteenth century, Thomas Clark named the house and land he purchased in Manhattan "Chelsea" after the English home of Sir Thomas More, the Catholic saint and sixteenth-century counselor to King Henry VIII of England, who had him beheaded. Chelsea passed to Clark's grandson Clement Clarke Moore, whose wealth was based on its development as a prime residential area. While living here, Clement Clarke Moore wrote the poem "A Visit from St. Nicholas," which originated our image of Santa Claus. By the end of the nineteenth century, the proximity of Chelsea to the large piers of the Hudson River pushed the neighborhood

toward industrialization. It became a neighborhood of factories and warehouses. In the 1980s and '90s, the art community moved into Chelsea because of its many big lofts and low rents. Today, there are hundreds of art galleries in Chelsea that exhibit the well-known and the up-and-coming. Fashion stores, restaurants and modern housing make this a desirable area for New Yorkers and visitors. Chelsea has retained its eclectic feel with a vibrant and diverse population. Chelsea is the area of Manhattan from 8th to 10th Avenues and from 19th to 23rd Streets.

In the seventeenth century, the Bowery—whose name is taken from the Dutch word *bouwerij*, or farm—was a productive agricultural area. It evolved into a respectable residential area in the early eighteenth century. But by the mid-nineteenth century, the Bowery had become an area of gangs, flophouses and drugs. The Bowery is the neighborhood from Canal Street north to 4th Street and Allen Street to Little Italy. There is also a main thoroughfare within this area named the Bowery. The neighborhood has recently been undergoing a major renaissance with art museums taking the lead.

In the twenty-first century, New York City continues its evolution in new and exciting ways. There is an ongoing tension between great change and, since the 1970s, an increased sensitivity to the preservation of the past.

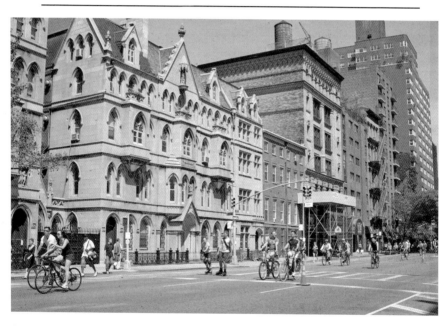

Grace Church Houses. *Courtesy of James Maher.*

South Street Seaport Museum
12 Fulton Street • Lower Manhattan
212-748-8600 • www.southstreetseaportmuseum.org • Free/Fee

The visitor center is on Schermerhorn Row. The Titanic Memorial Lighthouse stands at the entrance to the Seaport area. A port for seagoing ships has existed in this area since the seventeenth century. With its cobblestone streets and old buildings now preserved as part of the South Street Seaport Museum, this historic district recalls the earlier era and the bold growth of the nineteenth century. It was from here that Robert Fulton started his ferry service to Brooklyn and that international ships brought goods into New York and the United States. Particularly with the construction of the Erie Canal, which opened in 1825, the port became dominant on the East Coast of the United States. Today, the port of New York, which includes the New Jersey waterfront, is the third busiest in the United States after Los Angeles and Long Beach, California.

The Street of Ships is part of the South Street Seaport Museum. Docked at Pier 16 in South Street Seaport, the *Ambrose*, built in 1907, was a floating lighthouse used to guide shipping from the Atlantic Ocean into New York Bay. The United States Coast Guard donated the lighship *Ambrose* to the South Street Seaport Museum in 1968. It is a favorite of visitors. The *Lettie G. Howard* is a remarkable 1893 North Atlantic Ocean fishing schooner, a kind of boat that was once common but is now rare. Even at its advanced age of more than 120 years, the *Lettie B. Howard* is reluctant to retire. It is now a sailing school vessel teaching the fine art of sailing to future generations. Also still at work is the *W.O. Decker*, a 1930 wooden tugboat used when any of the museum's fleet of ships is moved. The four-masted barque the *Peking*, the 1885 wrought-iron cargo sailing ship the *Wavertree* and the nineteenth-century schooner the *Pioneer* complete the fleet here at South Street. In appropriate weather, the *Pioneer* takes passengers for a sail around New York Harbor. The *Ambrose* and the *Lettie G. Howard* are each designated as National Historic Landmarks.

The Schermerhorn Row Galleries include exhibits on the history and commercial significance of the port of New York, "Monarchs of the Sea: Celebrating the Ocean Liner Era" and maritime paintings and artifacts. Bowne and Company Stationers at 211 Water Street in South Street Seaport is a nineteenth-century print shop that continues to function as it once did, re-creating old books, documents and paper products that are for sale. The Walter Lord and Port Life and Melville Library Galleries at 209 and 213

Water Street in the South Street Seaport display a large model of the *Queen Mary* ocean liner of Cunard fame and rotating exhibits on the life of the port and other maritime topics.

Water Cruises Around Manhattan
212-563-3200 • www.circleline42.com • Admission Fee
212-445-7599 • www.citysightseeingny.com • Admission Fee
212-619-6900 • www.manhattanbysail.com • Admission Fee
212-742-1969 • www.nywatertaxi.com • Admission Fee

One of the best ways to appreciate the fact that Manhattan is an island is to take a water tour around it. Circle Line Cruises, Gray Line New York, the Water Taxi and Manhattan by Sail are commercial entities that offer options for water tours around the island or into New York Harbor.

Staten Island Ferry
4 South Street at the Whitehall Ferry Terminal • Lower Manhattan
1 Bay Street at the St. George Ferry Terminal • Staten Island
212-639-9675 • www.siferry.com • Free

Departures are twenty-four hours a day, seven days a week. The five-mile, twenty-five-minute ride on the ferry to Staten Island is free. Though most of the seventy thousand passengers who make the trip daily do so for work, visitors to New York can take advantage of this offering as one of the best ways to see the city skyline. The ferry also offers a good look at the Statue of Liberty.

Stone Street Historic District
Stone, South William and Pearl Streets and Coenties Alley • Lower Manhattan

This is a charming historic district of narrow, winding streets, reminiscent of the way early New York looked under Dutch rule. The buildings are mid-nineteenth century, replacing older structures that burned in the Great Fire of 1835. Stone Street was one of the first in New Amsterdam to be paved with stone, hence its name. Today, it is a lively area of restaurants, bars and coffeehouses with the added advantage that some of the streets are closed to vehicular traffic, allowing for pleasant outdoor dining in good weather.

Washington Square Park

5th Avenue at Waverly Place, West 4th and MacDougal Streets •
Manhattan/Greenwich Village
www.nycgovparks.org/parks/washington-square-park

This 9.75-acre park and marble arch of triumph honor George Washington. In the eighteenth century, public executions occurred on this site. In the nineteenth century, it became a military parade ground and then, in 1827, a public park. Its conversion to a park led it to become a fashionable address for the wealthy, who built Greek Revival–style homes along its perimeter. Some of these houses still remain. A temporary wooden arch was erected in 1889 to celebrate the centennial of George Washington's New York City inauguration as president. It proved so popular that the city commissioned architect Stanford White to design a permanent marble arch. At 73.5 feet high, the arch has served as the centerpiece of the park since 1895. Among the statues scattered around the park are two of George Washington: a 1916 statue by Hermon MacNeil and a 1918 statue by Alexander Stirling Calder.

Stonewall Inn

53 Christopher Street • Manhattan/Greenwich Village
212-488-2705 • www.thestonewallinnnyc.com • Fee

The Stonewall Inn is a gay bar that is recognized as the birthplace of the modern LGBT movement. A gay establishment since the mid-1960s, it was the site of frequent police raids at a time when it was illegal for members of the same sex to dance together. Arrests would occur, but the bar would quickly resume business. Then on June 28, 1969, the police raid met with serious resistance from patrons frustrated by years of intolerance and harassment. Resistance turned to rioting that continued into the next few days. In the aftermath of the violence, gay rights groups began to form across the country and attitudes toward gays began to change. It is a National Historic Landmark.

New York Marble Cemetery
41½ 2nd Avenue at 2nd Street • Manhattan/East Village
www.marblecemetery.org

This is the oldest public non-sectarian cemetery in New York City dating to 1830. The very small cemetery holds the remains of more than two thousand people buried here mostly during the 1830 to 1870 timeframe. Public tours are possible but very limited in terms of dates, times and weather conditions.

New York City Marble Cemetery
57–74 East 2nd Street between 1st and 2nd Avenues • Manhattan/East Village
www.nyc.mc.org

Confusing as it maybe, the second nonsectarian cemetery in New York City is close to the first with a very similar name. It was founded shortly after the New York Marble Cemetery. There is no public entrance, but it is possible to peer through the iron gates to see the green final resting place of nineteenth-century New Yorkers.

The Merchant House Museum
29 East 4th Street • Manhattan/East Village
212-777-1089 • www.merchantshouse.org • Admission Fee

This 1832 Federal-style brick exterior home with a Greek Revival–style interior was built in 1832 by Joseph Brewster in what was a fashionable area of New York City. This is the only preserved nineteenth-century New York City home with furnishings open to the public. Seabury Tredwell, a retired hardware business owner, bought the home in 1835. The Tredwell family remained in the house for the next one hundred years even as the neighborhood became increasingly commercial. The Tredwell family purportedly haunts the Merchant House. Gertrude Tredwell, who was born and died in the house, may tease visitors with her ghostly presence. In October, the museum offers ghost tours so that visitors can see for themselves. Lectures and other tours—some designed for children—are also offered. This site is a National Historic Landmark.

Grace Church

800 to 804 Broadway at 10th Street • Manhattan/East Village
212-254-2000 • www.gracechurchnyc.org • Donation

Grace Church is an active Episcopal church with regular services and activities. Its origins date to the early nineteenth century, when it was the church of the well-to-do in a mostly Protestant, Episcopal city of English heritage. The church has been in its current location since 1846, when the congregation and the building moved to what was then an extremely fashionable residential area. This French Gothic–style masterpiece is the work of architect James Renwick Jr. It was this church that enhanced his reputation and won him further commissions such as St. Patrick's Cathedral in New York City and the Smithsonian Institution Castle in Washington, D.C. The exterior marble, the spire and the stained-glass windows make Grace Church, a National Historic Landmark, worth the visit.

Union Square

Broadway to 4th Avenue and East 14th Street to East 17th Street •
Manhattan/Gramercy
www.nycgovparks.org/parks/union-squarepark

Over the years, Union Square has gained a reputation as a gathering place—sometimes for protests. It was the site of the first Labor Day Parade that occurred on September 5, 1882, when ten thousand workers marched up Broadway to Union Square. The name Union Square, however, refers to the fact that it is located at a convergence, or union, of streets, not to its place in history of the American labor movement. More recently, it became a place to gather after the tragic events of September 11, 2001. Those seeking loved ones who were missing posted photographs and messages in Union Square.

The James Fountain in the middle of Union Square is a popular meeting place. Named in honor of its donor, Daniel James, it is the work of sculptor Adolf Donndorf. There is a statue of George Washington on horseback by Henry Kirke Brown that depicts Washington's return to New York City on Evacuation Day, November 25, 1783. Henry Kirke Brown also designed the statue of Abraham Lincoln that stands in the park. The statue of the Marquis de LaFayette by Frederic Auguste Bartholdi, who also created the Statue of Liberty, was dedicated on July 4, 1876, as part of the Centennial Celebration in New York. The site is a National Historic Landmark.

MADISON SQUARE PARK

5ᵗʰ to Madison Avenues and 23ʳᵈ to 26ᵗʰ Streets • Manhattan/Gramercy
www.madisonsquarepark.org

Madison Square Park opened to the public in 1847. It was named for our fourth president, James Madison (1809–17). Madison holds a particular significance for New York City, as it was here that he wrote the Bill of Rights to the Constitution while he was serving in the First United States Congress. There is a tall stump of an oak tree that grew in the park. The tree came to the park as a seedling from Montpelier, the home of James Madison in Orange, Virginia. In 1872, Frederick Law Olmsted and Calvert Vaux redesigned the park you visit today. Among the many statues in the park is one of President Chester Arthur by George Bissell. Arthur was the only other American president inaugurated in New York City after the 1789 George Washington inauguration. New Yorker Chester Arthur took the oath of office in 1881 after the assassination of President James Garfield. The Madison Square Park Conservancy that maintains the park has a regular and lively program of activities and performances for the public. The first public Christmas tree in the United States was here in Madison Square Park in 1912. The tradition continues each December with a tree illumination.

STUYVESANT SQUARE

East 15ᵗʰ to 17ᵗʰ Streets, Rutherford Place to Nathan D. Perlman •
Manhattan/Gramercy
www.nycgovparks.org/parks/stuyvesant-square

Peter Gerard Stuyvesant, the great-great-grandson of the original Peter Stuyvesant, who was the director general of New Netherlands, gave part of his farmland to New York City to serve as this park in 1836. There is a statue by Gertrude Vanderbilt Whitney of the original Peter Stuyvesant in the park.

GRAMERCY PARK

East 20ᵗʰ to 21ˢᵗ Streets, Park Avenue to 3ʳᵈ Avenue • Manhattan/Gramercy

Created in 1832, this is the only private park in Manhattan. A fence with a locked gate encloses its two landscaped acres. Only residents in the

immediate neighborhood have a key to the gate. In the middle of the park is an Edmond T. Quinn statue of the famed American nineteenth-century Shakespearean actor Edwin Booth. He was the brother of John Wilkes Booth, who assassinated Abraham Lincoln. Edwin Booth purchased the mansion on Gramercy Park that he donated to the Players Club, which he also founded. The Players Club continues today as a private social club in one of the beautiful houses around the park.

A LIST OF THE PARKS IN NEW YORK CITY

www.nycgovparks.org

THE LITTLE RED LIGHTHOUSE

Fort Washington Park, Hudson River Greenway • Manhattan/Washington Heights
212-628-2345 • www.historichousetrust.org • Free

Open house tours are offered once a month from June through October by the Urban Park Rangers. While no longer a functioning lighthouse, the Jeffrey's Hook Light—its official name—was reconstructed here in 1921 from a lighthouse that had stood at Sandy Hook, New Jersey, to help guide ships through a treacherous stretch of the Hudson River. When the George Washington Bridge opened in 1931, the bridge's bright lights lit the river and overshadowed the lighthouse. The lighthouse was almost sold, but public support for this sentimental favorite kept it in place for all to enjoy. The New York City Department of Parks & Recreation owns the Little Red Lighthouse.

FULTON FERRY LANDING

At the foot of Old Fulton Street on the East River • Brooklyn
www.brooklynbridgepark.org/park/fulton-ferry-landing

The Fulton Ferry Landing Pier in Brooklyn Bridge Park is at the site of the first Brooklyn-to-Manhattan ferry service that began in 1642. The ferries used wind power. Depending on the weather, the ride could go quickly or not, depositing customers at varying points on either side of the East River. In 1814, Robert Fulton's steamship service began operations, offering shorter commute times with great certainty of arriving predictably at the

desired location. After the Brooklyn Bridge opened in 1883, ferry service between Manhattan and Brooklyn went into a long decline. An East River Ferry and the New York Water Taxi continue to depart today from Brooklyn Bridge Park, where the Fulton Ferry Landing Pier is located.

Brooklyn Bridge Park
Brooklyn
www.brooklynbridgepark.org

Brooklyn Bridge Park is an eighty-five-acre park in Brooklyn on the East River with promenades along the water that offer glorious views of the New York skyline, grassy areas to relax, six piers with various sporting activities, playgrounds, a barge with musical performances, a theater in a nineteenth-century tobacco warehouse and a 1922 carousel named Jane's Carousel, in honor of Jane and David Walentas, who donated it to the park. There are history tours of the Brooklyn waterfront offered on the website. There is also information on the ferries and water taxis that depart from Brooklyn Bridge Park. For theater performances at St. Ann's Warehouse, visit the website www.stannswarehouse.org. For information on the carousel, which has forty-eight horses, two chariots and a glass pavilion that permits it to operate throughout the year, visit the website www.janescarousel.com.

The Plymouth Church
75 Hicks Street • Brooklyn
718-624-4743 • www.plymouthchurch.org • Donation

Tours are offered after Sunday service. This Congregational Church, founded in 1847, was used as an Underground Railroad site to help escaping African American slaves move to the safety of the North. Henry Ward Beecher, an ardent abolitionist, was the minister. His sermons attracted such large crowds that when the original church burned in 1849, a new, larger church was built to accommodate the growing congregation. Henry Ward Beecher was the brother of Harriet Beecher Stowe, author of *Uncle Tom's Cabin*. Frederick Douglass spoke here, and Abraham Lincoln worshipped here. A plaque marks the pew where Lincoln sat. The site is a National Historic Landmark.

WAVE HILL

West 249ᵗʰ Street • The Bronx
718-549-3200 • www.wavehill.org • Admission Fee

Built in 1843 by William Lewis Morris, the home today serves as an exhibit space for the arts and for performances. It is noted for its gardens, which overlook the Hudson River.

EDGAR ALLAN POE COTTAGE

Poe Park Grand Concourse at Kingsbridge Road • The Bronx
718-881-8900 • www.bronxhistoricalsociety.org/poecottage • Admission Fee

The famed poet Edgar Allan Poe lived in this 1812 farmhouse from 1846 to 1849, when he died in mysterious circumstances in Baltimore, Maryland. While here, Poe wrote many works, including the poem "Annabel Lee." The house is a National Historic Landmark.

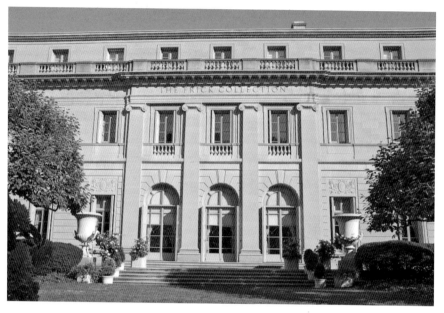

The Frick Collection. *Courtesy of James Maher.*

MILLIONAIRES AND MANSIONS

TWENTY-THREE BEDROOMS AND A BALLROOM

The second half of the nineteenth century in the United States was a time when a very few made enormous fortunes. There was no personal income tax, and business activities were unregulated. In 1900, 1 percent of the American population enjoyed over 50 percent of the country's wealth. "Robber baron" was a term applied to Rockefeller, Vanderbilt, Morgan, Carnegie, Frick and others who built their millions and their corporations through cutthroat competition.

American novelist and humorist Mark Twain called this era "the Gilded Age" in his 1873 novel of the same name, co-written with Charles Dudley Warner. The novel satirized greed and excess in vivid imagery that made a lasting impression on the public. Indeed, the extravagance of the rich during the Gilded Age was legendary. A popular way to demonstrate wealth was to build elaborate mansions. Fabulous, incredible and magnificent were fitting adjectives for the huge and grandiose Italianate villas, Neoclassical French chateaus and massive English manors that became home to New York's wealthiest residents. Fifth Avenue from 50th to 95th Streets was nicknamed "Millionaires' Row."

One family in particular, the Vanderbilts, sought to make 5th Avenue their neighborhood. Cornelius Vanderbilt was a local boy who had made good. Cornelius started out with a $100 investment in a ferry between Staten Island and Manhattan. He went on to build an empire in Hudson River shipping and railroads. Forever known as the "Commodore," Cornelius was the richest man in America when he died in 1877. His estate was worth

more than $100 million. Most of this went to his eldest son, William Henry Vanderbilt, who had doubled the fortune to $200 million by the time of his own death in 1885.

The Vanderbilts used their money to crash all social barriers. They were not the first in New York nor the last to do this, but they were certainly among the most ostentatious. It was the home of Cornelius's grandson William Kissam Vanderbilt and his wife, Alva, that set the standard by which all others would be judged. Designed by Richard Morris Hunt and completed in 1883 at a cost of $3 million, the splendid French chateau stood at 660 5th Avenue and 52nd Street.

This Vanderbilt challenge to social order offended Mrs. William Backhouse Astor Jr., who preferred to be called "the Mrs. Astor." The Mrs. Astor felt it was her obligation to maintain the distinction between the old moneyed New York set and the newly rich. She created the first American social register. This listed New Yorkers who could trace their families back three generations in the city—no mean feat for the nineteenth century. The Astor money had begun with John Jacob Astor. After arriving from Germany nearly penniless in 1784, he started in the fur business and branched into real estate. Astor bought up considerable early New York property, making him the richest man in America by 1830. Astor Place in Lower Manhattan, the Waldorf Astoria Hotel and the Astor Court at the St. Regis Hotel, with its portrait of John Jacob Astor, are reminders of the prominence of the Astor family in New York.

In a very expensive tit for tat, in 1893, the Mrs. Astor had constructed an enormous double chateau at 840 5th Avenue at 65th Street. As with the William Kissam Vanderbilt home, the architect was Richard Morris Hunt. The new Astor mansion was meant to surpass all others. It featured separate residences for mother and son, John Jacob Astor IV, with shared first-floor entertaining areas, including a very large ballroom.

The Vanderbilt and Astor homes no longer stand as magnificent testimony to their petty competition. Each home was demolished in the twentieth century. A high-rise replaced the Vanderbilt home. Temple Emanu-El, home to a reform Jewish congregation founded in 1845, has stood on the site of the Astor mansion since 1929.

Another equally impressive competition in New York City home building occurred a few years later between two other great rivals: Andrew Carnegie and Henry Clay Frick. In this case, however, and to our benefit, the homes survived. Today, they are exceptional museums.

Andrew Carnegie, born in Scotland in 1835, came to the United States with his family when he was thirteen. In Alleghany, Pennsylvania, Andrew

found work as a bobbin boy in a cotton mill, earning $1.20 a week. Energetic and enterprising, Andrew believed it possible in the United States for a poor boy like himself to get ahead. He found better and better jobs until, as a telegraph operator with the Pennsylvania Railroad, he met people who would offer him his first investment opportunity. Andrew Carnegie, in the 1870s, was one of the first in the United States to recognize the emerging importance of steel. By the end of the nineteenth century, the output of Carnegie Steel had exceeded the output of all of the steel factories in Great Britain. When Carnegie decided to retire, J.P. Morgan bought him out to form the United States Steel Corporation, the nation's first billion-dollar corporation. This made Andrew Carnegie the richest man in America.

Carnegie's tastes were not quite as extravagant as the Vanderbilts'. The Carnegie home exterior was brick, not marble, giving it a less ostentatious appearance than many other mansions. Still, it is hardly possible to call his sixty-four-room, English-style manor home on 5th Avenue at 91st Street modest. The great hall, with its Scottish oak paneling, and the garden vestibule, with its Tiffany windows, speak of great expense. Carnegie wanted all the latest technology in his house. He had electricity, central heating and air conditioning installed. This was the first private home in New York City to have an elevator.

Carnegie created not only an imposing home for himself but also an entire neighborhood of luxurious mansions. He bought much of the land surrounding his new home, reselling the lots to wealthy friends who would agree to build their own residential palaces in the vicinity. George Baker, Collis Huntington, William Sloane and others were only too happy to accommodate him and themselves. The Carnegie Hill Historic District is the beneficiary of this legacy of wealth and extravagance.

In retirement, Carnegie devoted his energy to giving away the money he had earned. He believed that "the man who dies rich, dies disgraced." Before his death, Carnegie gave away 90 percent of his fortune to thousands of recipients. He did keep $22 million, so he was by no means impoverished. He founded the Carnegie Technical School, later Carnegie-Mellon University, in Pittsburgh, Pennsylvania. He built Carnegie Hall in New York City, as well as libraries in New York and across the country. He also established the Carnegie Endowment for International Peace in Washington, D.C.

Carnegie's partner in the steel industry was Henry Clay Frick. Frick had brought to the business his holdings in coke, the fuel needed to run the furnaces to make Carnegie's steel. Like Carnegie, Frick was a self-made

man. Carnegie appreciated Frick's ruthlessness and made him president of Carnegie Steel. In 1899, however, Carnegie forced Frick out of the steel company, blaming him for many labor problems, including the violent Homestead Mill Strike of 1892. The two men became bitter enemies.

Frick, therefore, enjoyed "besting" Carnegie. He built a larger office building in Pittsburgh than Carnegie. When Frick left Pittsburgh to come to New York, he wanted a New York City home grander than Carnegie's. Frick succeeded when he commissioned a marble palace in 1914 by architect Thomas Hastings. Frick conceived of his home as a future art museum that would hold his very important paintings and artifacts. The Frick Collection is the realization of his dreams.

Although many of New York City's most imposing private homes have fallen to the wrecking ball, a surprising number have survived. Today, their original elegance is put to new use in museums, schools, commercial establishments, diplomatic missions, nonprofit institutions, apartments and, in some cases, individual homes once again. Take a walk up Millionaires' Row. Make a detour onto the blocks of streets off 5th Avenue on the Upper East Side. Enjoy those homes that are open to the public. Those not open to visitors still present beautiful façades to the passerby, enhancing New York's glamour.

YOUR GUIDE TO HISTORY

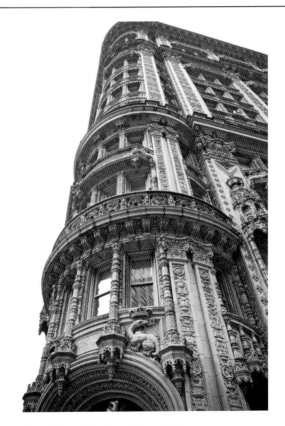

Alwyn Court. *Courtesy of James Maher.*

Open House New York
www.ohny.org

Each year on a weekend in October, this nonprofit organization organizes special tours of New York City sites, many of which are not normally open to the public. While some visits are free, others require advance registration and involve a fee. The mission of Open House New York is to educate the public on the architecture of the city. On occasion, one of the Gilded Age mansions not ordinarily open to the public will be part of the Open House New York tours.

Proceeding north along 5th Avenue are many mansions that you may visit or at least enjoy their exteriors.

Versace
647 5th Avenue at 52nd Street • Manhattan/Midtown

Designed by Hunt and Hunt, this 1905 home was built for William K. Vanderbilt, who was a younger son of the "Commodore" Cornelius Vanderbilt. A short list of wealthy New Yorkers lived at number 647, the only remaining Vanderbilt home on 5th Avenue where once many Vanderbilt mansions stood. Today, it is the New York flagship store of the Italian fashion house Versace. It is possible to conjure up the glory of the home from its structure and overall presentation.

Cartier's
651 5th Avenue at 52nd Street • Manhattan/Midtown

One of the Vanderbilt neighbors on 5th Avenue was Morton F. Plant, a successful banker who commissioned Robert Gibson and Cass Gilbert to build for him a beautiful Italian Renaissance–style marble and granite palazzo. Soon after his home's completion in 1904, Plant became disenchanted with the neighborhood, as it was becoming increasingly commercial. He moved his residence farther up 5th Avenue to 86th Street. Plant sold the home at 651 5th Avenue to the French jeweler Cartier, who converted it to a store. It remains Cartier's today. There is one account of the transaction that alleges that Cartier obtained the home for a string of pearls that Morton Plant wanted for his wife.

The Plaza Hotel
768 5th Avenue at 59th Street • Manhattan/Midtown

Henry J. Hardenbergh designed this magnificent nineteen-story French Renaissance–style masterpiece. The hotel, which faces the Grand Army Plaza, opened for business in 1907. It is a National Historic Landmark.

On the south side of the Grand Army Plaza once stood the 1883 home of Cornelius Vanderbilt II, the eldest grandson of the "Commodore," Cornelius Vanderbilt. Designed by George B. Post and Richard Morris Hunt, this was the largest private home ever built in New York City. This house was demolished to make way for the elegant ladies' fashion store Bergdorf Goodman's, which has occupied this site since 1928.

In front of the Plaza Hotel there is a 1916 memorial to Joseph Pulitzer, the publisher of the New York newspaper the *World*. It was built with funds that Pulitzer provided himself. Carrere & Hastings designed the Pulitzer Memorial. The sculpture by Karl Bitter is a series of basins topped by the bronze figure of a young woman. The memorial has the extremely apt title for an area of so much wealth: *The Fountain of Abundance*. A 1903 statue of Civil War general William Tecumseh Sherman by Augustus Saint-Gaudens is also in the Grand Army Plaza. The Grand Army Plaza was named in honor of the Grand Army, the formal name for the Union army during the Civil War.

Near the Plaza Hotel on the park side of Central Park South are horse-drawn carriages for hire for rides through the park. These carriages offer a nineteenth-century experience in present-day New York.

THE FRICK COLLECTION

1 East 70th Street at 5th Avenue • Manhattan/Upper East Side
212-288-0700 • www.frick.org • Admission Fee

The beautiful Louis XIV–style home sits back from 70th Street while its gardens border 5th Avenue. When Frick had the home built, he envisioned that it would open one day as a museum to display his important art collection, which includes paintings by Rembrandt, Vermeer, Velazquez, Degas, Turner and many others. The home, furnished as it was when Henry Clay Frick lived here, has sixteen galleries of important furniture and decorative arts. Thomas Hastings of Carrere & Hastings designed the residence, completed in 1914. Architect John Russell Pope made additions to the original building to enhance its suitability as a museum. It is a National Historic Landmark.

THE COMMONWEALTH FUND

1 East 75th Street at 5th Avenue • Manhattan/Upper East Side
Exterior Only

This Italian Renaissance–style palace, built in 1896, is the former home of Edward Harkness, the son of a founder of Standard Oil. James Gamble Rogers was the architect. The home is surrounded by a beautiful wrought-

iron fence with a fleur-de-lis motif. The home is now the headquarters of the Commonwealth Fund, a nonprofit organization founded by Edward Harkness and his mother, Ann, that promotes public health policy. In the early twentieth century, Edward Harkness was listed as the sixth richest person in the United States, after John D. Rockefeller, Henry Clay Frick, Andrew Carnegie, George F. Baker and William Rockefeller. A philanthropist, Harkness gave generously to the New York Public Library and to the Metropolitan Museum of Art. Much of the Egyptian collection at the Met, including the Tomb of Perneb, was the result of contributions by Harkness. The close collaboration of Harkness and architect James Gamble Rogers continued when Rogers built the impressive mausoleum for Harkness at Woodlawn Cemetery in 1925. It awaited Harkness until his death in 1940.

THE NEW YORK UNIVERSITY INSTITUTE OF FINE ARTS
1 East 78th Street at 5th • Manhattan/Upper East Side
Exterior Only

Since 1958, the NYU Institute of Fine Arts has occupied the former home of James Duke, a self-made man. Duke, for whom Duke University is named, was the founder of the American Tobacco Company in North Carolina. Until James Duke and the second half of the nineteenth century, tobacco users in this country smoked cigars or pinched snuff. Duke popularized the cigarette. He had a flair for marketing—he had celebrities endorse his cigarettes and put their photos on the back of cigarette packages, making them collectibles. Duke also profited from the 1884 invention of the cigarette-rolling machine by James Bonsack. The machine brought cigarette prices down dramatically. Ever cheaper, cigarettes became increasingly popular. Duke's fortune paid for this lovely 1912 French Neoclassical chateau in white. Architect Horace Trumbauer patterned the mansion after the eighteenth-century Labottiere home in Bordeaux, France.

THE CULTURAL SERVICES OF THE FRENCH EMBASSY IN NEW YORK CITY
972 5th Avenue at 79th Street • Manhattan/Upper East Side
www.frenchculture.org • Free/Fee

The Embassy of France in the United States has a very active branch for cultural services in New York City. Art, musical performances, films and lectures fill the annual calendar. The mission is to inform Americans of French culture with the goal of good Franco-American relations. The French Cultural Services are housed in a beautiful 1904 Italian Renaissance mansion. Famed architect Stanford White designed the house for Payne and Helen Hay Whitney.

The Ukrainian Institute of America
2 East 79th Street at 5th Avenue • Manhattan/Upper East Side
212-888-8660 • www.ukrainianinstitute.org • Free

This is the former home of industrialist Isaac D. Fletcher, designed by Cass Gilbert and completed in 1899. A later occupant of this home was Harry F. Sinclair, founder of the Sinclair Oil Company. The Ukrainian Institute of America has owned this French Renaissance–style mansion since 1955. The institute exhibits the works of Ukrainian artists and hosts a classical music concert series. This site is also visited in Chapter 8. It is a National Historic Landmark.

Neue Galerie
1048 5th Avenue at East 86th Street • Manhattan/Upper East Side
212-628-6200 • www.neuegalerie.org • Admission Fee

This is one of New York's more recent art museums, dating to 2001. Philanthropist Ron Lauder and the estate of Serge Sabarsky established the museum. Its setting is the beautiful 1914 Carrere & Hastings–designed Louis XIII–style town house, once home to William Starr Miller. The museum contains Austrian and German art of the 1890 to 1940 period and includes works by Gustav Klimt, Egon Schiele, Oskar Kokoschka, Max Beckmann, Ernst Kirchner and Emil Nolde. The famous 1907 Gustav Klimt painting of Adele Bloch-Bauer—the "woman in gold"—is here. In addition to the art, there are concerts, lectures and films presented at the Neue Galerie.

The National Academy of Design
1083 5th Avenue between 89th and 90th Streets • Manhattan/Upper East Side
212-369-4880 • www.nationalacademy.org • Admission Fee

This Beaux-Arts mansion, enlarged in 1914 by architect Ogden Codman Jr., was the home of Archer Huntington and his wife, sculptor Anna Hyatt Huntington. Archer Huntington was heir to the fortune of his railroad magnate father, Collis Huntington. Archer and Anna Huntington left the house to the National Academy of Design in 1939. Rembrandt Peale, Samuel F.B. Morse and other artists founded the National Academy in 1825 to educate Americans regarding the importance of art. Today, the National Academy of Design has a large collection of nineteenth- and twentieth-century American art with rotating exhibits.

THE COOPER HEWITT SMITHSONIAN DESIGN MUSEUM
2 East 91ˢᵗ Street at 5ᵗʰ Avenue • Manhattan/Upper East Side
212-849-8400 • www.cooperhewitt.org • Admission Fee

The home of Andrew Carnegie is today the Cooper-Hewitt Smithsonian Design Museum. This Smithsonian Museum is dedicated to the study and display of historic and contemporary design. The museum has a varied collection of applied arts, industrial design, drawings and textiles on display with rotating exhibits. Sarah and Eleanor Hewitt, the granddaughters of Peter Cooper, the iron works magnate and inventor of the steam locomotive in this country, began the collection in 1897. These two sisters sought the same recognition for the interior design of a house that architects such as Stanford White and Cass Gilbert achieved for the exterior. Originally, Cooper Union housed the collection.

The Cooper-Hewitt has occupied the Carnegie Mansion since 1976. The Carnegie Mansion is one of the few remaining New York mansions with a lawn and a garden to give visitors a true appreciation for what New York was like for the wealthy at home in the late nineteenth and early twentieth centuries. While the house is not furnished today, there is an interactive display on the second floor that shows photographs of the mansion as it would have looked when Andrew Carnegie and his wife lived here. Visitors can experience the original house by taking the central stairway with its sumptuous oak paneling to the second floor. The first-floor library retains on its walls stencils of Carnegie's favorite homilies that inspired and motivated him. Try to imagine the large pipe organ that once stood in the main hallway to play music each morning to awaken the Carnegies. Andrew Carnegie loved music. He was a member of the New York Oratorio Society and contributed the funds to build Carnegie Hall in New York City. The 1901 Georgian-style brick home, designed by architects Babb, Cook & Willard, had all the latest technology, including central heat, air conditioning, electricity and telephones. The house is a National Historic Landmark.

THE JEWISH MUSEUM
1109 5ᵗʰ Avenue at 92ⁿᵈ Street • Manhattan/Upper East Side
212-423-3200 • www.thejewishmuseum.org • Admission Fee

Cass Gilbert designed this exceptional French chateau, completed in 1908, for financier Felix M. Warburg and his family. Frieda Schiff Warburg donated the family home for use as the Jewish Museum in 1944. Renovations and additions have since expanded the museum's gallery space. The museum's permanent collection and rotating exhibits provide insights into Jewish culture and art.

Richard Jenrette Residence
67 and 69 East 93rd Street • Manhattan/Upper East Side
212-369-4460 • www.classicalamericanhomes.org • Not Routinely Open to the Public

The home at 67 East 93rd Street is the private residence of Richard Jenrette, who founded the Classical American Homes Preservation Trust. Jenrette opens his house to the public for prearranged group tours. The beautifully appointed home, built in the 1920s for the George F. Baker family and designed by Delano & Aldrich, includes paintings of early New York scenes and public figures such as Governor DeWitt Clinton. More information is on the website. The tour fee is a contribution to the Classical American Homes Preservation Trust. The building at 69 East 93rd Street is the former carriage house for the complex. Today, it serves as home to the administrative offices of the Classical American Homes Preservation Trust. It is not open to the public.

The Russian Orthodox Synod
75 East 93rd Street • Manhattan/Upper East Side
www.classicalamericanhomes.org • Exterior Only

Delano & Aldrich, sought-after residential New York architects in the early twentieth century, designed a complex of Neo Federal– and Classical-style homes in the 1920s for George F. Baker and his son George F. Baker Jr. The home at 75 East 93rd Street now houses the offices of the Russian Orthodox Synod in the United States. The senior Baker was chairman of the First National Bank of New York—a forerunner of Citibank—and a close friend of J.P. Morgan. As an indicator of their wealth, not only were the homes spectacular, but the Bakers also had railway tracks constructed in the basement for their private rail car to join the main tracks running under Park Avenue.

Private Residence
1130 5th Avenue at 94th Street • Manhattan/Upper East Side
Exterior Only

The Williard Straight House is red brick with white marble trim in the Federal style. Designed by Delano & Aldrich, it dates to 1915. Williard Straight was a diplomat, financier and founder of the *New Republic*. Sadly, Williard Straight died only three years after the home's completion while serving in the American Expeditionary Forces in Europe during World War I. The house has since had a number of occupants, including the Audubon Society and the International Center of Photography. It is now again a private residence.

The New York Palace Hotel
457 Madison Avenue at 50th Street, New York • Manhattan/Midtown

The New York Palace Hotel restored six town houses originally built in 1884 for Henry Villard, founder of the Northern Pacific Railroad and publisher of the *New York Evening Post.* Mrs. Henry Villard was the daughter of the abolitionist William Lloyd Garrison. Enter the hotel that incorporates the Villard town houses on Madison Avenue to appreciate the exterior courtyard and the massive foyer with its double staircase, enormous chandelier and rose marble fireplace. Villard had intended to live in one of the six houses designed to resemble a single Italian palazzo but never did because of financial problems. Happily, the McKim, Mead & White–designed homes survived Villard's problems.

The Ralph Lauren Store
867 Madison Avenue at 72nd Street • Manhattan/Upper East Side

The flagship store of Ralph Lauren, with the interiors restored to give the impression of an elegant home, is in the house built for Gertrude Rhinelander Waldo. Waldo never took up residence in this 1898 home, possibly because she ran out of money before its completion. This extraordinary French Renaissance–style house, designed by architect Francis H. Kimball, has an elaborate scheme of windows, chimneys and medieval statuary.

The Rockefeller "Neighborhood"
West 54th Street between 5th and 6th Avenues • Manhattan/Midtown
Exterior Only

If 5th Avenue were once a Vanderbilt neighborhood, the Rockefeller neighborhood was West 54th Street between 5th and 6th Avenues. John D. Rockefeller Sr. had a home at 4 West 54th Street. The elegant Moorish Room from this now demolished home is in the Brooklyn Museum. Architect Henry Hardenbergh designed the elegant homes still standing at numbers 13 to 15 West 54th Street from 1896 to 1897 for members of the Rockefeller family. Nelson Rockefeller, vice president of the United States during the tenure of President Gerald Ford, died at 13 West 54th Street on January 26, 1979. These homes were close to Rockefeller Center and even closer to the Museum of Modern Art, which was founded by Abby Aldrich Rockefeller, wife of John D. Rockefeller Jr. and mother of Nelson Rockefeller.

Alwyn Court
180 West 58th Street • Manhattan/Midtown
Exterior Only

The architectural firm of Harde & Short designed this twelve-story apartment building, completed in 1909. Built in the style of the French Renaissance and with detailed exterior terra-cotta ornamentation, it is one of the most beautiful apartment buildings in New York City. It remains an apartment building today, with a first-floor restaurant open to the public. Although multi-family dwellings and apartment buildings had long existed in the city, they had been for the poor, not the rich. But at the end of the nineteenth century, the rich also became interested in apartment living. Particularly after 1916, with the institution of the income tax, as well as rising New York City land values, few could afford individual homes here. Luxury apartment buildings accommodated the increased demand. This building is on the National Register of Historic Places.

The Dakota
1 West 72nd Street at Central Park West • Manhattan/Upper West Side
Exterior Only

One of the earliest and most famous of New York's elegant apartment buildings was the Dakota—so named because its location at West 72nd Street and Central Park West in 1884 seemed as far from central New York City as the Dakota Territory. Henry Hardenbergh was the architect. The Dakota has been home over the years to many famous people, especially those in show business. John Lennon was living in the Dakota when he was shot and killed on its doorstep in 1980. It is a National Historic Landmark.

Visits to other historic homes are included in Chapter 8.

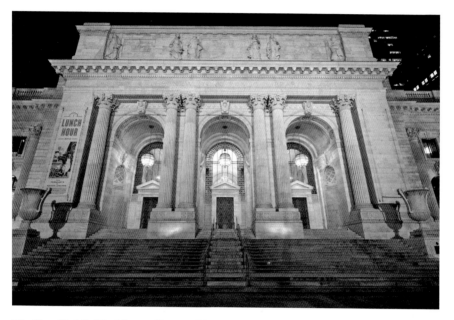

The New York Public Library. *Courtesy of James Maher.*

CHAPTER 5

THE CITY IS BEAUTIFUL

MUSEUM METROPOLIS

In the late nineteenth century, the wealthy wanted elegance for themselves. They wanted grandeur for their city. Leaders of major American metropolitan areas built museums, libraries, post offices and train stations that were as magnificent as they were functional. This "City Beautiful" movement occurred across the United States. In New York, it would be on a scale so large and impressive that it would forever enhance the city's stature.

After the Civil War ended in 1865, rich Americans traveled to Europe, where they visited museums of art and natural history in London, Paris, Berlin and Rome. At the time, nothing comparable existed in the United States. Returning home, the wealthy worked to create museums in the United States. Between 1870 and 1890, the cities of New York, Boston, Philadelphia, Chicago, St. Louis and Washington, D.C., opened significant art museums.

In an 1866 visit to Paris, New Yorkers met with the grandson of Founding Father John Jay, also named John Jay. The younger Jay was a prominent New York lawyer and also a diplomat. Jay urged them to found a national museum of art similar to the Louvre in Paris. When Jay returned to New York City, plans began in earnest to create such an institution. William Cullen Bryant, the editor in chief of the *New York Evening Post*, took a particularly active part in the undertaking. He and other city leaders succeeded in establishing the Metropolitan Museum of Art in 1870. The museum found temporary shelter until its own grand building could be constructed. Initial Metropolitan holdings consisted of 174 Dutch and French paintings, including some still on display today, such as Nicolas Poussin's *Midas Washing at the Source of the Pactolus*.

When the museum formally opened in 1880, President Rutherford B. Hayes was on hand for the dedication ceremony. The museum's principal façade—a Victorian Gothic structure designed by Calvert Vaux and Jacob Wrey Mould—faced Central Park. Today, the Metropolitan Museum of Art remains the only major building constructed on land allocated to Central Park. It is still possible to view the west façade of the original building in the Robert Lehman Wing.

Years and many additions have turned the museum toward 5th Avenue. The current entryway, at 82nd Street, is through the imposing three arches designed by architect Richard Morris Hunt that were added in 1902. The Hunt addition, completed by his son Richard Howland Hunt after his father's death, includes the Great Hall where visitors first enter the museum. Architects McKim, Mead & White designed the north and south wings on 5th Avenue, which were added in 1906. A master plan by architects Roche, Dinkeloo & Associates was initiated in 1971 and completed in 1991. As part of this plan, new additions to the central building have contributed to the further enlargement and splendor of the Metropolitan Museum of Art, including the Robert Lehman Wing, the Sackler Wing, the American Wing, the Michael C. Rockefeller Wing, the Lila Acheson Wallace Wing and the Henry R. Kravis Wing.

The Metropolitan Museum of Art is one of the world's preeminent collections of art. Its holdings include the greatest assembly of American art in the world, a major collection of European masters and impressionists, the largest holdings of Egyptian art outside of Cairo, the exceptional Costume Institute and celebrated collections of Asian, Near Eastern, African and Oceanic Art. In 1938, the Metropolitan Museum added to its stature when it opened the Cloisters Museum and Gardens in Fort Tyron Park on the Hudson River. The Cloisters, built to resemble a medieval monastery, was based on the extensive collection of medieval art belonging to George Grey Barnard, a sculptor in his own right. Funding to create the Cloisters as part of the Metropolitan Museum came from John D. Rockefeller Jr.

John D. Rockefeller Jr.'s wife, Abby, was a key founder of another important New York City museum, the Museum of Modern Art (MOMA). MOMA dates to 1929 and to the support of Abby Rockefeller, Lillie Bliss and Mary Quinn Sullivan, who shared a devotion to modern art. From the beginning, MOMA has been one of the world's foremost collections of modern and contemporary art.

In 1930, Gertrude Vanderbilt Whitney, an artist as well as an offspring of the Vanderbilt family who married into yet more wealth, offered five hundred modern American paintings to the Metropolitan Museum of Art. The museum rejected the offer as it deemed the paintings too contemporary.

Gertrude Vanderbilt Whitney took her paintings and her money and founded the Whitney Museum. The museum was at first located in four town houses on West 8th Street in the Village. It was the first museum dedicated strictly to American art. The Whitney played a significant role in bringing American art to the world's attention. Today, it is the foremost museum in the world of American contemporary art.

Another outstanding New York City art museum is the Guggenheim. The foundation of the Guggenheim Museum's collection was the personal art of Solomon R. Guggenheim (1937), a wealthy businessman whose fortune came from the gold mining industry. His niece Peggy Guggenheim contributed art and effort to make this museum, which opened in 1959, a reality.

In addition to art museums, New Yorkers considered public libraries to be a hallmark of a cultivated and prominent city. The first American privately funded library with free public access was the Astor Library in New York City. Founded by John Jacob Astor, it opened in 1854. Another important library was the Lenox Library, founded by James Lenox to serve as an institution of scholarly research. The Lenox Library building, later demolished, was on the site now occupied by the Frick Collection. In 1895, Samuel Tilden bequeathed funds to establish the research collection of the New York Public Library by combining the Astor Library and the Lenox Library into this one grand library. The City of New York donated land for a new building on the condition that the library be public.

The New York Public Library was constructed on land along 5th Avenue between 40th and 42nd Streets. This land was previously the Croton Reservoir, built in 1842 to provide the first fresh drinking water to New York City. The reservoir was relocated to make way for the library. The beautiful iron-and-glass Crystal Palace stood on this site from 1853 until it burned in 1858. The New York Public Library's white marble Beaux-Arts building, designed by John M. Carrere and Thomas Hastings, opened in 1911. It is considered by many to be the finest example of Beaux-Arts architecture in New York City. "Beaux Arts" was named for the École des Beaux-Arts in Paris, which trained many prominent American architects in the late nineteenth and early twentieth centuries. Grandeur, balance, arches and colonnades were key elements of the Beaux-Arts style. It drew on ancient Greece and Rome for inspiration.

The front entrance to the New York Public Library building, set back from 5th Avenue, has wide steps leading to magnificent arches. Flanking the steps are two proud and majestic stone lions in Tennessee marble by Edward Clark Potter. These lions, imbued with the sense that what they are guarding is very important, were originally called Leo Astor and Leo Lenox after John Jacob Astor and James Lenox, whose contributions made

possible the New York Public Library. However, during the Great Depression of the 1930s, New York City mayor Fiorella LaGuardia renamed the lions "Patience" and "Fortitude," the qualities New Yorkers would most need to survive those difficult times. Today, Patience, sitting to the south of the entrance, and Fortitude, sitting to the north, continue to inspire New Yorkers and other visitors with their resoluteness and dignity. On the west side of the library is Bryant Park, which dates to 1871. The park, named for William Cullen Bryant, has a statue of Bryant, as well as benches and grass, offering a moment of repose in hectic midtown Manhattan.

Complementing the venues for art and for learning were important sites for music. The 3,700-seat Metropolitan Opera House opened in 1883 on Broadway between 39th and 40th Streets. The Metropolitan Opera soon supplanted the older Academy of Music, whose leaders, the Astors, had snubbed the Vanderbilts, the Morgans and other new money New Yorkers, refusing them entry. As it turned out, the Academy could not compete with the new Met. It closed its doors three years after the Metropolitan Opera House opened. The Met has had a long and distinguished history since 1883. The celebrated tenor Enrico Caruso made his American debut with the Metropolitan Opera on November 23, 1903. From 1908 to 1915, the great Arturo Toscanini was the orchestra conductor. The original Metropolitan Opera House was demolished in 1967 after the Met had moved to Lincoln Center.

Andrew Carnegie contributed $2 million to build a home in 1891 for the Oratorio Society. Carnegie, who enjoyed singing, was president of the Oratorio Society. Carnegie chose as the architect for the new building a young unknown named William Burnet Tuthill, a fellow member of the Oratorio Society. The celebrated Russian composer Peter Tchaikovsky conducted the orchestra for the opening concert on May 5, 1891. The New York Philharmonic Orchestra made Carnegie Hall its home until it left for Lincoln Center in 1962.

Nowhere else in the world is there a venue for artistic and musical performances as large and as varied as New York City's Lincoln Center. Promoted as a concept by John D. Rockefeller 3rd and other city leaders, it took a major step toward reality in the May 14, 1959 groundbreaking ceremony, which President Dwight D. Eisenhower attended. The sixteen-acre complex near Columbus Circle has thirty indoor and outdoor performance areas that offer opera, the ballet, chamber and orchestral music, as well as jazz, theater, film and, each fall, the circus. The Metropolitan Opera, the New York City Philharmonic Orchestra and the New York City Ballet make their home in Lincoln Center.

Your Guide to History

The steps of the Metropolitan Museum of Art. *Courtesy of James Maher.*

New Museum of Contemporary Art
235 Bowery at Prince Street • Manhattan/Bowery
212-219-1222 • www.newmuseum.org • Admission Fee

The museum space designed by Japanese architects Kazuyo Sejima and Ryue Nishizawa reflect the museum's mission to be open to new ideas, artistic concepts and forms. Founded in 1977 by Marcia Tucker, the New Museum focuses on contemporary art by living artists.

The Joseph Papp Public Theater or the Astor Library
425 Lafayette Street • Manhattan/Greenwich Village
212-539-8500 • www.publictheater.org • Admission Fee

This building was originally the Astor Library. It opened in 1854 as the first library in the United States intended for the general public. John Jacob Astor built the library over a period of thirty years in the style of an Italian Renaissance palace. After the New York Public Library on 5th Avenue at 42nd Street opened in 1911, number 425 Lafayette Street closed as a library. For a while, it housed the Hebrew Immigrant Aid Society.

The old Astor Library was almost torn down in 1965 but was saved by the Landmarks Preservation Commission and by Joseph Papp, director of the Shakespeare Festival Public Theater. Today, it is the Joseph Papp Public Theater. The theater offers regular performances of plays by Shakespeare. It often serves as the off-Broadway venue for shows that become hits and move to larger theaters on Broadway. In the summer, the theater gives free outdoor performances of Shakespeare's plays at the Delacorte Theater in Central Park.

Whitney Museum of American Art
99 Gansevoort Street • Manhattan/Meatpacking District
212-570-3600 • www.whitney.org • Admission Fee

The dramatic, open and airy building by architect Renzo Piano now housing the Whitney Museum opened in 2015. In addition to holding the world's most important collection of twentieth-century and contemporary American art, the museum has outdoor terraces with views across Lower Manhattan. The large presence of the Whitney in the Meatpacking

District is further indication that this New York neighborhood has evolved from industrial to artistic and residential. The Whitney is located at the southernmost point of the High Line. In addition to its permanent collection, the museum hosts rotating exhibits, films, lectures and musical performances. From 1966 to 2014, the Whitney was housed in a granite Bauhaus-style building by architect Marcel Breuer located at 945 Madison Avenue. The Metropolitan Museum of Art plans to open the Met Breuer in this former Whitney space in 2016.

NEW YORK GENERAL POST OFFICE
421 8th Avenue between 31st and 33rd Streets • Manhattan/Garment District

The colonnaded Beaux-Arts structure designed by McKim, Mead & White opened in 1914 as the largest post office in the United States. This architectural team also designed the beautiful Penn Station on the other side of 8th Avenue that was demolished in 1963. Preliminary plans would move the Amtrak terminal from the current dreadful Penn Station location across the street to this beautiful and grand building. This will take years. The New York General Post Office is named the James A. Farley Post Office for the New Yorker who served as United States postmaster general under President Franklin D. Roosevelt. The exterior bears the inscription from Herodotus that serves as the unofficial motto of the United States Postal Service: "Neither snow nor rain nor heat nor gloom of night stays these couriers from the swift completion of their appointed rounds."

NEW YORK PUBLIC LIBRARY
5th Avenue at West 42nd Street • Manhattan/Midtown
917-275-6975 • www.nypl.org • Free

There are regularly scheduled guided tours of the Stephen A. Schwarzman Building, named for a principal benefactor of the New York Public Library on 5th Avenue. In 1886, Samuel Tilden, a former governor of New York State and presidential candidate, willed the Tilden Trust to establish a free library for the public in New York City. Ten years later, the Tilden Trust, in combination with the Astor and Lenox Libraries, formed the New York Public Library. Municipal funds

financed the construction of the magnificent Beaux Arts marble building by architectural firm Carrere & Hastings on 5th Avenue at 42nd Street. President William Howard Taft presided over the dedication ceremony of the library on May 23, 1911.

Andrew Carnegie contributed funds to add branch library buildings throughout New York City. Many of these continue to operate today. The NYPL remains dependent on private funding as it operates as a not-for-profit corporation in cooperation with the government of the City of New York. It is not only a critical asset for the people of New York, but it also offers around-the-clock and around-the-globe access to information and research material through its extensive online resources.

The NYPL holds a number of important collections that are intended for serious scholarship. It is possible for visitors to peek into a number of reading rooms, such as the Henry W. and Albert A. Berg Collection of English and American Literature in room 320. The collection has a special focus on British novelist Charles Dickens, who spent a month in New York City in 1843. It has a mahogany writing table, an armchair and a brass lamp that belonged to Dickens, as well as a letter opener with the handle made of a forepaw of the author's cat Bob.

The 1877 Lenox Library, a reference library founded by James Lenox, was on the site now occupied by the Frick Museum. The Astor Library, founded by John Jacob Astor, opened in 1854 in the East Village as the first American privately funded library with free public access. Portraits of many members of the Astor family and other distinguished New Yorkers line the walls of the Solomon Room on the second floor. In addition to serving as a photo gallery, it functions as an Internet reading room.

Enter the Schwarzman building through the impressive Astor Hall, named for John Jacob Astor, with its thirty-seven-foot-high ceiling and dazzling interior of white Vermont marble. The impressive third-floor McGraw Rotunda, built in the Beaux-Arts style, makes extensive use of marble and murals to awe visitors. Appropriate for a library, the Edward Laning murals tell the story of the recorded word from Moses and the stone tablets to linotype, or type-setting, machines, the latest thing when the murals were completed. Prometheus, on the ceiling, is bringing mankind the gift of fire, in this case symbolizing knowledge. The Gutenberg Bible on display in the rotunda was originally in the Lenox Library.

The rotunda serves as the vestibule to the celebrated Rose Main Reading Room. With its historic ceiling currently undergoing restoration, the Rose

Main Reading Room will reopen to the public in 2017. There are also many other areas of the NYPL with beautiful murals, woodwork and light fixtures. It is a National Historic Landmark.

Bryant Park, described in Chapter 6, is directly behind the Schwarzman Building.

The Museum of Modern Art
11 West 53rd Street between 5th and 6th Avenues • Manhattan/Midtown
212-708-9400 • www.moma.org • Admission Fee

The greatest collection of modern and contemporary art in the world is in the Museum of Modern Art, or MOMA, as it is affectionately known. MOMA has been in its current Edward Durrell Stone building since 1939. It is located not far from where the Rockefellers lived. Philip Johnson designed the Abby Aldrich Rockefeller Garden, an inviting outdoor space for visitors to pause. Cesar Pelli was the architect for an extensive 1984 addition and Yoshio Taniguchi for an even larger space in 2006.

MOMA's collection focuses on paintings, sculpture, drawings, prints, photographs, films and design. It regularly stages new exhibitions, drawing upon its own extensive holdings and loans from other museums. Gallery talks, lectures and activities for adults and children are part of its multitude of offerings. There is an array of guided tours for visitors, including a museum highlights tour. MOMA is one of the foremost research institutions in the world for modern and contemporary art.

Carnegie Hall
881 7th Avenue at 57th Street • Manhattan/Midtown
212-247-7800 • www.carnegiehall.org • Admission Fee

With three auditoriums that have a combined seating capacity of over 3,600, Carnegie Hall is an active and prestigious site for classical and popular musical performances. One-hour public tours of Carnegie Hall are available October through June. The tour includes the Rose Museum, funded by the Susan and Elihu Rose Foundation. Manuscripts, photographs and other historical treasures in the museum detail the history of the building and the many outstanding performances by storied artists. It is also possible to take a self-guided tour of the Rose Museum. Carnegie Hall, known for its

wonderful acoustics, was designed by architect William Burnet Tuthill and opened in 1891. When the New York Philharmonic Orchestra left Carnegie Hall for Lincoln Center in 1962, Carnegie Hall was to be torn down. However, violinist Isaac Stern led the successful effort to save Carnegie Hall. The principal performance venue in Carnegie Hall is named Stern Auditorium in his honor.

Grand Army Plaza and the Sherman Statue
5th Avenue at Central Park South • Manhattan/Midtown
www.centralparknyc.org • Free

Although across Central Park South from Central Park, the Grand Army Plaza is actually part of the 843-acre park. Completed in 1916, the plaza is named in honor of the Civil War Union army, whose formal name was the Grand Army of the Potomac. Deliberately designed to be in two sections, in the northern half of the plaza stands a gilded bronze statue of one of the Union's most successful generals, General William Tecumseh Sherman, by Augustus Saint-Gaudens. Sherman moved to New York City after the Civil War. He was a popular figure as he rode his horse and carriage through Central Park. In the southern half of the plaza is the Pulitzer Fountain, designed by sculptor Karl Bitter with the statue of the figure of abundance at the top.

Museum of Arts and Design
2 Columbus Circle • Manhattan/Midtown
212-299-7777 • www.madmuseum.org • Admission Fee

The Museum of Arts and Design celebrates innovation in the creation of all forms of crafts, arts and design. It has a large permanent collection that includes wearable art and jewelry and also rotating exhibits. A unique aspect of this museum is that it offers visitors the opportunity to interact with artists in the creative process through its open studios program. Founded by Aileen Osborn Webb in 1956, the museum has been in its current building, designed by Brad Cloepfil, since 2008.

Lincoln Center

10 Lincoln Center Plaza • Manhattan/Upper West Side
212-875-5456 • www.lincolncenter.org • Admission Fee

Lincoln Center is sixteen acres of culture in Manhattan. As you face the central plaza—the Jose Robertson Plaza—you look toward the Metropolitan Opera House (opened in 1966) with the David H. Koch Theater on the left (opened in 1964) and Avery Fisher Hall on the right (opened in 1962 as home to the New York Philharmonic Orchestra). Architect Wallace Harrison created the overall master plan and designed the Metropolitan Opera House. Other buildings are the work of well-known architects, including Philip Johnson and Eero Saarinen.

Key buildings are the Vivian Beaumont Theater, the Julliard School and the New York Public Library for the Performing Arts. The Big Apple Circus has performed in Damrosch Park at Lincoln Center each fall to winter season since 1981. Nearby the main campus is Dizzy's Club Coca-Cola for jazz.

For visitors, the David Rubenstein Atrium, on Broadway between 62nd and 63rd Streets adjacent to Lincoln Center, offers information and ticketing, including discount ticketing to many performances both at Lincoln Center and other venues around the city. There are also many free performances at Lincoln Center in a wide variety of the musical, theater and film arts. Lincoln Center is without peer in the world of cultural entertainment.

Museum of American Folk Art

2 Lincoln Square at Columbus Avenue and 66th Street • Manhattan/Upper West Side
212-595-9533 • www.folkartmuseum.org • Free/Donation

"American" refers to the location of the museum rather than its collection, as the museum presents an international vision of folk art that is individualistic and self-taught. In recent years, the museum has also concentrated on art by African American and Latino artists. It was the goal of Joseph Martinson and Adele Earnest to present the collection. First chartered as a museum in 1961, the Museum of American Folk Art has had several homes in New York City but has enjoyed its principal location in this building designed by Tod Williams and Billie Tsien since 2011.

CHILDREN'S MUSEUM OF MANHATTAN
212 West 83rd Street • Manhattan/Upper West Side
212-721-1223 • www.cmom.org • Admission Fee

This is a museum that invites children, including very young children, to delve in. Interactive exhibits provide children of all backgrounds with experiences in adventures, healthy lifestyles, creativity and world cultures.

THE PARK AVENUE ARMORY
643 Park Avenue between 66th and 67th Streets • Manhattan/ Upper East Side
212-616-3937 • www.armoryonpark.org • Admission Fee

There is an online registration form to schedule a tour of the magnificent rooms of the Park Avenue Armory. This 1881 Gothic Revival building, designed to resemble a fortress, was built by and for the Seventh Regiment of the National Guard of New York. It offers one of the most significant nineteenth-century interiors in the United States. The fifty-five-thousand-square-foot Wade Thompson Drill Hall, with its eighty-foot-high barrel vaulted roof, amazes visitors that such an enormous interior space exists in New York City. The Seventh Regiment was a military unit of Gilded Age New York aristocrats, including the Vanderbilts, Roosevelts, Livingstons and Harrimans. The armory actually functioned more as a social club than as a military site. The architect, Charles W. Clinton, was a member of the Seventh Regiment. There are many interior rooms with beautiful woodwork, stained glass and marble that were the creation of noted architects and artists, including the Herter brothers, Stanford White and Louis Comfort Tiffany. In addition to offering tours of the building, the armory is a venue for unconventional and cutting-edge artistic performances. It is also a National Historic Landmark.

THE FRICK COLLECTION

The Frick Collection at 1 East 70th Street is described in Chapter 4.

The Met Breuer

945 Madison Avenue at 75th Street • Manhattan/Upper East Side
212-535-7710 • www.metmuseum.org • Admission Fee

After the Whitney vacated this location, the Metropolitan Museum of Art decided to seize the opportunity to utilize the iconic Bauhaus-style building, designed by architect Marcel Breuer, for an extension of its twentieth- and twenty-first-century collections. It plans to use the space for educational outreach, lectures and performances in addition to displays of art. The Met Breuer opens in March 2016. Additional information is on the Metropolitan Museum website.

Museum Mile Festival

5th Avenue from 82nd to 105th Streets • Manhattan/Upper East Side
212-606-2296 • www.museummilefestival.org • Free

One day each June every year since 1978, nine museums along 5th Avenue from 82nd to 105th Street open their doors to the public for free. To facilitate the public's enjoyment, the city blocks all but pedestrian traffic on 5th Avenue for the festival's duration.

The Metropolitan Museum of Art

1000 5th Avenue at 82nd Street • Manhattan/Upper East Side
212-535-7710 • www.metmuseum.org • Admission Fee

The Met is a national treasure. Today, it is the largest museum in the Western Hemisphere. In addition to the main building on 5th Avenue, the Cloisters in Morningside Heights and the Met Breuer on Madison Avenue are also part of the Metropolitan Museum of Art. The Met's collection of paintings includes one of the world's most extensive holdings of Rembrants, Vermeers, Breughels and Rubens. Its galleries of impressionists are second only to the Gare d'Orsay Museum in Paris. Manet, Monet, Cezanne, Renoir and successors such as Van Gogh, Gauguin and Seurat delight visitors. American artists, including Gilbert Stuart, Thomas Eakins, John Singer Sargent and James Whistler, are on display. There are furniture collections—even entire rooms. There is a sixteenth-century Spanish courtyard and the fifteenth-century Temple of Dendur, a magnificent gift from the government of Egypt. The Met, in fact, has the largest collection

of Egyptian art and artifacts in the world outside of Egypt. Tours, gallery talks, concerts, other extensive programming and many special exhibits, in addition to the permanent collection, allow visitors to take full advantage of the Metropolitan Museum. An added factor is the easily understandable floor plan of the museum and the many helpful guards and information desk personnel who make a visit to the Met a time to relax and focus on the wonderful art and artifacts. The museum is a National Historic Landmark.

There is an impressive memorial to architect Richard Morris Hunt on the Central Park side of 5th Avenue at 71st Street. The bust of Hunt is the work of Daniel Chester French, who also sculpted Abraham Lincoln for the Lincoln Memorial in Washington, D.C.

Solomon R. Guggenheim Museum
1071 5th Avenue at 89th Street • Manhattan/Upper East Side
212-423-361 • www.guggenheim.org • Admission Fee

The Guggenheim in New York is well known for its Frank Lloyd Wright dramatic geometric-design building with its high domed rotunda and continuous circular ramp. The Guggenheim Museum has an important permanent collection of mid-nineteenth-, twentieth- and twentieth-first-century international art works by Claude Monet, Paul Cezanne, Vincent VanGogh, Pablo Picasso, Amedeo Modigliani, Wassily Kandinsky and many, many others. The foundation of the museum's collection was the personal art of Solomon R. Guggenheim (1937), a wealthy businessman. His niece Peggy Guggenheim contributed art and effort to make the museum, which opened in 1959, a reality. The museum offers lectures, musical performances and other artistic opportunities. It is a National Historic Landmark.

Today, the Guggenheim in New York is at the center of an international network of Guggenheim museums that includes institutions in Venice, Italy, and Bilbao, Spain. A new Guggenheim in Abu Dhabi is underway.

Cathedral of St. John the Divine
1047 Amsterdam Avenue at 112th Street • Manhattan/Morningside Heights
212-316-7540 • www.stjohndivine.org • Donation

With a length of 601 feet and a height at the nave of 124 feet, this is the largest cathedral in the world. Five thousand may attend Episcopal services

here or one of the many concerts the cathedral hosts. Notable features are the Rose Window, forty feet in diameter, and the celebrated Great Organ. The idea of building this cathedral dates to the early part of the nineteenth century. Church officials laid the cornerstone in 1892 with its consecration not occurring until 1941. The cathedral remains unfinished today. The original architects were Heins & Lafarge, though it was Ralph Adams Cram who shaped the cathedral in the Gothic Revival style. St. John the Divine wrote the Book of Revelation that envisions the end of the world. There are symbolic references throughout the cathedral to St. John the Divine.

THE CLOISTERS
99 Margaret Corbin Drive, Fort Tyron Park • Manhattan/Morningside Heights
212-923-3700 • www.metmuseum.org • Admission Fee

The Cloisters is a branch of the Metropolitan Museum of Art that houses an extensive collection of medieval art. It opened to the public in 1938 with the support of John D. Rockefeller Jr. The museum building itself is designed to resemble a Romanesque-style medieval monastery with courtyards and covered walkways adjoining the museum galleries. The location in northern Manhattan has beautiful gardens and a setting on the Hudson River. The museum offers tours. This is a wonderful setting for the many concerts and performances hosted by the Cloisters.

GENERAL GRANT NATIONAL MEMORIAL
122nd Street and Riverside Drive • Manhattan/Morningside Heights
212-666-1640 • www.nps.gov/gegr • Free

This is the largest mausoleum in North America. It is a National Park Service site and a National Memorial. John Duncan, the architect, intended the massive size of the final resting place of Ulysses S. Grant to reflect the importance of this man. As the general commanding the Union forces, Grant saved the country, and as president (1869–77) he led the country through the war's difficult aftermath. Ulysses S. Grant was a beloved hero. To build this imposing Classical-style monument, more people from around the world contributed more money than had occurred in any prior fundraising effort.

After his presidency, Ulysses S. Grant adopted New York City as his home. When he died in 1885, New York showed its appreciation when over one

million people turned out for the funeral procession. After the dedication of Grant's memorial by President William McKinley on April 27, 1897, the seventy-fifth anniversary of Grant's birth, this was, for many years, the most popular tourist destination in New York City. The memorial also enjoyed renown as the focal point for a trick question: "Who is buried in Grant's tomb?" In addition to the president himself, his wife, Julia, is also interred here.

GRAND ARMY PLAZA
Eastern Parkway at the main entrance to Prospect Park • Brooklyn
www.nycgovparks.org

A large traffic circle with myriad offshoot streets surrounds the impressively dignified Soldiers' and Sailors' Arch. The eighty-foot-high arch, designed by John H. Duncan, was dedicated in 1892 in honor of the Union soldiers and sailors who fought in the Civil War. President Grover Cleveland participated in the dedication. On top of the arch is a sculpture by Frederick MacMonnies of the winged goddess of victory in a large chariot. Within Grand Army Plaza are statues of historic figures, including a bust of President John F. Kennedy by sculptor Neil Estern. It is a National Historic Landmark.

THE BROOKLYN MUSEUM
200 Eastern Parkway • Brooklyn
718-638-5000 • www.brooklynmuseum.org • Admission Fee

The Brooklyn Museum is vast. Yet it is only one-fifth the size originally intended. Work on the museum began shortly before Brooklyn joined Manhattan to form a Greater New York in 1898. Once the two rival cities were united as one, it was no longer deemed as important to have so large a museum in Brooklyn. Yet the Brooklyn Museum remains one of the world's great art museums, with a large and impressive collection of American art in its Luce Center and a floor of Egyptian art, including the Mummy Chamber. The Brooklyn Museum of Art also houses a series of period rooms that provide insight into the way Americans lived. One of these rooms, the Moorish Room, comes from the house of John D. Rockefeller. The building, designed by McKim, Mead & White, opened its doors in 1897.

MOMA PS1

22–25 Jackson Avenue at 46th Street • Long Island City/Queens
718-784-2084 • www.momaps1.org • Admission Fee

This is an art exhibition space that focuses on emerging artists and new art forms, as well as performance art. The origins of the museum date to 1971. In 2000, the museum became an affiliate of the Museum of Modern Art.

The Bow Bridge in Central Park. *Courtesy of James Maher.*

BACK TO NATURE IN THE CITY

RAMBLING ON THE MEADOW IN CENTRAL PARK

In the second half of the nineteenth century, a prescient few in this country began to realize that in the American haste to settle the land, we were cutting down too many trees, destroying too much wildlife and leaving precious little of our natural resources for future generations. The outline of the United States had filled in. It also seemed in danger of filling up.

A notable few called for a return to and respect for nature. Henry David Thoreau wrote *Walden: Life in the Woods*, published in 1854, moving many to contemplate our fundamental values. Albert Bierstadt, Thomas Moran and Frederic Edwin Church were part of the Hudson River School of painters who depicted large, lush, romantic landscapes that inspired dreams of a pristine environment. John Wesley Powell sent back popular reports of his expeditions down the Colorado River. John Muir made a stand for the redwoods of California, trees that were thousands of years old and at risk.

Congress responded to an awakened public demand to preserve the wilderness. In 1872, it passed a bill signed into law by President Ulysses S. Grant to create Yellowstone as the first American National Park. Congress created five more parks in 1900 legislation. Today, the American national park system has more than four hundred areas in every state of the Union and the District of Columbia.

The first to call for a large park in New York City was William Cullen Bryant, the influential editor-in-chief of the *New York Evening Post*. By mid-century, the city was experiencing growing congestion and diminishing open space. Unless there were a commitment of vacant land to a park in the

very near future, the opportunity would disappear in the accelerating urban development. Responding to citizens' pressure, city leaders considered several locations for a park. The one they selected was at a central location and so became known as Central Park. It was at a site largely undeveloped because the land was particularly rocky. To determine the exact layout and design of the park, in 1857, the city announced a competition. The winners were Calvert Vaux and Frederick Law Olmsted. There is no doubt that their proposal "Greensward" was a masterpiece. The park that they proposed and built has endured to this day, offering relief from concrete and crowds to tens of millions each year.

From 1858 to 1873, 3,600 workers moved millions of cubic feet of earth to create the 843-acre park. Central Park is half a mile wide from 5th Avenue to 8th Avenue—now called Central Park West. The park is two and a half miles long from 59th Street to 110th Street. Vaux and Olmsted designed a park that looked natural. Although the park has features that appear as though they were always there, they are man made. Other entrants in the competition had suggested multiple buildings and elaborate structures. Vaux and Olmsted kept these to a minimum. Instead, they focused on a large parade ground and playing field that offered green, open space to the city. This area is Sheep Meadow.

They designed the Ramble, a thirty-seven-acre wilderness area in the park that serves as a haven for birds and small wildlife. They met the requirement that four or more streets cross the park. To enhance the natural aspect of the park, they laid the streets in trenches eight feet deep so that the roads would be visibly less intrusive for park visitors.

The ornamentation is minimal but brilliant. One of the most arresting aspects of their design is the Mall, placed at an angle, to give it a long visual reach in the relatively narrow park. The focal point at the northern end of the Mall is the Bethesda Terrace and Fountain. Jacob Wrey Mould designed the lovely double staircase leading to the fountain with its statue, *Angel of the Waters* by Emma Stebbins. The Book of John in the Bible tells the story of an angel who gives healing powers to the Pool of Bethesda in Jerusalem. Gazing at the Bethesda Fountain today away from the hubbub of the city similarly soothes visitors.

In addition to Central Park, New Yorkers pressed on in their support for the environment. In 1869, a group of prominent city leaders gathered in the home of Theodore Roosevelt, the father of the future president, at 28 East 20th Street to create the charter for the American Museum of Natural History. Excitement about the many scientific discoveries of the age, the

exploration of the West by Louis and Clark and the growing interest in understanding and appreciating the natural world generated the impetus to raise the funds for a new museum. President Ulysses S. Grant laid the cornerstone for the American Museum of Natural History in 1874, and President Rutherford B. Hayes opened it in 1877. The first exhibits for the museum were stuffed birds and mammals from the collection of German naturalist Prince Maximilian zu Wied-Neuwiebl.

There was a demand to view living as well as stuffed animals. The result was the creation of the zoo. After the first zoo in the United States opened in Philadelphia, other cities that boasted of a zoo by 1900 included Buffalo, Baltimore, Cincinnati, San Francisco and Washington, D.C. It was, however, the New York Zoological Park, opening in 1899, that defined for the future what a zoo would be. More than a collection of exotic animals on display, a true zoo would also be an institution for research and conservation. Modern zoos take this mission very seriously. The New York Zoological Park has been commonly known as the Bronx Zoo because of its location. Today, the formal name—the International Wildlife Conservation Park—emphasizes the purpose of the modern zoo.

Literary Walk in Central Park. *Courtesy of James Maher.*

Central Park
59th or Central Park South to 110th Streets, 5th Avenue to Central Park West
www.centralparknyc.org

Central Park is a wonderland of natural vegetation, open spaces, broad expanses of water, beautiful sculpture and bridges and plentiful activities. Or it is just a place to chill. See the website for a wide offering of these activities and also for guided tours of Central Park that begin at various locations (free or fee). The website is also extremely useful in providing information for self-guided tours and for background on all aspects of Central Park.

There are five visitor centers in Central Park run by the Central Park Conservancy, the nonprofit organization that manages Central Park for the City of New York. During the 1960s and '70s, like much of the city, the park experienced a serious decline, with vegetation at risk and buildings in disrepair. The Central Park Conservancy, beginning in 1980, stepped in to maintain and improve the park. Today, it raises funds from private sources to provide 75 percent of the park's annual operating budget. Thanks to the Central Park Conservancy, the park is a restorative and enjoyable place for the forty-two million visits it receives each year. It is the most visited urban park in the United States. Central Park is a National Historic Landmark.

In addition to the attractions noted below, Central Park has twenty-one playgrounds for children. Improvements to the playgrounds, including for accessibility, are ongoing. Walkways make the park easy to enjoy. On Central Park South, there are horse-drawn carriages that offer a pleasant option for seeing the park. There are also pedi-cabs. These rent by the minute with varying rates, so it's important to note and confirm with the driver before getting into the pedi-cab. Citibikes and bike rentals on Central Park South are also available to visitors. Bicycling in Central Park is very popular.

Central Park from Central Park South to 72nd Street

Columbus Circle Information Kiosk
Central Park South at Central Park West

In warmer months, there are also umbrella stands at many locations in the park with staff ready to provide information and directions.

Gapstow Bridge
Central Park South, East

This stone bridge across the Pond dates to 1896. It replaced an original wooden bridge designed by Jacob Wrey Mould that had rotted. The clean lines and gentle arc of the Gapstow Bridge make it look as though it always belonged here.

The Pond
Central Park South, East

Olmsted and Vaux created this water feature that is just steps away from 5th Avenue. There is a constantly changing floral spectacular near the Pond that makes for a visual treat each season of the year. The Pond adjoins the Hallett Nature Sanctuary.

Hallett Nature Sanctuary
60th to 62nd Streets, East

This four-acre woodland near the southern end of the park is closed to human visitors most of the time in order to protect many wildlife species that make Central Park their home. From time to time, the Central Park Conservancy opens up the sanctuary, named for George Harvey Hallett Jr. (1895–1985), an avid birdwatcher and political activist.

The Arsenal
64th Street, East

This is the headquarters of New York City's Department of Parks & Recreation and the Central Park Zoo. The building predates Central Park. Completed in 1851, it was originally used for ammunition storage by the New York State National Guard. There is a gallery open to the public with free exhibitions of fine art and photography with a nature theme.

Chess and Checkers House
64th Street, Center
212-794-4064

Visitors may stop by for information and to play a game of chess or checkers. Players bring their own games or borrow pieces from the park to play on site.

The Dairy Visitor Center and Gift Shop
65th Street, Center
212-794-6564

Calvert Vaux designed this Victorian cottage, which offered milk for visiting children in nineteenth-century New York. Olmsted and Vaux concentrated many features designed to appeal to children in the area of the park below 65th Street.

Wollman Rink
62nd to 63rd Streets, East

When Central Park first opened, visitors could ice skate on the lake. After that practice was deemed unsafe, Wollman Rink opened to ice skaters in 1950.

Central Park Zoo
63rd to 66th Streets, East
Admission Fee

An odd collection of animals—most of which were cast-off pets and circus animals, including one elephant and a tiger—went on display in New York in 1861 as the Central Park Menagerie. Today, this small and very attractive zoo is under the umbrella of the Wildlife Conservation Society. One of its most popular features is the sea lion pool where sea lions entertain the public with their food-inspired antics. Elsewhere in the zoo, it is worth waiting for the moment on the hour or half hour when the George Delacorte Musical Clock with its bear, hippopotamus and friends

dance and play musical themes. Delacorte, a New York philanthropist, provided funding for the clock. Children may pet and feed goats, sheep and a cow at the Tisch Children's Zoo, which also offers an Enchanted Forest and two theaters for performances for the very young.

CAROUSEL
64th Street, Center
Admission Fee

A carousel has been a popular feature of Central Park since 1871. This is the fourth to stand here after earlier carousels were lost to decay or fire. This 1908 carousel moved to Central Park from Coney Island in 1950. It is a work of art with fifty-seven hand-carved horses from the Stein & Goldstein factory in Brooklyn. Operation of the carousel is seasonal and weather dependent.

THE MALL AND LITERARY WALK
66th to 72nd Streets, Center

A mall is a traditional place to stroll. This quarter-mile-long path offers visitors a lovely place to promenade under a canopy of rare American elms on either side of the pathway. Near 66th Street, the Mall is called the Literary Walk because of the statues of writers and poets, including Robert Burns and Sir Walter Scott. There is also a statue of Christopher Columbus by the Literary Walk.

SHEEP MEADOW
66th to 69th Streets, West

This large, open, green space for lounging about, picnicking or grabbing some peace and quiet originally hosted a flock of sheep when Central Park opened. The intent was to create a pastoral setting in the busy city. The sheep remained in the meadow until 1934. There are wonderful views of the New York City skyline from Sheep Meadow.

Balto

67th Street, East

This 1925 statue by Frederick G.R. Roth honors the heroic Siberian husky named Balto that led sled teams across frozen turf to bring medicine to the children of Alaska threatened by a diphtheria epidemic. The statue is a favorite of children today.

Central Park from 72nd to 86th Streets

The Lake

71st to 78th Streets, Center

This twenty-acre lake was part of the original Olmsted and Vaux plan. It has a lovely natural feel to it, although it is man-made. One of its most attractive features is the Hernshead, a rocky outgrowth that borders the lake near 75th Street. "Hern" is a corruption of "heron," a bird found here in abundance. On the lake near 75th Street on the west side is the Ladies' Pavilion, designed by Jacob Wrey Mould in 1871.

The Loeb Boathouse

74th to 75th Streets, East
www.thecentralparkboathouse.com

Visitors can rent bicycles or rowboats to take out on the lake. There is also a restaurant, café and grill.

Bethesda Terrace and Fountain

72nd Street, Center

Sculptor Emma Stebbins created the iconic *Angel of the Waters* statue that tops the fountain. The fountain represents the healing waters of the Pool of Bethesda from the Book of John in the Bible. This is one of the most photogenic and visited sites in Central Park. The Bethesda Fountain sits on the Bethesda Terrace designed by Olmsted and Vaux. While here, be sure to admire the beautiful English Minton tiles designed by Jacob Wrey Mould in the ceiling of the Terrace Arcade.

Bow Bridge
74th Street, Center near the Bethesda Terrace

Admired for its simplicity and harmony with nature, this is the second-oldest cast-iron bridge in the United States, dating to 1862. The bridge takes its name from its graceful arch, which is similar to the shape of a violin bow. Olmsted and Vaux designed the bridge to connect the lake and the Ramble with Cherry Hill. This is a good place to pause for a moment and appreciate the tranquility of Central Park.

Cherry Hill
72nd Street, Center

In the spring, this is a favored spot for its blooming cherry trees, forsythia and azaleas. Visitors enjoy lying on the ground and gazing at the blossoms.

The Ramble
73rd to 79th Streets, Center

Thirty-six acres of vegetation and deep undergrowth provide a wildlife habitat that offers bird-watching enthusiasts and picknickers alike a place to escape the city and to enjoy nature. The rugged beauty found here is unique in the park.

Conservatory Water
72nd to 75th Streets, East

In the summer, children (and adults) enjoy sending their model boats across Conservatory Water. Bring your own boat or rent a sailboat here from a cart near the water. Kerbs Boathouse on the Conservatory Water has an array of model yachts, some of which are very impressive, stored by their owners over the summer months. In good weather, there is a café with tables overlooking the water. In the winter, the water turns to ice and offers free skating.

Hans Christian Andersen Statue
74th Street East

Hans Christian Andersen, the Danish author of children's stories, was an amazing storyteller. His statue is the site of the summertime storytelling program in Central Park. The statue of the author was a gift to the park by the Danish American Women's Association. Children are welcome to climb on the author, cast in bronze, who has opened his book *The Ugly Duckling* to read.

Alice in Wonderland
75th Street East

Benefactor George Delacorte commissioned Spanish-born artist Jose de Creeft to sculpt this statue of the Lewis Carroll figure that has been in the park since 1959. Children love to climb on the bronze statue of Alice sitting on a large mushroom while the Mad Hatter and the White Rabbit join her in undoubtedly zany conversation.

Strawberry Fields
71st to 74th Streets West

English singer-songwriter John Lennon came to New York City to make it his home. He lived at the Dakota apartment building at 1 West 72nd Street. It was in front of the Dakota that he died on December 8, 1980, shot by a deranged stalker. John Lennon was forty years old. His wife, Yoko Ono Lennon, dedicated this memorial to her husband in 1985. It consists of a mosaic embedded in the ground created by Italian artists and donated by the City of Naples, Italy. With the Beatles, Lennon wrote and recorded the song "Strawberry Fields Forever," which speaks to peace and harmony. Visitors to the park can seek that peace here. Benches at the memorial are dedicated to others who have come to this site for reflection.

Marionette Theater at the Swedish Cottage
79th Street West
Admission Fee

The Swedish Cottage was Sweden's exhibit in the 1876 Philadelphia Centennial Exposition. Charmed by it, Frederic Law Olmsted brought the structure to Central Park in 1877. Today, it provides the setting for regular performances for children by the Marionette Theater.

Shakespeare Garden
79th to 80th Streets, West

In 1913, this four-acre garden was dedicated to famed English poet and playwright William Shakespeare. The plants in the garden are those Shakespeare noted in his works, while bronze plaques appear throughout the garden with quotes from Shakespeare's writings.

Belvedere Castle
79th Street, Center
212-772-0288

This castle with an Italian name for "beautiful view" offers just that—lovely views of Central Park and the New York City skyline. Belvedere Castle, designed by Calvert Vaux, was built in 1869 from the natural stone, called Manhattan schist, found in the park. Temperatures and other indicators of New York City weather are recorded for the National Weather Service at Belvedere Castle. Belvedere Castle serves as a visitor center for the park. If Belvedere Castle looks familiar to children and their parents, it may be because it serves as the home for Count von Count of the television show *Sesame Street*.

The Delacorte Theater

80th Street, Center

Free

In the summer, there are productions of plays by William Shakespeare, often starring notable actors and actresses. The tickets are free but require standing in line to obtain them. Information is on the website. The large amphitheater was the gift of philanthropist George Delacorte Jr.

The Obelisk

81st Street, East

This sixty-nine-foot-high granite monument, nicknamed Cleopatra's Needle, is the oldest monument in New York City. It dates to 1450 BC. Its original location was on the Nile River in Egypt. In 1880, the leader of Egypt offered this obelisk to the United States. It has stood in Central Park since 1881.

The Great Lawn

79th to 85th Streets, Center

When Central Park opened, this was at the site of the Croton Reservoir, used to provide water to New York City. After the reservoir was eliminated in the 1930s, this area was filled in to create a vast open space often used for major concerts. Today, its fifty-five acres provide a great place to lounge on the grass or enjoy a game of baseball on one of the several baseball diamonds.

Central Park from 86th to 110th Streets

The Reservoir

85th to 96th Streets, East to West

This beautiful body of water, once used as a reservoir for the city, is now strictly ornamental. There is a popular 1.58-mile running track around the reservoir that is named in honor of Jacqueline Kennedy Onassis.

The North Woods
101ˢᵗ to 110ᵗʰ Streets, West to Center

Hiking along a path in the North Woods, it is possible to forget that you are even in New York City. This is an area favored by bird watchers and those seeking real solitude. Because it is so isolated, it is best for new visitors to take a guided tour of this area rather than attempt it on their own. Key landmarks within the North Woods are the Ravine (103ʳᵈ Street, Center Park), the Loch (102ⁿᵈ Street, Center Park) and the Glen Span Arch. Olmsted and Vaux built dams in three areas along the Loch—Scottish for lake—to create small waterfalls whose sounds are as delightful as their appearance. The Glen Span Arch stands at the Loch at its southern point, and the Huddlestone Arch stands at the northern point of the Loch. Olmsted and Vaux dammed up a natural stream in the North Woods to create the Pool, with its man-made grotto and waterfall.

Conservatory Garden
104ᵗʰ to 106ᵗʰ Streets, East

In a park of wide-open lawns and natural foliage, this is Central Park's only formal garden. The six-acre garden has three parts: the English garden, the French garden and the Italian garden. In the English garden is the Frances Hodgeson Burnett Memorial Fountain in honor of the woman who wrote the children's book *The Secret Garden*. The sculptor was Bessie Potter Vonnoh. The principal entry to the Conservatory Garden is at 105ᵗʰ Street through a beautiful wrought-iron gate. Designed by architect George B. Post, the gate originally stood in front of the 1883 Cornelius Vanderbilt II mansion, also designed by Post, at 5ᵗʰ Avenue and 58ᵗʰ Street. This Vanderbilt house was once the largest single-family home in the United States. It was demolished in 1926.

Harlem Meer
106ᵗʰ to 110ᵗʰ Streets, East

Meer is the Dutch word for "lake." Harlem is named for the city of Haarlem in the Netherlands. Olmsted and Vaux designed this body of water to honor and remember the Dutch and the role they played in

founding Manhattan. Today, the Harlem Meer provides a wonderful setting for many activities and community programs.

Charles A. Dana Discovery Center
110th Street, East
212-860-1374

This charming small building on the edge of the Harlem Meer dates to 1993. In addition to serving as a visitor center, it offers special events such as summer performances, a small flotilla of lighted Halloween pumpkins in the fall and December holiday decorations. Charles A. Dana was a twentieth-century New York businessman and philanthropist who had a home near Central Park.

We are now leaving Central Park.

American Museum of Natural History
Central Park West at 79th Street • Manhattan/Upper West Side
212-769-5100 • www.amnh.org • Admission Fee

If you are traveling with children, make this museum a priority. The American Museum of Natural History includes forty-five permanent halls and the Rose Center for Earth and Space, as well as rotating exhibits. For an additional fee, there is an IMAX theater that features changing films on science and the universe. Some of the perennial favorites at the American Museum of Natural History are the ninety-four-foot-long fiberglass blue whale suspended overhead in the Irma and Paul Milstein Family Hall of Ocean Life. In addition to this oceangoing mammal, there is an exhibit of the largest living land mammal: the African elephant. The Hayden Planetarium Space Theater projects the galaxy and beyond overhead and all around. Dinosaurs and diamonds are also on display in the museum. The mission of the museum is to inspire visitors to learn more about our world and to do more to protect its wonders. In addition to museum tours and regular gallery talks, there are bird walks in Central Park just across the street and extensive educational programs for children of all ages. There are also popular sleepover programs for children and parents on certain weekends.

Visitors enter the museum through the enormous and impressive Theodore Roosevelt Memorial Hall. The walls display quotes from President Theodore Roosevelt on youth, manhood, nature and the state. Roosevelt wanted to be remembered as our "Conservation President." What immediately grabs visitors' attention are the two large dinosaurs cast from real specimens: a barosaurus and an allosaurus. The museum has the world's largest collection of real fossils of dinosaurs, mammals and other vertebrates. In front of the museum is a statue of Theodore Roosevelt on horseback, by John Russell Pope.

BRYANT PARK
5th Avenue at 42nd Street • Manhattan/Midtown
www.bryantpark.org • Free

This small park behind the New York Public Library was named in honor of William Cullen Bryant in 1884, six years after his death. It is a fitting tribute to the man who, as editor-in-chief of the *New York Evening Post*, used his considerable influence to promote the creation of Central Park in New York. Today, Bryant Park is a pleasant place to take a break and relax on the grass. There is a 1911 William Cullen Bryant Memorial, which is the work of sculptor Herbert Adams. An iron-and-glass structure attached to the back of the library houses several restaurants. The structure is reminiscent of the iron-and-glass Crystal Palace that existed here from 1853 to 1858, hosting the first World's Fair in the Western Hemisphere in 1853. A fourteen-animal carousel, "Le Carrousel," entertains children in Bryant Park. In the colder months, there is an ice-skating rink in the park. In warmer months, there are organized tours and outdoor movies.

PROSPECT PARK
Near Park Slope, Prospect Lefferts Gardens and Windsor Terrace • Brooklyn
718-965-8951 • www.prospect.org • Free

The Prospect Park website provides a map of the park with its multiple entrances and attractions marked. Take your dog for a swim, organize a baseball game, pedal a boat on the lake in the summer, ice skate at Wollman Rink in the winter or simply stroll the large and varied grounds

of this important 585-acre park that is a centerpiece of Brooklyn. Like Central Park, Prospect Park was the work of Frederick Law Olmsted and Calvert Vaux. Work began in 1866. Many consider the Ravine the centerpiece of Prospect Park and the extensive waterway to be the most masterful piece of urban park planning in the country.

The Prospect Park Zoo (admission fee) at 450 Flatbush Avenue in the park with over six hundred animals on display is a popular attraction for both children and adults. Another extremely popular feature with children is the 1912 carousel (admission fee) carved by Charles Carmel. Its animated horses, lion, deer and dragons charm children and enthrall adults. The Grand Army Plaza described in Chapter 5 is at the Eastern Parkway entrance to Prospect Park.

The Prospect Park Audubon Center is near the Lincoln Road entrance to the park and the boathouse. It offers free public programs to explore nature in the park. Also in Prospect Park is the Lefferts Historic House, described in Chapter 2.

BROOKLYN BOTANIC GARDEN
990 Washington Avenue • Brooklyn
718-623-7200 • www.bbg.org • Admission Fee

The fifty-two-acre Brooklyn Botanic Garden dates to 1910. Each year brings an enhancement or restoration to this beautiful urban oasis in the heart of Brooklyn. Guided tours of the garden are offered during the summer months. Whether visitors are strolling through the Japanese Hill-and-Pond Garden, the Lily Pool Terrace, the Fragrance Garden or one of the many other gardens within the garden, the experience is delightful.

THE NEW YORK AQUARIUM
602 Surf Avenue at West 8th Street • Brooklyn
718-220-5100 • www.nyaquarium.com • Admission Fee

The New York Aquarium is the oldest aquarium in continuous operation in the United States. It opened in Castle Garden in the Battery in 1896. It has been at its current fourteen-acre site on the Coney Island Boardwalk since 1957. In recent years, the aquarium has undergone extensive renovation and enlargement with new exhibits planned, including Ocean

Wonders: Sharks! The aquarium is part of the Wildlife Conservation Society, which is also responsible for the zoos in the Bronx, Brooklyn, Queens and Central Park in Manhattan. Its mission is to conduct research on aquatic life in addition to public education.

Queens Zoo
53–51 111ᵗʰ Street, Corona • Queens
718-271-1500 • www.queenszoo.com • Admission Fee

Wildlife from the Americas, a domestic animal petting zoo, a waterfowl marsh and many other exhibits, experiences and programs make the Queens Zoo, a branch of the Wildlife Conservation Society, a real treat to visit.

The New York Botanical Garden
2900 Southern Boulevard • The Bronx
718-817-8700 • www.nybg.org • Admission Fee

This 250-acre site of beautiful gardens and Beaux-Art buildings, such as the elegant library, is both inspirational and restorative. The NYBG is much more than a pretty walk down a garden path. Its mission is plant research and conservation. The garden dates to 1891, when Dr. Nathaniel Lord and his wife, Elizabeth Britton, opened the gardens after their visit to Kew Gardens in England. The centerpiece is the magical 1902 glass-and-steel crystal palace Haupt Conservatory.

During the Christmas season, the Haupt Conservatory houses the Holiday Train Show. Visitors experience the wonder of New York in miniature as model trains wind their way along a track that takes them by 150 small replicas of famous New York landmarks, such as the Statue of Liberty, St. Patrick's Cathedral and the Empire State Building. Most impressive is the fact that the garden's miniatures are all made of leaves, bark, twigs and other natural materials. The site is a National Historic Landmark.

The Bronx Zoo

2300 Southern Boulevard • The Bronx
718-367-1010 • www.bronxzoo.com • Admission Fee

Originally known as the New York Zoological Park when it opened in 1899, this zoo has always been commonly known as the Bronx Zoo because of its location. Today, the formal name, the International Wildlife Conservation Park, reinforces the mission of the modern zoological park. The zoo has over four thousand animals on display in an area encompassing 265 acres. The Bronx Zoo features natural, open-air settings such as Jungle World and the Congo Gorilla Forest. There is also a wonderful recently renovated Children's Zoo. The Wildlife Conservation Society is an umbrella organization denoting the important mission undertaken by the modern zoo. Included in this group is not only the Bronx Zoo but also the Central Park Zoo, the New York Aquarium, the Prospect Park Zoo and the Queens Zoo.

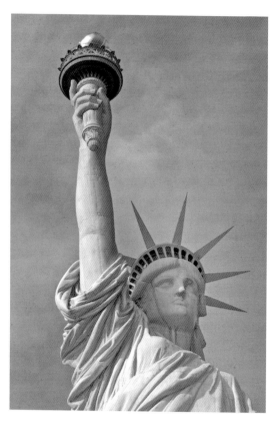

The Statue of Liberty. *Courtesy of James Maher.*

LAND OF LIBERTY

SHE LIFTS HER LAMP BY THE GOLDEN DOOR

The monuments to the arts, sciences and education built in the late nineteenth and early twentieth centuries contributed to New York's stature in the world. But like many cities of the era, New York was a place of stark contrasts. Not only the rich came to New York. The poor, often more amply equipped with hope than with the skills to make their way in the rough city streets, also came. Many were from other countries. One characteristic these immigrants had in common was a fearless commitment to a new way of life. It was not the timid who embarked on the challenging journey to an unfamiliar land.

Immigration to the United States changed dramatically as the nineteenth century progressed. The numbers of immigrants grew significantly, and the principal countries of origin changed. Five million people immigrated to the United States in the forty-five years between 1815 and 1860; ten million came in the thirty years between 1860 and 1890. In the fifty years between 1870 and 1920, twenty-three million people immigrated to this country. Until the 1880s, immigrants to the United States were most likely to be from Northern Europe. They were English, Scot, Irish, German and Scandinavian. After 1880, immigrants were predominantly from Southern and Eastern Europe. They were Italian, Greek, Armenian, Polish, Romanian, Hungarian and Russian.

Immigrants came for many reasons. Opportunity in the United States attracted them. Events in their homeland triggered their departures: Irish potato famines, German revolutions and economic and political

upheaval in Italy and Greece sent many to our shores. The Russians who came were mostly Jews fleeing the anti-Semitism of late nineteenth-century Eastern Europe. Between 1881 and 1910, over 1.5 million Jews came to America.

While differing motivations inspired people to come to the United States, technology in the form of the steamship facilitated immigration. Americans Robert Fulton and Robert Livingston partnered to create the first steamboat passenger line from New York City to Albany on the Hudson River in 1807. As the steam engine became more reliable and efficient, transatlantic service began in 1838. After 1868, the great Cunard Line initiated the golden age of transatlantic ocean travel that lasted well into the twentieth century. It was not until the 1950s that airplanes provided most transatlantic transport.

With the advent of the steamship, sailing time across the Atlantic Ocean took two weeks instead of two months. Accordingly, it became cheaper and safer. Before the introduction of the steamship, long months in the hold of a ship would leave passengers sick and weakened by the time they disembarked in the United States. With the steamship, entire families—including children—could easily make the passage across the Atlantic.

By the mid-nineteenth century, the large numbers of immigrants arriving at the port of New York clearly required more than the existing ad hoc approach to admitting the new arrivals. New York State, therefore, opened in 1855 the Main Immigrant Landing Depot at Castle Garden at the lower tip of Manhattan. Castle Garden was part of a system of fortifications built around New York City Harbor after the Revolutionary War and before the War of 1812 to defend against the anticipated British attack. Castle Garden never saw action. Demilitarized, the fort was named Castle Clinton in 1817 in honor of DeWitt Clinton, the mayor of New York who oversaw the city's fortifications during the War of 1812. Renamed Castle Garden in 1823, it served as the Main Immigrant Landing Depot in New York beginning in 1855. Castle Garden processed more than eight million immigrants entering the United States between 1855 and 1890, or two out of every three people who immigrated to this country during that time period.

In 1892, a new, larger and significantly different immigration depot opened: Ellis Island. Ellis Island was much more than an entry point into the United States; it was a screening center operated not by New York but by the United States federal government. It was clear to the immigrants arriving at Ellis Island that admittance into the United States

was no longer automatic. There were tests for contagious disease and suitability tests to screen out those deemed "morally corrupt" or totally indigent. After 1917, there were even literacy tests. Failure to pass these tests could mean a forced return to the country of origin.

Ellis Island was not, however, a required rite of passage for everyone. Passengers who could afford to book their Atlantic Ocean transit in first or second class on one of the great seagoing lines of the day, such as Cunard, could step off the boat in New York and only pass through customs before going about their business. If you had the money to travel by first or second class, presumably you would not be a burden when you arrived in the United States. It was the passengers in third class who, after their ship arrived at a New York City pier, went to Ellis Island for processing. By barge or ferry, these would-be immigrants made the short trip over to Ellis Island. Ellis Island became "the Island of Hope." For others, Ellis Island was "the Island of Tears." So many had come so far only to face rejection.

In fact, few were denied entrance to this country. In the peak year of 1907, 1.3 million people entered the United States through Ellis Island. From 1892 to 1954, when Ellis Island closed as an immigration center, more than 12 million immigrants to the United States were processed at the Main Building, making it by far the largest entry point in the country.

Immigration slowed dramatically during World War I, the Great Depression of the 1930s and World War II. When immigration picked up again in the 1950s, the ship was no longer the dominant mode of intercontinental transportation. Immigrants came by airplane or by automobile. Admission to the United States through Ellis Island had dwindled to a few thousand a year before the Main Building doors closed in 1954. Still, 40 percent of Americans have an ancestor who entered this country through Ellis Island.

No matter their country of origin, after 1886, new arrivals to the United States shared one similar experience as they approached the Port of New York: the Statue of Liberty greeted them. There are few symbols of American freedom more stirring than the Statue of Liberty. The statue stands 305 feet tall on Liberty Island in New York Harbor at the tip of Manhattan. For 130 years, the statue has served as a visible and revered symbol of welcome to newcomers and to those returning home.

The statue was a gift from the people of France to the people of the United States. The intent was to commemorate the 100th anniversary of the 1776 American Revolution. Structural issues in the statue and

fundraising problems on both sides of the Atlantic Ocean, however, caused a ten-year delay beyond the one hundred years. The people of France felt an affinity for Americans. They had embraced the young country in the Revolutionary War by sending ships, money, guns and the Marquis de LaFayette to help the colonists fight their common enemy, England.

France's own experience with freedom in the nineteenth century had been mixed. The 1789 French Revolution had given way to the bloodbaths of the Reign of Terror and then to the authoritarian empire of Napoleon. After Napoleon came the Restoration of the French monarchy, two further revolutions in 1830 and 1848 and then the Empire of Napoleon III. By 1871, however, France had established the democratic Third Republic. In this environment, a French historian Édouard René de Laboulaye conceived of the idea of a gift from the people of France to the people of the United States to commemorate their friendship and the French role in the American Revolution. Laboulaye was joined in his project by the French sculptor Frederic Auguste Bartholdi. Bartholdi created a statue of a woman, representing liberty, holding high a torch that symbolizes the burning flame of freedom. Liberty's left hand holds a tablet marked July 4, 1776, to signify the Declaration of Independence. On Liberty's head is a crown with seven rays for the seven continents and the seven seas.

Bartholdi made the statue his life's work. It took him over twenty years to complete it. Bartholdi himself, after traveling all around the United States, chose Bedloe Island in New York Harbor as the site for the statue. The island was named for its first seventeenth-century colonial owner, Isaac Bedloe. Today, the island is called Liberty Island. To help with concerns about the statue's stability in windy New York Harbor, Bartholdi enlisted the help of Gustave Eiffel, who would, a few years later, craft the Eiffel Tower in Paris. Eiffel devised a flexible steel frame for the statue to which Bartholdi riveted sheets of copper. In the weather, the copper sheeting has turned a soft green.

Inspired by Bartholdi's vision for this gift of "liberty" to the United States, thousands of French men and women contributed to a statue-building fund. The hand and head of Liberty soon rose over the Paris rooftops. She became a familiar and cherished sight that many Frenchmen and women were reluctant to see leave. But go she would. On July 4, 1884, in a formal ceremony in Paris, the people of France presented the Statue of Liberty to the people of the United States. Like the millions

of others who came to this country in the nineteenth century, Liberty arrived by ship in New York Harbor.

For her 1885 trip, all 225 tons of her were packed into 214 boxes. The statue, however, did not immediately find a home. There was a delay due to a lack of a pedestal on which to place Liberty. The American contribution to build the pedestal had fallen short. Then, just as many ordinary French people had contributed to build the statue, thousands of Americans contributed to the pedestal. They were inspired—or rather shamed into it—by Joseph Pulitzer, publisher of the *New York World*, New York's largest-circulation newspaper. Pulitzer recognized the Statue of Liberty for the powerful symbol she would become. Pulitzer himself had immigrated to the United States from Hungary as a teenager. He fought in the Civil War and then took a job working as a newspaper reporter in St. Louis, Missouri. Soon, he owned a newspaper in St. Louis. Pulitzer left St. Louis for New York and for the newspaper with which he became most associated: the *New York World*.

Each day, Pulitzer wrote an editorial on the statue in the *New York World*. Thousands responded to his message, sending their pennies and dollars to ensure that the pedestal would be built. The pedestal was completed and the statue emplaced. On October 28, 1886, the president of the United States, Grover Cleveland, led throngs of thousands in officially welcoming the *Statue of Liberty Enlightening the World* to her home in New York Harbor. Bands played, and military ships saluted with blazing cannons. Fireworks illuminated the sky.

On a plaque on the pedestal is a poem, "The New Colossus," written in 1883 by a young woman named Emma Lazarus. Emma Lazarus found inspiration for her poem in the immigration of Jews seeking refuge from the murderous pogroms in Russia. Her own family, also Jewish, had immigrated to the United States from Portugal during colonial times. Sadly, Emma Lazarus died young, not living to see the plaque with her poem engraved on it placed on Liberty's pedestal in 1903. In the poem, donated to raise funds for the pedestal, Emma referred to the Statue of Liberty as the "Mother of Exiles." She wrote:

Give me your tired, your poor,
Your huddled masses yearning to breathe free,
The wretched refuse of your teaming shore.
Send these, the homeless, tempest-tost to me.
I lift my lamp beside the golden door.

The Statue of Liberty invoked an immediate response in the hearts of the American people. *Liberty Enlightening the World* has become one of the most endearing and recognizable American images. The statue became an important American symbol not only of liberty but also of welcome to the many who, like the statue, came to this country for refuge and a future.

YOUR GUIDE TO HISTORY

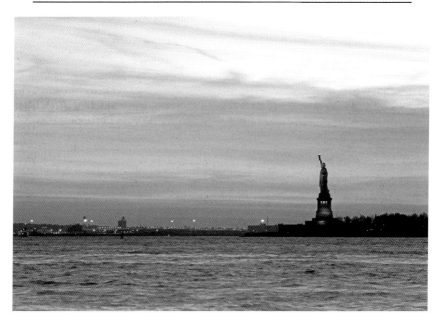

New York Harbor with the Statue of Liberty. *Courtesy of James Maher.*

Castle Clinton National Monument
In the Battery • Lower Manhattan
212-344-7220 • www.nps.gov/cacl • Free

Castle Clinton, operated by the National Park Service, offers ranger-guided tours and a small museum with displays on the history of the fort. It is also the location to purchase tickets for the ferry that departs from here to the Statue of Liberty and to Ellis Island. Once an island, landfill has joined Castle Clinton to Manhattan. Built after the Revolutionary War, as part of the fortifications for New York City in anticipation of renewed fighting with the English, the fort became Castle Clinton in 1817. It was named for DeWitt Clinton, former mayor of New York City and, later, governor of New York State. In 1823, the fort became Castle Garden. There were theaters and restaurants on the site. Castle Garden also became an official welcome site for distinguished visitors to the city. New York greeted the Marquis de Lafayette, the French hero and supporter of the American Revolutionary War, at Castle Garden on the occasion of his 1824 visit to the United States. In 1855, Castle Garden became the immigrant depot for New York. After it stopped serving in this capacity, it housed the beloved New York City Aquarium. When the aquarium moved to Coney Island in 1941, Castle Garden closed and faced the prospect of demolition. Preservationists fought to save it. It reopened as Castle Clinton in 1975. It is a National Monument.

The Statue of Liberty National Monument
Lower Manhattan
www.nps.gov/stli • Visit www.statuecruises.com to reserve tickets to visit the Statue of Liberty • Fee for the Cruise

Advance reservations are advisable as this is one of the most popular attractions in New York City. Departures are from the Battery near Castle Clinton. There are three approaches to touring the statue: grounds only, the pedestal and the crown. Grounds-only tickets bring you onto Liberty Island for a walk around the exterior, where you may admire the statue up close and see the Emma Lazarus poem. It is possible to obtain same-day tickets for the cruise and grounds at Castle Clinton.

Pedestal tickets permit you access inside the pedestal for a visit to the museum with items of great interest related to the many immigrants who passed the Statue of Liberty on their voyage into New York Harbor. Access

to the pedestal interior is by elevator or a walk up 215 steps. Access to the crown offers an unparalleled experience that is inspiring but also strenuous, as it involves ascending 377 steps up a circular staircase. Access to the crown is best secured in advance. Cautionary notes are on the statue cruise's website. Administered by the National Park Service, the Statue of Liberty, together with Ellis Island, is a National Monument.

Ellis Island
Lower Manhattan
www.nps.gov/ellis • Fee for the Cruise

The website www.statuecruises.com provides information on the ship departures from the Battery near Castle Clinton to Ellis Island, as well as to the Statue of Liberty

As you ride the ferry to Ellis Island, imagine the experience of those who approached the island by ship over one hundred years ago. Excitement, trepidation, fear and hope mingled in the hearts and minds of many as they neared the final hurdle to making a new home in the United States. More than twelve million of our grandparents and great-grandparents passed this way.

After the ship docks at Ellis Island, the visit to the Main Building that is operated by the National Park Service is free. There is an introductory film *Island of Hope, Island of Tears*. The tour of the museum is self-guided, although there are National Park Service Rangers around to answer questions and to give specialized tours and talks. There are many individual stories told exceptionally well in this museum, which opened in 1990, thirty-six years after the last of the millions of immigrants to this country entered through these doors. To discover whether one of your ancestors came to the United States through Ellis Island, visit the American Family Immigration History Center on the first floor of the museum. It is also possible to access this information online at www.ellisisland.org. Ellis Island is named for Samuel Ellis, who owned this land in the eighteenth century. Together with the Statue of Liberty, Ellis Island is a National Monument.

Cunard Line Building
25 Broadway near Beaver Street • Lower Manhattan
Exterior Only

This is now a privately owned event space. Should you have the opportunity to enter the building, the sight will be spectacular. Open House New York, in the month of October, has included the Cunard Line Building in its tours. The lobby once housed the offices of the Cunard Steamship Lines New York. The Italian Renaissance–style architecture of this enormous building is equaled by the grandeur of the booking hall, with its sixty-five-foot-high ceiling, where tickets for the great transatlantic ocean liners were purchased. There are ceiling paintings by Ezra Winter of the sailing ships of Christopher Columbus, Leif Eriksson, John Cabot and Sir Francis Drake. The flags of the empires they helped build also adorn the ceiling. The intention was to impress and awe potential passengers with the magnificence of it all. The Cunard Building was as overwhelming as Ellis Island but in a very different way. Completed in 1921, the design is by architects Benjamin Wister Morris and Carrere & Hastings.

Hudson River Park
Battery Place to West 59th Street along the Hudson River •
Lower to Midtown Manhattan
www.hudsonriverpark.org

The Hudson River Park is 550 acres, of which more than 400 acres are actually the Hudson River itself. With the focus on water, recreational opportunities include kayaking, rowing, outrigger canoe paddling, sailing and swimming. Multiple piers once used for ocean liners are now home to water cruise ships and yachts and to the popular water taxi. Other piers house dog parks and large playing fields. The busiest bike path in the world is the Hudson River Park Bikeway, dedicated to bicyclists, rollerbladers and skateboarders. It runs the five-mile length of the park. You may use your own bicycle or rent one. The website has a long list of events and activities and their location in the Hudson River Park.

Chelsea Piers
62 Chelsea Piers at West 23rd Street • Manhattan/Chelsea
212-336-6666 • www.chelseapiers.com • Admission Fee

Today, this is a modern commercial complex of sports clubs, restaurants and amusements that forms one of the larger attractions in the Hudson River Park. Formerly, it was a large pier to dock cruise ships. It was the intended destination of the *Titanic* when it sank in 1912. Within the pier buildings are photographs of the historic Chelsea Pier on display. Walking the pier and seeing the photographs will give you an idea of the vastness and importance of the cruise ships in their golden age.

Pier 55
Pier 55 at West 13th Street • Manhattan/Meatpacking District

In a very exciting development, New York City has plans underway to build a new 2.7-acre public park on concrete poles in the Hudson River on the current site of Pier 54. Pier 55, within the Hudson River Park, will feature an amphitheater for performances and grassy slopes for relaxation. A nonprofit group will plan events and activities for the site after its anticipated completion in 2018. The park will include the historic Cunard Arch from Pier 54. A grant of $100 million from the Diller-von Furstenberg Family Foundation is the principal funding source for Pier 55. It will also receive city funding.

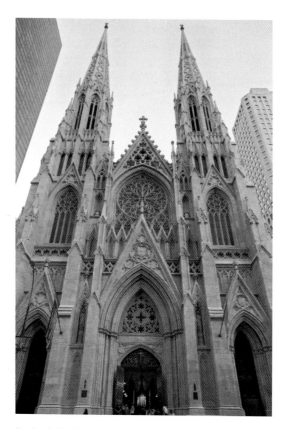

St. Patrick's Cathedral. *Courtesy of James Maher.*

THE DIMENSIONS OF DIVERSITY

SEPARATE AND TOGETHER

The newly arrived immigrant who was literally "just off the boat" and unsure how to begin life in the United States would seek out fellow countrymen for help with settling in. Communities of Irish, Germans, Italians, Chinese and Eastern European Jews developed in nineteenth-century New York City. Part of the magic of New York is not only the blend of the many cultures in the city but also their distinct preservation.

In the five years after the 1845 potato famine that killed more than two million people in Ireland, one million Irish immigrated to the United States. An additional one million came during the following twenty years. The United States represented life for these immigrants. Many settled in the port cities where they first entered this country, particularly in Boston and New York. The Irish were Catholic and working class. In nineteenth-century New York, this meant that they were subject to widespread discrimination. "No Irish permitted in this Establishment" was a common placard.

There was one notable instance where perceived discrimination turned to violence. In July 1863, in the midst of the Civil War, the Federal government attempted to enforce a law requiring all men between the ages of twenty and forty-five years to serve in the Union army. However, anyone could buy his way out of service with a $300 payment. Only the wealthy could afford such a large sum. The New York City poor, many of whom were recent Irish immigrants, protested. Angry mobs burned to the ground the Colored Orphan Asylum, churches and the homes of abolitionists. It took Federal troops returning from the Gettysburg battlefield to quell the violence that

took 120 lives and injured thousands. To this day, the New York City Draft Riots of 1863 remain the largest civil disturbance with the most fatalities in American history.

To counter harsh treatment, the Irish turned to the Catholic Church. There is a beautiful and enduring reminder of the Irish presence in and contribution to New York: St. Patrick's Cathedral. Saint Patrick, who brought Christianity to fifth-century Ireland, becoming its patron saint, was special to Irish immigrants in New York. Like them, Saint Patrick, born in England, left his homeland to make a life in a new land.

Until the mid-nineteenth century, New York had been a majority Protestant town. Irish immigration changed that. By 1858, when the Right Reverend John Hughes, the first Catholic archbishop of New York, laid the cornerstone for St. Patrick's Cathedral on 5th Avenue, Catholics were the largest single religious denomination in the city. His successor as archbishop of New York, John McCloskey, would become the first American cardinal in 1875.

The architect for St. Patrick's Cathedral was James Renwick Jr. Renwick designed the magnificent granite and white marble twin-spired Gothic cathedral. The cathedral occupied an entire city block at 5th Avenue and East 50th Street in what was then a little developed area of New York. The exterior is reminiscent of the renowned cathedral in Cologne, Germany, while the interior elements recall the great French cathedrals of Rouen and Amiens, as well as London's Westminster Abbey. Many of its windows were manufactured in Chartres, France, home of a cathedral known for its beautiful stained glass. In one window, designed by James Renwick, there is the image of Saint Patrick with Renwick and Archbishop Hughes. The bronze doors at the main entrance, added later, weigh twenty thousand pounds and bear figures that depict the New York saints.

Completed in 1878, the cathedral was dedicated on May 25, 1879. It would take another nine years to complete the spires. Rising 330 feet above the pavement, the spires could be seen at great distances throughout the New York City of the late nineteenth century. Though today dwarfed by neighboring skyscrapers, the cathedral remains an inspirational sight. Seating approximately 2,400 people, St. Patrick's is the largest Catholic cathedral in the United States. Each year on March 17, the annual St. Patrick's Day Parade marches by St. Patrick's Cathedral. While St. Patrick's Day is a national holiday in Ireland, the parades—first held in New York City—and the green beer are an American contribution to the annual celebration.

In addition to St. Patrick's Day, the Irish brought another tradition to the United States: Halloween. Although the origins of Halloween are somewhat murky, the date is on the eve of All Saints' or All Hallows' Day, November 1. It coincides with the Gaelic pagan holiday Samhain, which was celebrated at the end of the harvest season when the days darken early and the souls of the dead are all about. Brave citizens went door to door to beg for food. They were disguised so the spirits would not recognize them. Halloween parties began in the United States in the late nineteenth century while trick-or-treating became popular in the 1930s. Today, the largest Halloween parade in the world is in New York City.

Others besides the Irish came to New York. In 1848, a revolution in Germany, followed by continuing political uncertainty, convinced many Germans to come to the United States. Initially, Germans settled in the Lower East Side; part of this area became known as Kleindeutschland, or Little Germany. Other German immigrants found to their liking the Upper East Side of New York, east of Lexington Avenue between 83rd and 88th Streets, an area called Yorkville. Germans have since mostly scattered throughout New York City. A reminder of their presence is Carl Schurz Park overlooking the East River. It is named for the German immigrant who became a Union general during the Civil War and then a United States senator from Missouri. As secretary of the interior from 1877 to 1881 in the administration of President Rutherford B. Hayes, Schurz was a strong advocate for the federal preservation of forests. Carl Schurz spent his final years living in New York City.

Little Italy, in the area of Mulberry, Hester and Grand Streets, is now more Chinese than Italian. However, each September, large numbers of Italian Americans return to Mulberry Street to celebrate the Feast of San Gennaro in honor of the patron saint of Naples, Italy. Naples sent many of its sons and daughters to New York City. And Italians have left an indelible mark on New York.

More than 200,000 Chinese came to the United States from 1860 to 1880. The vast majority of Chinese immigrants were men who worked on the transcontinental railroad. As that work wound down, many Chinese moved from the West of the United States to New York City. The first restrictive immigration legislation in the United States was directed at the Chinese. In 1882, Congress passed the Chinese Exclusion Act, which not only barred Chinese from entering the United States but also denied citizenship to those already here. Chinese men were not permitted to bring their wives to the United States. With no family life, the men frequented the many

modest restaurants that would help sustain them. In New York City, the Chinese settled in the area around Mott and Pell Streets, later expanding to Canal and Bayard Streets. Chinatown flourishes today with many shops, restaurants and food stores. New York City has the largest community of people of Chinese origin in the Western Hemisphere.

Orchard Street was at the heart of the nineteenth-century Jewish Lower East Side. The area around Orchard, Grand, Delancey, Broome and Eldridge Streets contained kosher food shops and synagogues for the newly arrived Jewish immigrants who settled, worked and lived here. Between 1880 and 1925, two and a half million Eastern European Jews came to the United States. Approximately 85 percent of them settled in New York City, and most of those chose the Lower East Side for their new home. This was the most crowded neighborhood in the world.

By the beginning of the twentieth century, the Jewish population in New York City was greater than in any other city anywhere. It was around this time that a Jewish immigrant, Israel Zangwill, wrote a play, *The Melting Pot*, which played on Broadway for over two years. It celebrated the blending together of the many into one great New York City. While many of the former Lower East Side Jewish residents have dispersed throughout New York, there is a serious effort in the neighborhood to preserve the synagogues and acknowledge the contributions to the city and to the United States of those who once lived here.

Another popular area for Jews to settle in New York was in Harlem. Harlem, however, became much better known for becoming a center of African American community and culture in the city.

Harlem, the area of New York City north of 96th Street stretching up to the northern handle of Washington Heights, began as an early Dutch colonial farming settlement. A group came here in 1658 to farm, building the small village of Nieuw Haarlem, named for the city of Haarlem in the Netherlands. Haarlem, or Harlem, became an area of grand homes and large, productive farms, providing food to the larger town of New Amsterdam just ten miles away. By the early nineteenth century, however, farming had depleted the soil. As a result, most of the farmers left.

A Harlem rebirth occurred after 1837, when a railroad line opened between City Hall and the Harlem River. This cut travel time significantly, revitalizing the area. Even more instrumental in the renewed settlement of Harlem was the construction of elevated railroad lines, or "Els," along 2nd and 3rd Avenues in 1870. Then, in 1904, the Lenox Avenue Subway opened at 145th Street. Harlem became completely developed as a transportation-inspired building boom led to the construction of middle- and upper-

middle-class housing. Elegant homes and luxury apartment buildings made Harlem a desirable address. Many nineteenth-century immigrants, especially the Irish, Germans and Jews who prospered in Manhattan, bought property in Harlem.

The bubble burst early in the twentieth century as over-development sharply drove down prices. This decline coincided with the great migration of African Americans from the South to northern cities in the years before World War I. And from 1906 to 1910, the construction of the Pennsylvania Rail Road Station in the area of New York City known as "the Tenderloin" disrupted the African American neighborhood that ran along Broadway from 23rd to 42nd Street. Police captain Alexander "Clubber" Williams had given the Tenderloin its name. Williams made so much money taking bribes in exchange for protection in this section of New York City that he boasted he could afford tenderloin steak for dinner every night.

Blacks were able to find housing in Harlem thanks to an African American businessman named Philip Payton, who founded the Afro-American Realty Company in 1904. Taking advantage of the depressed housing market in Harlem, he convinced white owners to rent homes in the area to blacks. This opened up an attractive neighborhood previously closed to African Americans. Many took advantage of this relaxation in discriminatory practices. By 1920, 200,000 African Americans lived in Harlem. Some Harlem neighborhoods were over 50 percent black.

Harlem became a magnet for black writers, artists and musicians in the 1920s, an era known as the Harlem Renaissance. The poet Langston Hughes, the writer Zora Neale Hurston and musicians Duke Ellington and Cab Calloway were among those who gathered here, creating literature and music with great appeal. One popular area to live was the section of Harlem known as Sugar Hill because it was "sweet and expensive." Sugar Hill is the neighborhood from 138th to 155th Streets west of 8th Avenue, now called Frederick Douglass Boulevard. Its geography along the Harlem River provides it with an attractive, elevated setting. Those who lived here included Bill "Bojangles" Robinson, Duke Ellington and Cab Calloway.

Another attractive housing area is Striver's Row. David King developed this area of Harlem in 1891. King hired prominent architects such as Stanford White, Price and Luce and James Brown to build rows of lovely homes on West 138th and 139th Streets near Frederick Douglass Boulevard. The style of these homes in the St. Nicholas Historic District, as the area is formally known due to its proximity to St. Nicholas Park, vary from Georgian to Renaissance to Victorian. Initially, these homes were restricted to "whites

only." In the 1920s, blacks began to move here. But only the most successful could afford to—in other words, those who would "strive" for success. And so the King model homes became commonly known as Striver's Row. Jazz great Eubie Blake and Congressman Adam Clayton Powell Jr., among many other notables, have made their homes on Striver's Row.

Many who came to New York found neither Sugar Hill nor Striver's Row. Dreams quickly yielded to the harsh reality of actual living conditions. There may have been visions of mansions, but a tenement was the more likely shelter. A tenement, or "tenant house," was a building that housed multiple low-income families. An apartment intended for one family might be broken up into living quarters for several families. By the mid-nineteenth century, half of New York's population lived in tenements. New York had the reputation for having the worst slums in the world.

Recognizing the deplorable living conditions in these buildings, New York tried reform. In 1879, it passed the Tenement House Law. Unfortunately, this law made matters worse. It created, based on an architectural competition, a model for all future tenement construction that became known as the "dumb bell" from the shape of the floor plan. The law dictated a space twenty-five feet wide and one hundred feet deep with apartments in the front and apartments in the back. The center of the building would be indented and contain the stairway. The intent was good: to let light into the center of the building. All bedrooms were to have access to light either through a window or this center area. But overcrowding in the tight confines of the tenements made conditions even more difficult than before. The buildings, one right next to the other, were firetraps. They became breeding grounds for tuberculosis and other deadly diseases. A typical apartment had three rooms. Bedrooms were small—seven by eight and a half feet. Often, several families occupied one apartment. Toilets were rare. If available, they were shared by several families.

The appalling living conditions for many were equaled by difficult labor conditions. In the late nineteenth century, working hours were long, wages were low and the environment was unhealthy and dangerous. Child labor was common. American workers recognized this difficult situation. Many began to organize to convince employers to make improvements. Higher wages, an eight-hour workday and better factory conditions were the goal. The first American Labor Day Parade occurred in New York City on September 5, 1882, proceeding from City Hall to Union Square. Ironically, the name Union Square has nothing to do with unions but rather with the convergence, or union, of streets in the area. The workers gathered to call

for their rights. They also wanted a national day off in honor of labor—a day that would be devoted to discussion and consideration of workers' issues.

There were ten thousand labor strikes in the United States from 1880 to 1890. One strike was particularly violent. In July 1892, workers at the Carnegie Steel Company in Homestead, Pennsylvania, protested when owner Andrew Carnegie cut wages. Carnegie's manager, Henry Clay Frick, hired guards to enforce order. An exchange of gunfire killed more than sixteen people. Frick brought in new labor and broke the union. Carnegie Steel imposed its objective of lower wages and longer hours on its employees. Then, in 1893, the worst depression of the nineteenth century hit the United States. Five successive years of drought forced farms to go under. Banks financing the farms foreclosed on unpaid loans. The banks, in turn, failed. Businesses closed. Even railroads—one of the great drivers of nineteenth-century prosperity—shut down. Unemployment skyrocketed to somewhere around 20 percent. There were more strikes and violence. In 1894, President Grover Cleveland (1885–89 and 1893–97) sent federal troops to break the strike at the Pullman Company of Illinois. The federal troops fired on the strikers. In an attempt at national reconciliation, President Cleveland signed legislation in August 1894 to set aside the first Monday after the first weekend in September for Labor Day. The holiday's intent is to recognize the contributions of the American worker to the nation and to discuss workforce rights.

But American labor wanted more than a parade. Workers continued to organize during this period. One leader was Samuel Gompers, who believed the purpose of a union was to enter into collective bargaining with management for increased wages, better hours and improved conditions. Gompers had come to this country as a boy when his parents moved here from Holland and Great Britain. The Gompers family settled in New York, where young Sam became a cigar maker. The labor environment for cigar makers was deplorable. They worked in small sweatshops, ventilation was poor, hours were unregulated and pay was ridiculously low. Cigar makers, however, had the distinctive tradition of reading to one another as they worked. This added to their education and awareness of general working conditions. And they unionized. Gompers joined Cigar Makers Union Local 144 in New York, rising through the ranks to become its president. Gompers recognized the need for unity and organization among different trades. He, therefore, founded the American Federation of Labor, or AFL, a federation of unions of mostly skilled workers, in 1886. By 1900, the AFL had a membership of half a million. Gompers would remain AFL president

until 1924. In 1955, the AFL joined with the Committee for Industrial Organization, or CIO, founded by John Lewis to become the AFL-CIO.

One incident in New York City history that demonstrated the need for labor reform stands out. On March 25, 1911, 146 people, mostly women, died in a fire at the Triangle Shirtwaist Company in New York City. Most of the young women died because they were locked into the workplace and could not escape the fire. This tragedy pointed out the need for basic safety regulations and improved conditions for American labor. Frances Perkins, an advocate for New York workers, witnessed the Triangle fire. The horror of the agonizing deaths remained with Frances Perkins when she became secretary of the Department of Labor in 1933 under President Franklin Delano Roosevelt. Perkins was the first woman ever to serve in a presidential cabinet. To this day, she remains the longest-serving secretary of labor as she stayed on the job until 1945. Francis Perkins put her experiences in New York City to good use in the federal government. She played a major role in Franklin Roosevelt's New Deal, instituting the minimum wage.

A vendor in Chinatown. *Courtesy of James Maher.*

The Tenement Museum
103 Orchard Street at Delancey Street • Manhattan/Lower East Side
877-975-3786 • www.tenement.org • Admission Fee

Purchase tickets in advance, either online or by telephone, or in person at the visitor center. The visit to the museum is by a guided tour only, which begins at the visitor center and then proceeds to the tenement building at 97 Orchard Street. The Tenement Museum tours last one to two hours. Each has a special focus—such as "Sweatshop Workers," which includes a visit to the home where the Levine family had a garment workshop, or "Hard Times," which involves a visit to the homes of the Gumpertz and Baldizzi families. Descriptions are on the museum website. In addition to the building tours, there are neighborhood walking tours. The Tenement Museum and the walking tours are mostly recommended for ages eight years and above. One tour is designed specifically for young children. There are also food tours that include a sampling of Lower East Side specialties.

The Lower East Side Tenement Museum is housed in a real tenement built in 1864. For seventy years, this building was home to countless numbers of immigrant families who struggled to make ends meet in New York City's Lower East Side. Stricter housing codes resulted in the tenement closing in 1935. While there were shops on the lower level, the upper-floor apartments were boarded up. The entry hall of the tenement is basically in the condition in which it was found in the 1980s. The museum also offers visits to restored apartments with a re-creation of the lives of those who lived there in late nineteenth- and early twentieth-century New York. Some tours include reenactors.

The story of each family who lived here at 97 Orchard Street is compelling. Widow Julia Langolar supported herself and her two children by taking in laundry. Nathalia Grumpertz worked as a dressmaker after her husband walked out on her and their four children. This was their world. The museum has made an impressive and successful effort to reach out to the descendants of those who lived at 97 Orchard Street to enrich further the history conveyed here. The museum shop hosts Tenement Talks, which focus on New York City. The museum offers extensive educational outreach for students. It is a National Historic Site.

St. James Roman Catholic Church
132 James Street at Madison Street • Lower Manhattan
212-233-0161 • Donation

Dedicated in 1836 for its Irish parish, a plaque on its exterior commemorates the founding of the Ancient Order of Hibernians (AOH) at St. James Church in 1836. The AOH worked to combat violence and discrimination against the Irish in New York and to help Irish immigrants find work and housing. Ireland in Latin is *Hibernia*. St. James was the parish church of Al Smith, who went on to become governor of New York and, in 1928, the first Catholic to run for president of the United States. St. James remains an active parish church with Sunday services.

Old St. Patrick's Cathedral
263 Mulberry Street, New York • Manhattan/Little Italy
www.oldcathedral.org • Donation

This is the second Catholic church in Manhattan, dating to 1815. It would become the first cathedral church for the Diocese of New York. Pope Pius IV created the Archdiocese of New York in 1850, elevating John Hughes to archbishop. John Cardinal McCloskey became the first American cardinal in 1875. The new St. Patrick's Cathedral on 5th Avenue replaced Old St. Patrick's as seat of the Archdiocese of New York in May 1879.

Five Points
Columbus Park, 67 Mulberry Street • Manhattan/Little Italy
www.nycgovparks.org/parks/columbus-park • Free

The geography of Five Points no longer exists in Lower Manhattan. In the early to mid-nineteenth century, it was an area of five points formed by streets that intersected here: Mulberry, Anthony (now Worth), Cross (now Mosco), Orange (now Baxter) and Little Water Street (no longer exists). Where once a pond had existed, landfill, though poorly executed, permitted settlement by middle-class families who then fled the area in the 1820s. Five Points became home to the poorest of the Irish immigrants and to newly emancipated African Americans. Poverty led to disease, infant mortality and also to vice and gangs in one of the worst slums in the world. In

1834 and 1835, anti-immigrant, anti-Irish gangs attacked the Five Points neighborhood. Irish gangs responded in kind, leading to major violent street brawls that further darkened the reputation of this area.

In the late nineteenth century, reformers, fueled by the photographs by Jacob Riis of the misery of Five Points, demolished most of the buildings in the area and reconfigured it to "eliminate" the problems. Part of the Five Points area is now the civic center with its massive city, state and federal buildings. Columbus Park, originally designed by Calvert Vaux, opened in 1897. In 1911, it was named Columbus Park in honor of Christopher Columbus. The park is near Little Italy and Chinatown.

The Village Halloween Parade
Manhattan/Greenwich Village
www.halloween-nyc.com

This nighttime parade occurs on Halloween each October 31. The parade route is through Greenwich Village on 6th Avenue from Spring Street to 16th Street. Hundreds of giant puppets join bands, dancers and fifty thousand New Yorkers in their own costumes. Of course, this is New York, so those costumes tend to be pretty spectacular. This parade is an artistic delight offering sheer enjoyment for both participant and viewer.

St. Patrick's Cathedral
5th Avenue at 50th Street • Manhattan/Midtown
212-753-2261 • www.saintpatrickscathedral.org • Donation

Please remember when you visit that this is a place of worship and that it is important to dress and behave respectfully. By the mid-nineteenth century, the Archdiocese of New York saw the need for a larger, grander cathedral than the original St. Patrick's in New York, now known as Old St. Patrick's Cathedral. The church selected a site at 5th Avenue and 50th Streets, then in a little-developed area of New York. The cornerstone was laid on August 15, 1858. The cathedral was blessed and opened on May 25, 1879. The height of the spires is 330 feet. The beautiful Rose Window is 28 feet in diameter. This is the largest Catholic cathedral in the United States. It is a National Historic Landmark.

St. Patrick's Day Parade
www.nycstpatricksparade.org

The New York City Saint Patrick's Day Parade is the oldest and largest in the nation. The first parade was on March 17, 1762, in Lower Manhattan. Today, it occurs each March 17 except when that date falls on a Sunday; then it takes place on March 16. The parade begins at 44th Street on 5th Avenue, marches past St. Patrick's Cathedral and continues up 5th to 79th Street, where it ends at the Irish Historical Society. As many as 300,000 people have marched in a single parade and enjoyed its jubilation, floats and the wearing of the green. The Ancient Order of the Hibernians has sponsored the parade since the nineteenth century. The Archbishop of New York reviews the parade from the steps of St. Patrick's Cathedral. To serve as the parade's grand marshal is a great honor.

The American Irish Historical Society
991 5th Avenue at East 79th Street • Manhattan/Upper East Side
212-288-2263 • www.aihs.org • Admission Fee

In this lovely five-story town house, situated across the street from the Metropolitan Museum of Art, is the headquarters of the American Irish Historical Society. Founded in 1897 at a time when Irish Americans were making great strides economically and socially and yet still faced widespread discrimination, the society seeks to educate the public about the accomplishments of Irish Americans. There is an impressive library of ten thousand volumes on both Irish and Irish American history. The society sponsors frequent musical performances and lectures.

Italian American Museum
155 Mulberry Street at Grand Street • Manhattan/Little Italy
212-965-9000 • www.italianamericanmuseum.org • Free

The museum, founded in 2001, has as its mission to exhibit and interpret memorabilia and artifacts that explain both the achievements and the struggles of Italian Americans in this country. There is a special focus on Italian immigrants and their difficulties and successes in establishing themselves in the United States. The setting of the museum is appropriate.

It is the former Banca Stabile, founded in 1885, which offered newly arrived Italians banking, the telegraph and a post office to help them survive on the streets of New York while maintaining their ties to the homeland. The corner of Mulberry and Grand Streets was in the very heart of Little Italy. The museum has rotating exhibits highlighting the Italian American experience.

FEAST OF SAN GENNARO

Church of the Most Precious Blood, 109 Mulberry Street • Manhattan/Little Italy
212-226-6427 • www.sangennaro.org • www.gonyc.about.com

This festival, occurring in Little Italy in mid-September each year, honors the patron saint of Naples, San Gennaro, who was a martyr for the faith. The city of Naples in southern Italy sent many of its sons and daughters to New York City in the late nineteenth century. The festival is both secular and religious. There is abundant and very good food, a cannoli-eating contest, music and a parade with floats. There is also a religious procession and celebratory Mass at the Church of the Most Precious Blood, founded in 1891.

THE ITALIAN CULTURAL INSTITUTE

686 Park Avenue between 68th and 69th Streets • Manhattan/Upper East Side
212-879-4242 • www.iicnewyork.esteri.it

The institute provides a busy calendar of events, including musical performances and art exhibits to educate the public on the history and culture of Italy. It is located in the remarkable Georgian-style house designed by Delano & Aldrich in 1919.

THE GERMAN AMERICAN STEUBEN PARADE OF NEW YORK

5th Avenue from 68th to 86th Streets • Manhattan/Upper East Side
347-454-2269 • www.germanparadenyc.com

German culture and heritage are celebrated in one of the largest German American parades in the United States. Floats and marching bands with many participants in traditional German dress take to 5th Avenue, marching from East 68th to 86th Streets each September. The grandstand is at East

79th Street. Immediately after the parade, there is an Oktoberfest in Central Park. Some of the events associated with the parade and grandstand seating require a ticket.

Baron Friedrich von Steuben is well known to students of the American Revolution as the soldier who came to this country from Prussia to serve under General George Washington. At Valley Forge in 1778, von Steuben instilled into a ragtag group of soldiers a sense of discipline and purpose that they carried throughout the war to victory against the British. After the Revolutionary War, Friedrich von Steuben remained in the United States, dying in New York in 1794.

CARL SCHURZ PARK

East 84th Street to 86th Street at East End Avenue • Manhattan/Yorkville
www.carlschurzparknyc.etapwss.com

This fifteen-acre park dating to 1876 runs along the East River. It is in the area known as Yorkville that was once home to many German immigrants. Calvert Vaux and Samuel Parsons redesigned the landscape features early in the twentieth century. In 1910, German Americans realized their objective of having the park named in honor of Carl Schurz, a German immigrant who, during the Civil War, served as a United States ambassador to Spain and as a general in the Union army. After the Civil War, Schurz was the first German American elected to the United States Senate, where he represented Missouri.

Carl Schurz served as secretary of the interior in the cabinet of President Rutherford B. Hayes. In this position, Schurz was a strong advocate of the federal park system. After 1881, Carl Schurz moved to New York City, where he held a variety of jobs until he died there in 1906. His wife, Margarethe Schurz, also originally from Germany, was an educator who helped found the kindergarten system in this country. *Kinder* is "child" and *garten* is "garden" in the German language.

MUSEUM OF JEWISH HERITAGE

36 Battery Place • Lower Manhattan
646-437-4202 • www.mjhnyc.org • Admission Fee

The museum remembers those who died in the Holocaust through exhibits of personal items, photographs and letters. It also celebrates those who

survived and the vibrancy of Jewish life today. This museum has the Garden of Stones for reflection and the Keeping History Center for magnificent views of New York Harbor. There are also rotating exhibits, lectures and musical performances.

THE LOWER EAST SIDE JEWISH CONSERVANCY
Manhattan/Lower East Side
212-374-4100 • www.nycjewishtours.org • Admission Fee

This nonprofit organization offers public programs and tours of the Lower East Side that focus on the history of the Jewish community in this area and on the synagogues that served it.

MUSEUM AT ELDRIDGE STREET
12 Eldridge Street between Canal and Division Streets • Manhattan/Lower East Side
212-219-0888 • www.eldridgestreet.org • Admission Fee

The museum is housed in a synagogue built in 1887 for the Orthodox Jews who fled persecution in Eastern Europe for the asylum of the United States. The prominent and repeated display of the Jewish Star of David on the exterior of the synagogue building was a joyful expression of freedom of religion in their new homeland. In Eastern Europe, most often Jews had to worship discretely and without public display. Otherwise, they risked intolerance and even death. The docent may point out that the stars used to decorate the interior of the synagogue are not the six-sided Star of David but the five-sided American star reflecting the patriotism of these new immigrants to the United States. The architects of the Eldridge Street Synagogue were the Herter brothers, Catholic immigrants to the United States from Germany.

Synagogue members moved out of the Lower East Side in the mid-twentieth century, and the synagogue closed its doors as a place of religious worship. A major restoration, completed in 2007, repaired the beautiful Moorish interior and façade. There is also a large, striking, modern stained-glass window by Kiki Smith. Today, the synagogue remains active as home to a small Orthodox congregation. The collection in the small synagogue museum includes displays on the synagogue and religious objects. The museum offers guided synagogue tours and talks. On a Sunday each June,

the museum organizes an "Egg Rolls, Egg Creams, Empanadas Festival" to celebrate the diversity of the Jewish, Chinese and Puerto Rican neighborhood community. The building is a National Historic Landmark.

CONGREGATION SHEARITH ISRAEL
2 West 70th Street at Central Park West • Manhattan/Upper West Side
212-873-0300 • www.shearithisrael.org • Donation

The congregation offers tours the second Tuesday of every month of the beautiful Neoclassical synagogue by architect Arnold Brunner that dates to 1897. Of particular interest are the glass windows created by Louis Comfort Tiffany and religious ritual objects that date to the colonial period. This is the oldest Jewish congregation in North America, dating to 1654, when the first Jewish settlers arrived in New York from Portugal and Brazil. From 1654 to 1825, this was the only Jewish congregation in New York City. With the immigration of many Jews from Eastern Europe fleeing the pogroms of the late nineteenth and early twentieth centuries, other congregations were founded. Members of Congregation Shearith Israel were very active in assisting the newly arrived Jewish population to settle in, find employment and establish community.

THE JEWISH MUSEUM
1109 5th Avenue at 92nd Street • Manhattan/Upper East Side
212-423-3200 • www.thejewishmuseum.org • Admission Fee

Cass Gilbert designed this magnificent French chateau, completed in 1908, for the financier Felix M. Warburg. Since 1947, the former Warburg residence has housed the Jewish Museum, with its significant collection exploring Jewish culture and identity through works of art. The museum offers talks and special programs.

Chinatown

*South of Broome Street, north of Chambers Street, west of East Broadway
and east of Broadway*
www.explorechinatown.com

The largest population of Chinese in the Western Hemisphere lives in New York City. While there are a number of Chinese American neighborhoods in the city, the one that gets the most attention is in Lower Manhattan—100,000 strong. The streets of Chinatown with the residents, shops, restaurants and signage in the Chinese language transport visitors to another land.

Museum of Chinese in America

215 Centre Street between Grand and Howard Streets • Manhattan/Chinatown
212-619-4785 • www.mocanyc.org • Admission Fee

Within a Single Step: Stories in the Making of America is the core permanent exhibit of the Museum of Chinese in American (MOCA). It encapsulates the mission of this small museum: to help visitors understand the Chinese American experience in New York and the country as a whole, as well as to appreciate what Chinese Americans have contributed to the United States. The MOCA houses an extensive collection of artifacts, photographs and art to bring a depth of understanding of what it meant to arrive here, deal with prejudice and discrimination and to find your way in a new homeland. While MOCA began in 1980, its facility, designed by architect Maya Lin, offers a brilliant setting for the collection. The museum offers gallery talks and walking tours.

Chinese Lunar New Year Parade and Festival

Manhattan/Chinatown
www.betterchinatown.com

The Chinese New Year is based on a lunar calendar rather than on the Gregorian calendar in use in the United States and throughout the world. Therefore, the actual date of the celebration in January or February varies each year. The festival consists of a Firecracker Ceremony to ward off evil spirits and a parade that winds its way through Chinatown. It begins at Canal and Mott Streets and ends at Sara D. Roosevelt Park. This popular

parade is highly colorful with brilliantly adorned floats and dancers. The most anticipated are those costumed as lions and dragons.

The Asia Society
725 Park Avenue at 70th Street • Manhattan/Upper East Side
212-288-6400 • www.asiasociety.org/newyork • Admission Fee

The mission of the Asia Society is to educate the general public regarding Asia and the United States' relations with Asia. The Asia Society also has permanent and rotating exhibits on traditional and contemporary Asian art. Particularly noteworthy is its collection of art from Mr. and Mrs. John D. Rockefeller 3rd.

Ukrainian Museum
222 East 6th Street • Manhattan/East Village
212-228-0110 • www.ukrainianmuseum.org • Admission Fee

Ukrainian American architect George Sawicki designed this building, which opened in 2005. The museum has existed since it was founded in 1976 by the Ukrainian National Women's League of America. It has extensive educational outreach and programming and an impressive collection of Ukrainian folk art and costumes. In addition, the museum houses an archive of documents from Ukrainian immigration into the United States.

Ukrainian Institute of America
2 East 79th Street at 5th Avenue • Manhattan/Upper East Side
212-288-8660 • www.ukrainianinstitute.org • Admission Fee

This beautiful building is the design of Cass Gilbert. It dates to 1899. It was built as the home of industrialist Isaac Fletcher. After Fletcher died in 1917, the founder of Sinclair Oil, Harry F. Sinclair, bought the house and lived here until 1930. The Ukrainian Institute of America has owned the magnificent French Gothic–style mansion, a National Historic Landmark, since 1955.

St. Nicholas Russian Orthodox Cathedral
15 East 97th Street at 5th Avenue • Manhattan/Upper East Side
212-289-1915 • www.mospatusa.com • Donation

Czar Nicholas II of Russia donated the first contribution to make this cathedral, designed by John Bergesen, a reality. Church officials laid the cornerstone in 1901. This is the leading center of Russian Orthodoxy in the United States. The exterior onion domes and the breathtaking Baroque interior with red, blue and yellow tiles offer a glimpse of Russia in Manhattan. For those considering attending a service, there are no pews as the Orthodox stand during the lengthy services. Services are in English and Russian. Guided tours are by appointment.

The Americas Society
680 Park Avenue between 68th and 69th Streets • Manhattan/Upper East Side
212-249-8950 • www.as-coa.org

This building was originally a home constructed in 1909 for New York banker Percy Rivington Pyne. It was designed by the famed architectural team of McKim, Mead & White. The Americas Society—through its public programs, musical events and art exhibits—seeks to inform the public of the culture of Latin America, the Caribbean and Canada.

El Museo del Barrio
1230 5th Avenue at 104th Street • Manhattan/Upper East Side
212-831-7271 • www.elmuseo.org

The museum's mission is to present and promote understanding of the culture and art of Puerto Rico and all of Latin America. With its one floor of galleries of modern and contemporary art, traditional and folk art, as well as pre-Columbian artifacts, it takes seriously its work of educational outreach.

Hispanic Society of America
613 West 155th Street • Manhattan/Washington Heights
212-926-2234 • www.hispanicsociety.org • Free

The Hispanic Society, founded in 1904, has been housed in the lovely Beaux-Arts building on Audubon Terrace since 1908. The mission of the society is to further the study of the arts and culture of Spain, Portugal and Latin America. It has an extensive collection of Spanish paintings, as well as decorative arts and sculpture. There is an important research library as well. It is a National Historic Landmark.

Scandinavia House
58 Park Avenue at 38th Street • Manhattan/Midtown
212-779-3587 • www.scandanaviahouse.org • Admission Fee

This is the leading center for Nordic culture in the United States, focusing on the arts, music, literature and films of Denmark, Finland, Iceland, Norway and Sweden. National institutions in these nations often lend works of art for exhibit in Scandinavia House. There are regular concerts and also activities for children. Ennead Architects designed the striking modern building, completed in 2000.

Events12.com

This website is a good reference tool for festivals and festivities in New York City that occur throughout the calendar year.

Schomburg Center for Research in Black Culture
515 Malcolm X Boulevard • Manhattan/Harlem
917-275-6975 • www.nypl.org • Free

The Schomburg Center, a branch of the New York Public Library, is named for Puerto Rican–born black scholar Arturo Alfonso Schomburg, who began the collection. It is the world's largest holding of documents, photos and records of Afro-American culture. This research library also sponsors talks and exhibits, musical performances and films for the public and offers free tours.

The Studio Museum in Harlem
144 West 125th Street at Adam Clayton Powell Jr. Boulevard • Manhattan/Harlem
212-864-4500 • www.studiomuseum.org • Admission Fee

Entry to this museum, with its rotating exhibits, is free on Sundays in order to share with the community the work of artists of African descent. Founded in 1968, the museum's holdings include paintings and objects from the nineteenth century to the current day. Jacob Lawrence and Romare Bearden are among the talent represented in the collection. Another important holding is the photography of Harlem from 1906 to 1983 by James

VanDerZee. The "studio" in the name of the museum refers to the fact that it supports the ongoing work of artists in this attractive building, a former bank renovated by architect J. Max Bond Jr.

The Hotel Teresa
2082–96 Adam Clayton Powell Jr. Boulevard • Manhattan/Harlem
Exterior Only

German immigrant Gustavus Sidenberg named the hotel for his late wife, Teresa. The hotel opened 1913, serving primarily as a long-stay establishment with some overnight guests. Although, initially, the Teresa had a whites-only policy, it integrated in the 1940s and '50s and became known as the Harlem Waldorf. Many black celebrities stayed here and socialized at its famous bar and grill. The thirteen-story building, with its terra-cotta exterior ornamentation and large bay windows, is the work of the architectural firm of George and Edward Blum. Fortunately, the renovation to convert it to an office building, the Teresa Towers, in 1970 left the exterior in place.

The Apollo Theater
253 West 125th Street at Adam Clayton Powell Jr. Boulevard • Manhattan/Harlem
212-531-5305 • www.apollotheater.org • Admission Fee

This theater specializes in live acts and musical performances of a wide variety. Architect George Keister designed this large theater, which can hold an audience as large as 1,500 people. When it opened in 1914 as a venue for burlesque, it had a whites-only policy. It was not until it closed and then reopened in 1934 as the Apollo that it catered to black clientele, becoming the heartbeat of top black talent during the Harlem Renaissance. The list of talent that played here is staggering: Duke Ellington, Dizzie Gillespie, Count Basie, Mahalia Jackson, Ray Charles, Aretha Franklin and many others. The Apollo Theater became famous for discovering black talent who performed on amateur night. Jimi Hendrix was one of the amateurs who went on to fame and fortune. The Apollo Theater is located on 125th Street, the heart of Harlem. The Apollo Theater Foundation now owns the theater. It is on the National Register of Historic Places.

The Metropolitan Baptist Church
151 West 128th Street at Adam Clayton Powell Jr. Boulevard • Manhattan/Harlem
212-663-8990 • www.mbcharlem.org • Donation

The Romanesque and Gothic Revival building is the work of a series of architects over the years. The foundation of the church is two earlier churches that decided to combine and create an entirely new name. This was one of the earliest African American churches in Harlem and certainly one of the most important. It is on the National Register of Historic Places.

Striver's Row
West 138th and 139th Streets between Adam Clayton Powell Jr. and
Frederick Douglass Boulevards • Manhattan/Harlem
Exterior Only

The formal name for this area is the St. Nicholas Historic District. It's informal name, Striver's Row, derives from the expression that one had to strive to be able to afford one of the beautiful town homes here. The Georgian Revival–style red brick and brownstone homes on West 138th Street were the work of architect James Brown Lord. Bruce Price and Clarence Luce designed the yellow brick and white limestone buildings on West 138th and 139th Streets, while Stanford White of McKim, Mead & White was the architect for the Italian Renaissance brick and brownstone buildings on West 139th Street. Musician Eubie Blake, Congressman Adam Clayton Powell and composer W.C. Handy were among the many notables who have lived on Striver's Row. It is on the National Register of Historic Places.

The Abyssinian Baptist Church
132 Odell Clark Place (formerly West 138th Street) • Manhattan/Harlem
212-862-7474 • www.abyssinian.org • Donation

There is a special tourist entry door on the southeast corner of West 138th Street and Adam Clayton Powell Jr. Boulevard. The church welcomes visitors to the 11:00 a.m. Sunday service except on significant religious holidays and some church special event days. This is a working church. Visitors should dress and act with respect and not go in and out of the sanctuary during a service. Note that the service lasts two and a half hours. Founded in 1808,

this is the third-oldest Baptist Church in the United States. The church was initially located in Lower Manhattan. Sixteen worshippers who refused to accept the segregated seating policies then in effect in the First Baptist Church of New York founded this church. Abyssinia is an ancient name for Ethiopia. As African Americans moved north in New York City, the church followed. It built this large and lovely Gothic and Tudor building with extensive stained-glass windows on its current site in Harlem. Dedication of the church occurred in 1923. The church has long been active and influential in social justice issues. Adam Clayton Powell Jr. was pastor here before his election to the United States Congress representing this district.

HARLEM WEEK
877-427-5364 • www.harlemweek.com

Harlem Week is actually much more than a week. It is a series of events throughout the months of July and August each summer that celebrate the past and future of Harlem and all it has to offer. Outdoor concerts, the Charlie Parker Jazz Festival and sporting events keep the activities varied and popular with all ages. Activities occur throughout the neighborhood.

THE TRIANGLE SHIRTWAIST FACTORY
23–29 Washington Place at Greene Street • Manhattan/Greenwich Village
Exterior Only

The March 25, 1911 Triangle Shirtwaist Company fire that killed 146 garment workers, mostly women, occurred in the building at 23–29 Washington Place. Most of the young women died because they were locked into the workplace and could not escape the fire. This tragedy pointed out the need for basic safety regulations and improved conditions for American labor in the workplace. There are two bronze plaques on the building to remember the terrible event and the lives lost. New York University now owns the building, which is a National Historic Landmark.

The Museum at FIT

7th Avenue at 27th Street • Manhattan/Chelsea
212-217-4558 • www.fitnyc.edu • Free

Although the garment industry has left, New York City remains the fashion industry capital of the United States. FIT has three galleries of rotating exhibits. The Fashion and Textile History Gallery displays articles of historic importance from the last 250 years. The Fashion Institute of Technology is part of the State University of New York. It grants degrees in art and technology connected to fashion.

The Garment Worker Statue

555 7th Avenue between 39th and 40th Streets • Manhattan/Garment District

This eight-foot bronze sculpture by Judith Weller of a Jewish garment worker at his sewing machine dates to 1984. The artist and the Ladies Garment Workers Union presented the statue to the city as a gift to remember those who toiled so hard here. Street signs at this location also show 7th Avenue as Fashion Avenue. This was the heart of the New York garment district that produced most of the ready-to-wear clothing worn by Americans for over 150 years, from the early nineteenth century to the late twentieth century. The Garment District in Midtown Manhattan is the neighborhood from West 34th to West 42nd Street between 5th and 9th Avenues. The manufacture of less-expensive clothing has left Manhattan and moved overseas. The once busy factories in the area with their racks and racks of clothing are more and more becoming condominiums and office buildings.

Labor Day Parade

www.nycclc.org

No longer as large or celebratory as it once was, the Labor Day Parade occurs in New York City the first or second Saturday in September with a parade route on 5th Avenue that begins at East 44th Street and continues to East 72nd Street.

City Hall Park with the Manhattan Municipal Building. *Courtesy of James Maher.*

ALL POLITICS ARE LOCAL

THE HOME OF PRESIDENTS

Nineteenth-century New York was an economic force. Its extraordinary wealth and large population made it a political powerhouse as well. Many of the national political figures at the end of the nineteenth and early twentieth centuries came from New York State. In fact, in ten of the sixteen United States presidential elections between 1872 and 1932, either the Republican or Democratic candidate—or sometimes both—was a New Yorker.

During these years, three former governors of New York served as president of the United States: Grover Cleveland (1885–89 and 1893–97), Theodore Roosevelt (1901–09) and Franklin Delano Roosevelt (1933–45). Chester Arthur, previously the customs collector for the Port of New York, was elected vice president and then became president (1881–85) after the assassination of James Garfield. Only candidates from Ohio, with a record of six victories in six attempts, ran more successfully during this period than those from New York. More recently, New Yorker Nelson Rockefeller served as vice president from 1974 to 1977 under President Gerald Ford.

One president remembered as a New Yorker through and through was Theodore Roosevelt. Born in New York City in 1858, Teddy Roosevelt skyrocketed to national prominence as a Rough Rider charging up San Juan Heights, Cuba, in 1898 in the Spanish-American War. During his tenure as New York City's police commissioner and then as governor of New York (1899–1900), Roosevelt showed so much vigor in pursuing reform measures that New York politicians conspired to get rid of him. They worked to make

Teddy Roosevelt vice president of the United States, a position of little power where he could do them no harm.

Imagine their consternation when President William McKinley was assassinated on September 14, 1901, during a visit to Buffalo, New York, and Vice President Theodore Roosevelt succeeded him as president. President Theodore Roosevelt immediately undertook reforms that characterized his tenure in the White House as "the Progressive Era." More than any other individual, Teddy Roosevelt symbolized the excitement of the early twentieth century. His mediation of the end to the Russo-Japanese conflict in 1905 earned him the Nobel Peace Prize. And it was President Theodore Roosevelt who built the Panama Canal to create a shipping shortcut between the Atlantic and Pacific Oceans.

One New Yorker who did not win election to the presidency but who is remembered fondly is Al Smith. To this day, the Democratic Party holds an annual "Al Smith Dinner" in honor of the man known as "the Happy Warrior." Smith served four two-year terms as governor of New York in the 1920s. He ran for president on the Democratic ticket in 1928, the first Catholic to do so. Irving Berlin wrote "Happy Days Are Here Again" in support of Al Smith's presidential campaign. The song still plays on non-official occasions when a president enters the room. Smith himself considered the song "The Sidewalks of New York" to be his theme song.

Al Smith lost the election to Herbert Hoover, who promised voters "A chicken in every pot, a car in every garage." Hoover, taking office at the onset of the Depression, could not deliver on his pledge. He, in turn, lost the 1932 presidential election to New Yorker Franklin Delano Roosevelt, who would remain in the White House from 1933 until his death in 1945. FDR is the only American president who has won four elections to the highest office in the land. The Twenty-second Amendment to the United States Constitution, ratified in 1951, now limits presidents to two terms.

While New York sent presidents to the White House, William Marcy "Boss Tweed" and his Tammany Hall Gang made nineteenth-century New York hometown politics legendary. The famed Tammany Hall organization was originally formed in New York at the end of the eighteenth century as a counter to the political power of the wealthy landowners with their English affectations. "Tammany," a Native American name, emphasized the group's ties to America.

William Marcy "Boss" Tweed appealed to newly arrived immigrants, particularly to those who, like himself, were Irish. He offered friendship and assistance in finding housing and a job—often on the city payroll. Tweed

gave new meaning to the word "boss." Though he rose no higher in New York City electoral politics than the board of supervisors, behind the scenes, he controlled City Hall and often the New York governor's mansion through influence peddling and graft.

Tweed's size—he weighed over 240 pounds—became a symbol of excess in New York City politics. Estimates of Tweed's theft from the city coffers ran as high as $200 million. Boss Tweed and his gang nearly drove New York City into bankruptcy. Ultimately, Tweed overreached, leading to his own demise. It was the construction of the county courthouse that caused his downfall. The construction of this building, known as the "Tweed Courthouse," took twelve years (1861–72) and cost over $12 million, a vast sum in those days. Investigations of the Tweed Courthouse revealed blatant discrepancies, fraud and theft.

Cartoons of "Tweed-Le-Dee" by the well-respected political cartoonist Thomas Nast in the publication *Harper's Weekly* publicized Tweed's corruption. Nast had a large following, having become known for his iconic depiction of Santa Claus in *Harper's Weekly*, as well as his popularization of the donkey as the symbol of Democrats and the elephant as the symbol of Republicans. Nast relentlessly skewered Tweed, drawing cartoons with titles such as "Wholesale and Retail Thievery" and "The Tammany Tiger Loose—what are you going to do about it?" Tweed tried to bribe Nast to stop and even threatened him. His efforts to silence the influential cartoonist failed.

Reformer Samuel J. Tilden, head of the Democratic Party in New York after 1866 and governor of New York in 1874, spoke out, condemning Tweed. Finally, Tweed was arrested. William Marcy Tweed was tried for corruption in the very courthouse he had built and profited from so handsomely. Found guilty in 1877, he escaped overseas. However, Tweed was apprehended and returned to New York City. Boss Tweed died in a New York jail in 1878.

Tammany Hall influence in New York City politics continued. Jimmy Walker, one of the most colorful mayors in the history of the city, won election with Tammany backing. Serving as mayor from 1926 to 1932, Walker was at his best during the Roaring Twenties. He exemplified the era and enjoyed its excesses. Whether taking in the theater; enjoying the company of showgirls, despite the fact that he was married; or frequenting speakeasies during Prohibition, Walker popularized the fun-loving entertainment side of the city. But concerns about his corruption grew exponentially until New York governor and president-elect Franklin Delano Roosevelt removed Walker from office in 1932.

Fiorella LaGuardia, the son of Italian immigrants to the United States, won the 1933 mayoral election. La Guardia had worked on Ellis Island. He served as a member of the United States Congress and as an army airman in World War I. LaGuardia was mayor of New York from 1934 to 1945. He was known affectionately as the "little flower," the English translation of Fiorella. The nickname also derived from his stature—he was only five feet, two inches tall. LaGuardia would become one of the best mayors ever to run City Hall. He took on Tammany, cleaned up corruption, instituted a civil service in the city and expanded parks, the subway, public housing and airports. Interestingly, one of the strongest supporters of Republican Fiorella LaGuardia was the Democratic president of the United States, New Yorker Franklin Delano Roosevelt. LaGuardia Airport and LaGuardia High School in New York are named in honor of the "little flower."

A mayor and a city council govern the City of New York. The city council has fifty-one members, each representing a defined geographic district. The mayor and the council members are elected to four-year terms. The mayor of the City of New York today is Bill de Blasio, elected in 2013. The mayor's office is in City Hall. Mayor de Blasio and his family live at the official mayor's residence, Gracie Mansion.

New York City politics are never far from the spotlight. The mayor of the country's largest city commands national attention. Former mayors John Lindsey and Rudy Guiliani were presidential candidates, and another former mayor, Michael Bloomberg, was a prominent potential contender. Past governors of the state of New York, such as George Pataki and Mario Cuomo, have also dipped their toes into presidential politics. United States senators from the state of New York have played significant roles in the life of this country. Among the best known and most respected in recent years have been Jacob Javits, Kenneth Keating, Robert Kennedy, James Buckley, Daniel Patrick Moynihan and Hillary Clinton.

New York City is a global capital. It is the home of the United Nations. After World War I, statesmen had tried and failed to form an effective international institution for conflict resolution. Many attributed, in part, the outbreak of World War II to this earlier failure. In 1945, the United States, Great Britain, France, the Soviet Union and China led the effort to form a world body to promote peace and cooperation. Fifty-one nations signed the United Nations Charter in 1945. Today, 193 countries belong to the UN.

Meeting in London, England, in 1945, the United Nations General Assembly selected New York City to be the permanent host of the UN headquarters. This decision was facilitated by millionaire John D. Rockefeller

Jr., who donated funds to purchase eighteen acres of land on the East River for the United Nations. This land on which the UN sits is extraterritorial. In other words, neither New York City nor the United States government has legal authority on United Nations headquarters territory.

Of the five principal bodies of the United Nations, four are located in New York City: the General Assembly, the Security Council, the Secretariat and the Economic and Social Council. Only the International Court of Justice is not in New York. It is in The Hague in the Netherlands. An international team of architects—including American Wallace Harrison, Canadian Ernest Cormier, Frenchman Le Corbusier and Brazilian Oscar Niemeyer—designed the easily recognizable headquarters complex, which includes a tower for the Secretariat and a low, rectangular-shaped building for the General Assembly.

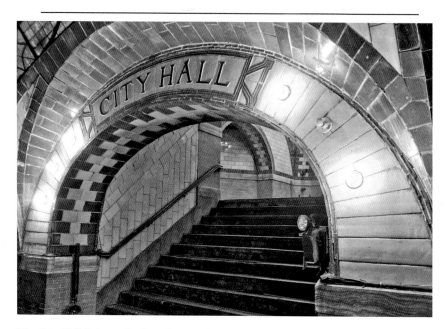

The City Hall Subway Station. *Courtesy of James Maher.*

CITY HALL
City Hall Park • Lower Manhattan
212-639-9675 • www.nyc.gov/cityhalltours • Free

The New York City Design Commission offers one-hour tours once a week to individuals and twice-weekly tours to groups. Both require advance registration on the website above. Occasionally, walk-up tours are offered on Wednesdays.

In 1812, when City Hall was built, its location on Foley Square marked the northern edge of the developed city. City Hall, therefore, faces south. At one point, the side facing north was not even finished, reflecting the belief that the city would not develop to its rear. The Neoclassical design, by Joseph-Francois Mangin and John McComb Jr., is held in high regard to this day. City Hall's masterpiece is a central rotunda whose grace, awe-inspiring height and elegant marble spiral staircase lends itself as a frequent backdrop for movies. The beautiful Governor's Room is both a reception hall and museum. Its collection of American portraiture is one of the most important in the country. The museum has the writing table that belonged to George Washington while he served as president of the United States in New York City in 1789. Two deceased presidents of the United States have lay in state in City Hall: Abraham Lincoln in 1865 and Ulysses S. Grant in 1885.

While the mayor's office is in City Hall, it is not open to the public. The city council chamber where the city council meets is open on many occasions. This room was created from three smaller spaces in 1897 in anticipation of the consolidation of Manhattan, Brooklyn, the Bronx, Queens and Staten Island into the City of New York in 1898. Beautiful ceiling murals by Taber Sears, completed in 1903, depict *The City of New York, as the Eastern Gateway of the American Continent, Receiving Tributes of the Nations*. It is a National Historic Landmark.

THE TWEED COURTHOUSE
52 Chambers Street at Broadway • Lower Manhattan
www.nyc.gov/cityhalltours • Free

To look at this white marble Italianate building today makes one think that at least New Yorkers got something for their money. Twice threatened with demolition in the twentieth century, the City of New York instead invested $85 million in an extensive renovation of the building. Formerly known as

the Old New York County Courthouse once the 1926 county courthouse on Centre Street was completed, today, 52 Chambers Street is again commonly referred to as the Tweed Courthouse. The building currently serves as office space for the city's Department of Education.

The office of the mayor offers tours of the building, with its cast-iron interior painted to look like stone and intricate buff, red and black brick Gothic arches. A large rotunda is the centerpiece of the building. The only light here comes from the skylight above. All other rooms, formerly courtrooms and now offices, radiate from the rotunda. The beautiful light fixtures in these rooms are reproductions of those that were here when Tweed was Boss and then on trial. The courthouse is the product of two architects with somewhat competing visions: John Kellum and Leopold Eidlitz. The rotunda today houses a large sculpture by American pop artist Roy Lichtenstein, which might strike some as out of place. Lichtenstein was born in Manhattan in 1923 and died in Manhattan in 1997. The building is a National Historic Landmark.

Surrogate Court Hall of Records

31 Chambers Street • Lower Manhattan
646-386-5000 • www.nycourts.gov/courts/1jd/surrogates • Free

This is the court of wills and estates for New Yorkers. This Beaux-Arts creation of white granite, completed in 1911, took twelve years to build. It is possible to enter the building to view the ornate interior central hall and stairway that is reminiscent of the Paris Opera. The building's ornamentation includes statues of distinguished New Yorkers, such as Peter Stuyvesant and DeWitt Clinton. It is a National Historic Landmark.

The Manhattan Municipal Building

1 Centre Street at Chambers Street • Lower Manhattan
Exterior Only

Originally called the Manhattan Municipal Building, this enormous structure designed by the architectural firm of McKim, Mead & White was built in 1914. It is said to have caught the fancy of Soviet dictator Josef Stalin when he viewed photographs of it, inspiring Stalinist architecture throughout the Soviet Union, including the central building at Moscow

University. In 2015, Mayor Bill de Blasio renamed the Manhattan Municipal Building in honor of former mayor David Dinkins.

THURGOOD MARSHALL UNITED STATES COURTHOUSE
40 Centre Street • Lower Manhattan
www.ca2.uscourts.gov • Exterior Only

The website offers a slide show virtual tour of the courthouse interior. Originally called the United States Courthouse, it was renamed in honor of Thurgood Marshall, United States Supreme Court justice. Marshall worked here before being nominated to the Supreme Court. This Classical Revival building, with its massive Corinthian columns, was the last building by noted architect Cass Gilbert. It opened in 1936 after his death. The thirty-seven-story federal building, which stands 590 feet tall, holds thirty-five courtrooms.

THE NEW YORK STATE SUPREME COURT BUILDING
60 Centre Street • Lower Manhattan
www.nycourts.gov

Formerly known as the New York County Courthouse, this building was completed in 1927 to replace Boss Tweed's earlier effort. Architect Guy Lowell designed the building to look like a Roman courthouse to give it gravitas. Thirty-two steps, which are one hundred feet wide, lead to sixteen granite columns at the entrance. In the interior, a seventy-five-foot-high central rotunda impresses visitors with ceiling murals painted in the 1930s by Attilio Pusteria and a team of artists supported by the Depression-era United States government Works Progress Administration.

THE NATIONAL ARTS CLUB AND SAMUEL J. TILDEN HOME
15 Gramercy Park South • Manhattan/Gramercy Park
212-475-3424 • www.nationalartsclub.org • Free

One of the outspoken opponents of Boss Tweed was Samuel J. Tilden, who was elected governor of New York State in 1874. Tilden ran on the Democratic ticket for president in 1876. He actually won the popular vote,

receiving 250,000 more votes nationwide than Rutherford B. Hayes. After ballots for Tilden in a number of southern states were thrown out, Hayes won the presidential election by the margin of one electoral vote (185 to 184). This is one of four times in this nation's history when the candidate who received the greater number of popular votes was not elected president. Samuel J. Tilden acquired 15 Gramercy South in 1863 and, a few years later, 14 Gramercy South as well. He hired noted architect Calvert Vaux to redesign the adjoined residences to serve as his home. It was outside this home in November 1876 that Tilden's well-wishers gathered to congratulate him—prematurely, it turned out—on his presidential election victory.

When Samuel J. Tilden died in 1884, he left $3 million to establish a free public library in New York City. This and funding from the Lenox family became the New York Public Library. Today, the Tilden home is the National Arts Club, a private club. The National Arts Club was founded in 1898 by author Charles DeKay, the art critic for the *New York Times*. Its mission, which continues to this day, is to promote public interest in and knowledge of the fine arts. The beautiful interiors of the home are open to the public on a limited schedule for exhibitions of its collections, lectures and musical performances. The schedule is on the website. It is a National Historic Landmark.

THE THEODORE ROOSEVELT BIRTHPLACE NATIONAL HISTORIC SITE

28 East 20th Street between Park Avenue South and Broadway • Manhattan/Gramercy
212-260-1616 • www.nps.gov/thrb • Free

National Park Service Rangers give guided tours of the period rooms. Many of the furnishings are original. This is a reconstruction of the home where Theodore Roosevelt Jr., president of the United States (1901–09), was born in 1858 and lived until his teenage years. Though he was sickly as a boy, his was a happy childhood with a loving mother and father. His father, Theodore Roosevelt Sr., was a leading citizen of New York involved in many city public improvement projects. The original home was demolished in 1916, causing immediate regret in New York City. In 1919, Theodate Pope Riddle, one of the first female American architects, was selected to build the precise replica of the original home that occupies the site today. It is a National Historic Site.

The United Nations
1st Avenue at 46th Street • Manhattan/Midtown
212-963-8687 • www.visit.un.org • Admission Fee

Tours are guided. They last sixty minutes and give a good overview of the history and mission of the United Nations. It is important to make reservations for a ticket in advance on the website. It is not possible to buy tickets at the United Nations Visitor Center. Tours are not open to children under five years of age. Arriving early for your reserved tour is a must as security is tight and federal identification for adults is necessary. There are separate procedures for groups. The actual route of the tour inside the United Nations Headquarters may vary depending on the time of the year and on-going activities. Most tours include a visit to the General Assembly Hall, the Security Council Chamber and the Economic and Social Council Chamber. The United Nations also has changing exhibits on its role in the promotion and preservation of international peace.

Roosevelt Island by Tram and the Franklin Delano Roosevelt Four Freedoms Memorial
The Tramway station is at 59th Street and 2nd Avenue • Manhattan/Upper East Side
212-308-6608 • www.rioc.com • Admission Fee

For the price of a subway fare purchased onsite, the five-minute aerial tramway ride from Midtown East to Roosevelt Island, as well as the return trip, offers delightful views of Manhattan. At first, it seems as though the rider is enjoying a Batman experience as the tram glides among the skyscrapers before it emerges to cross the East River and descend to Roosevelt Island. Once on the island, there is a small visitor center provided by the Roosevelt Island Historical Society that has maps and helpful directions. Visitors may proceed on foot for ten minutes to the southern tip of the island and to the 2012 Franklin Delano Roosevelt Four Freedoms Memorial, designed by architect Louis I. Kahn. The spectacular views of the East Side Manhattan skyline from this appealing, spare site include the East River, the United Nations and the Chrysler Building.

FDR made one of his most famous speeches on January 6, 1941, as Nazism and fascism were making the world an increasingly hostile place. The president outlined his vision of a world in which all people would enjoy freedom of expression, the freedom to worship God in their own way,

freedom from want and freedom from fear. While taking in the beauty of the view and the serenity of the memorial, visitors may wish to reflect on the universality of these four freedoms today.

Formerly Blackwell Island, named for the family who moved onto the island in 1676, it had a smallpox hospital designed by James Renwick Jr., now in ruins. It was also known as Welfare Island. The island was renamed Roosevelt Island in honor of the former president in 1971. At the tram disembarkment point, a free red bus takes visitors around Roosevelt Island. There is an 1872 lighthouse built to help ships navigate the dangerous Hell Gate waters of the East River.

The Sara Delano Roosevelt Memorial House
47–49 East 65th Street • Manhattan/Upper East Side
www.roosevelthouse.hunter.cuny.edu • Donation

There is an online application to tour Roosevelt House. Architect Charles A. Platt designed this Neo-Georgian double town house in 1907 for Franklin Delano Roosevelt's mother, Sara Delano Roosevelt. The overbearing Sara had Platt design the double town house to serve as a home for her and her son, the future president. It has the interesting feature of a single entry for the two adjoining town houses. The senior Mrs. Roosevelt moved into number 47 in 1908, while her darling Franklin, Eleanor and their young children moved into number 49. This was FDR's home as he launched his political career. He lived here when he won election as governor of New York in 1928 and as president of the United States in 1932. The tour focuses on the years that FDR and Eleanor lived here, the evolution of their political concepts and their many contributions to the United States.

When Sara Roosevelt died in 1941, Franklin Roosevelt put both homes up for sale. Hunter College of New York bought them. Today, they constitute the Roosevelt House Public Policy Institute at Hunter College, now part of the City University of New York. The homes are furnished as classrooms, with no remaining furniture from the FDR years.

Gracie Mansion
East End Avenue at 88th Street • Manhattan/Yorkville
212-570-4773 • www.gracie.tours@cityhall.nyc.gov • Free

Gracie Mansion tours traditionally occur on Wednesday through online registration well in advance of the desired date. Mayor Bill de Blasio has suspended the tours for an indefinite period of time in order for repairs to the home to occur.

Gracie Mansion has been the official residence of the mayors of New York City since 1942, when Fiorello LaGuardia was mayor. Archibald Gracie, a wealthy merchant in New York, built this Federal-style country home in 1799 looking out toward Hell's Gate, the treacherous channel in the East River between Manhattan, Long Island and Ward's Island. Archibald Gracie played host in the home to many notables in early American history, including John Quincy Adams, Alexander Hamilton and Washington Irving.

Gracie sold his home in 1819. The City of New York purchased it from subsequent owners in 1887 and added the grounds to the adjoining Carl Schurz Park described in Chapter 10. When the City of New York offered a house for the mayor to Fiorello LaGuardia in 1942, he passed up many grander homes for this one. The Gracie Mansion Conservancy operates Gracie Mansion.

Woodlawn Cemetery
517 East 233rd Street • The Bronx
718-920-0500 • www.thewoodlawncemetery.org • Free

The four-hundred-acre Woodlawn Cemetery dates to 1863. Over 300,000 people are interred here, while another 100,000 visit annually to pay their respects and also to appreciate the bucolic setting, with its distinctive monuments designed by some of the best sculptors in the history of the country, including Daniel Chester French, famed for his depiction of Abraham Lincoln in the Washington, D.C. memorial.

Among the notable people buried at Woodlawn are Fiorella LaGuardia, Noble Peace Prize winner Ralph Bunche, composer Irving Berlin, jazz musicians Duke Ellington and Lionel Hampton, writer Herman Melville, cartoonist Thomas Nast and artist and founder of the Whitney Museum Gertrude Vanderbilt Whitney. The site is a National Historic Landmark.

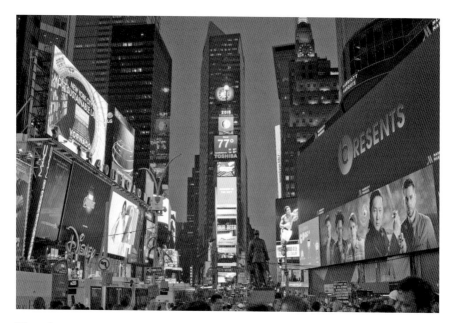

Times Square. *Courtesy of James Maher.*

MAKING NEWS

NOT EVERYTHING IS FIT TO PRINT

Politics and newspapers go hand in hand. Politicians love newspapers and the publicity they provide. And newspapers know politicians make good copy—whether for their leadership, their foibles or their misdeeds. So it should not come as a surprise that the offices of many New York newspapers were once conveniently located across from City Hall. On one street, which became known as "Newspaper Row," were the offices of the *New York Times*, the *New York Tribune*, the *Sun*, the *Post*, the *New York Herald*, the *New York Daily News*, the *New York World* and the *New York Journal*. These newspapers represented some of the best and worst of American journalism of the day.

In New York City, there was an incident that exemplified the tension between newspapers and government figures. John Peter Zenger, a newspaperman, went to trial in City Hall in 1735 for writing articles critical of the British royal governor. The court found Zenger innocent of libel, setting a precedent for the important principle of freedom of the press in American democracy.

Nineteenth-century New York newspapers were innovators and trendsetters. As literacy grew with universal free public education, more and more people could read. Newspapers increasingly catered to the masses as well as to the elite. First published in 1833, the *Sun* was a publication for the common man written by the common man. Reporters combed the city each day for stories about everyday people that would appeal to the general readership. Crime was a particular specialty of the *Sun*. The first editor, Benjamin Day, set the newspaper's course and philosophy with its motto:

"The *Sun*: It Shines for all." The *Sun* survived as an independent newspaper until 1950 and then through mergers with other newspapers, name and format changes until a final printing run in 1967.

The *New York Tribune* demonstrated the power of investigative journalism when articles and candid photos of New York's poor by Jacob Riis gave impetus to housing and workplace reforms. Horace Greeley, the editor of the *New York Tribune*, was so prominent that he became the Democratic candidate for president in 1872. He lost to Ulysses S. Grant.

Greeley had a great rival in James Bennett Jr., who took over publication of the *New York Herald* in 1866 after the death of his father—the paper's founder—James Bennett Sr., who had immigrated to the United States from Scotland. Under the senior Bennett, the *New York Herald* had become the largest-circulation newspaper in the United States. The younger Bennett increased its popularity even more through sensationalist stories that may not have been entirely true but were certainly entertaining. Bennett Jr. had a flamboyant life away from the printing presses. His behavior, often fueled by alcohol, scandalized polite society. However, as a sportsman, he organized the first tennis match and the first polo match in the United States, as well as the first transoceanic yacht race.

The most admired newspaper editor in late nineteenth-century New York was William Cullen Bryant. Bryant was the editor of the *New York Evening Post* from 1829 to 1878. He was an influential force behind the founding of the Metropolitan Museum of Art and the creation of Central Park in New York City. Bryant Park behind the New York Public Library is named for him.

Another publisher who was renowned was Joseph Pulitzer. Pulitzer immigrated to the United States from Hungary in 1864 and immediately enlisted in the Union army. After the Civil War, he made his fortune as the publisher of the *St. Louis Post-Dispatch*. In 1883, Joseph Pulitzer bought the *New York World* from Jay Gould and made it New York's most popular and respected newspaper. Pulitzer's *New York World* had the first editorial page and, in 1913, the first crossword puzzle of any newspaper in the United States. As a naturalized American citizen, Pulitzer was deeply patriotic. It was his love of country and of New York City that drove him to lead the campaign for funds for the pedestal to place the Statue of Liberty in New York Harbor.

Competitive in all ways, Pulitzer was determined to build a headquarters for the *New York World* that would be distinctive. The headquarters, designed by George Browne Post, were completed in 1890. The building was notable because it was the first skyscraper in New York to be taller than the spires of Trinity Church. It held the title of world's tallest skyscraper from 1890 to 1895.

From his offices on the highest floors of the building, Pulitzer could look down on the world he tirelessly described and sought to improve through the pages of his newspaper. The *New York World* headquarters building no longer stands. It was razed in 1955 to improve vehicular access to the Brooklyn Bridge.

Pulitzer met his match in the newspaper business when William Randolph Hearst bought the old *New York Journal* in 1895, a respectable publication with a sinking circulation. Hearst came to New York from San Francisco, where he had used his family fortune to buy the *San Francisco Examiner*. In New York, Hearst shook up the newspaper business. Charging a penny an issue, he directed the *New York Journal* toward a popular New York audience with racy descriptions of personalities and events in the growing metropolis. Hearst's *New York Journal* introduced the sports section in 1895.

Hearst also discovered that a wildly nationalistic stance in international affairs drove up circulation and undercut the competition. Hearst took up the cause of freedom for Cuba, then a colony of Spain. Not in the least concerned whether his newspaper's depictions of Spanish atrocities in Cuba were anywhere near the truth, he pressed for the United States to go to war with Spain. Pulitzer initially had not favored United States intervention in Cuba. He soon, however, reversed his position and abandoned all restraint in his competition with Hearst. Word for word, the *New York Journal* and the *New York World* led the outcry for war.

Although President McKinley had resisted declaring war on Spain, the pressure generated by Hearst and Pulitzer became overwhelming. When the battleship the USS *Maine*, built in the Brooklyn Navy Yard, blew up in Havana Harbor, "Remember the *Maine*" became the battle cry of the day. On April 25, 1897, the United States formally declared war on Spain. The war ended quickly. The United States won. In the peace treaty with Spain, Cuba gained independence and the United States gained three territories: Puerto Rico, the Philippines and Guam. Now an imperial power, the United States was becoming a major player on the international scene. In 1917, United States citizenship was granted to Puerto Ricans.

The Hearst-Pulitzer rivalry in warmongering extended to rivalry in comic strips. The *New York World* and the *New York Journal* competed for "The Yellow Kid," a comic by Richard Felton Outcault. Outcault had been a technical illustrator working for Thomas Edison who, on the side, drew humorous art for small publications. Joseph Pulitzer decided to include some of Outcault's drawings in the *New York World* in 1894. Outcault's "Hogan's Alley" cartoons became the rage. Outcault is considered the father of American newspaper comic strips. In 1895, Pulitzer published the Sunday comics in color. Outcault's

sassy boy hero, Mickey Dugan, wore a yellow coat. Mickey Dugan became known as the "Yellow Kid." Aimed at an adult audience, the "Yellow Kid" found humor in everyday New York life, poking fun at the rich and pompous. Hearst then struck again. He lured Outcault and his Yellow Kid away from the *New York World* to the *New York Journal*. Furious, Pulitzer hired George Luks to draw the *New York World*'s Yellow Kid. The rancorous competition between the two Yellow Kid cartoon characters, combined with the newspapers' shrill outcries for war against Spain, led to the term "yellow journalism."

While many of the New York City newspapers of this era no longer exist, one that does and that remains one of the country's most influential is the *New York Times*. First published in 1851 as the *New York Daily Times*, it became the *New York-Times* later in the century. After Adolph Ochs—who came to New York from Chattanooga, Tennessee—bought the newspaper in 1896, he dropped the hyphen and added the slogan "All the news that's fit to print." The *New York Times* first used this slogan on October 25, 1896, to distinguish itself from some of its mudslinging competitors.

By the turn of the twentieth century, the *New York Times* was ready to leave its Newspaper Row location and move uptown. Adolph Ochs commissioned architect Cyrus Eidlitz to design a skyscraper headquarters for the *New York Times* on a triangular-shaped lot bounded by Broadway, 7th Avenue and 42nd Street, known as Longacre Square. Ochs convinced the city to call the subway stop by this patch of land "Times Square." The name stuck. The new headquarters was a distinctive twenty-five-story Beaux Arts building. It was, at the time, the second-tallest building in Manhattan. Ochs decided to stage a grand opening for the new building on December 31, 1904, New Year's Eve, with a fireworks display. After the city expressed concerns about fireworks in such a confined area, Ochs created the drama of a ball being dropped down the flagpole on the Times Building to welcome in the year 1908. This has been a Times Square New Year's tradition ever since.

The inspiration for the Times Square New Year's Eve event came from the nineteenth-century time ball. To mark the noon hour, a ball would rise to the top of a long pole on the side of New York City's Western Union Building and fall to the bottom. Until 1883, this practice was as close as the city got to standardized time. The Western Union Telegraph Company had a close association with the railroads, whose tracks the telegraph lines followed. It was the railroad men in the late nineteenth century who established time zones in the United States to help the trains run to schedule.

New Year's Eve in Times Square has remained an American tradition, with hundreds of thousands of people gathered annually in the Square

and hundreds of millions across the nation and around the globe watching the celebration on television. Today, the ball is crystal instead of steel. The drama of the ball drop at midnight is preceded by big name entertainment.

Not just on New Year's Eve but all year round, visitors can catch late breaking news on electronic display boards in Times Square. In 1928, the results of the United States presidential election were displayed on the world's first moving electric light display on the Times Tower exterior: "Republican Herbert Hoover beat Democrat Al Smith of New York for the Presidency." Large screens called jumbotrons with flashing images today add to the vibrant feel of Times Square, which draws more visitors than any other site in New York City.

In the twenty-first century, New York City has three newspapers that rank among the top twenty-five in circulation in the United States: the *New York Times*, the *New York Daily News* and the *New York Post*. The *New York Times*, in fact, ranks number one in circulation and enjoys a national readership. A fourth New York newspaper, the *Wall Street Journal*, is one of the most respected and influential in the world in news coverage and financial insight.

If the print news has played a major role in the world of New York City and beyond, radio and television assumed a dominant position in the twentieth and twenty-first centuries. Radio reigned supreme through World War II. After the war, television grew exponentially and entered the homes of most Americans to be their greatest source of information and entertainment. David Sarnoff, the son of an immigrant from Belarus, and William S. Paley, the son of a Ukrainian immigrant, were in the United States because religious persecution had driven their families from their countries of origin. Each began his career in radio, continuing on to lead NBC and CBS television, respectively, in New York City. They were great rivals. By 1930, David Sarnoff, who never finished high school and started his career as an office boy, had become the president of the Radio Corporation of America (RCA) with its National Broadcasting Company (NBC) division. David Sarnoff presided over the first television broadcast in the United States on April 30, 1939. From the grounds of the New York World's Fair, NBC broadcast a speech by President Franklin Roosevelt to residents of New York City.

The headquarters and news bureaus of major television networks are in New York City. NBC, CBS, ABC, CNN and Fox News broadcast their evening news from here. Late night entertainment also has a home in New York. Popular television shows hosted by Jimmy Fallon, Stephen Colbert and Trevor Noah are taped live in New York, as is *Saturday Night Live*.

Your Guide to History

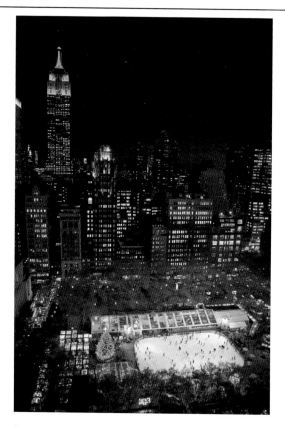

Bryant Park. *Courtesy of James Maher.*

Many of the old newspapers are now gone. Gone too are the "newsies"—the young boys who used to hawk newspapers on the street corners shouting, "Extra, extra, read all about it!" The newspapers that remain have relocated from Newspaper Row. The street has been renamed Park Row. There is a 1916 statue of Horace Greeley in City Hall Park by John Quincy Adams Ward showing the publisher with a newspaper. The New York World Building was razed in 1955. The New York Tribune Building on Park Row was demolished in 1966. The old New York Times Building, home to the newspaper from 1858 to 1904, remains at 41 Park Row as an office building.

PRINTING HOUSE SQUARE
Park Row at Nassau and Spruce Streets • Lower Manhattan

In Printing House Square, there is an 1872 statue of the greatest American newspaperman of them all: Benjamin Franklin, publisher of the *Pennsylvanian Gazette*. The statue is the work of sculptor Ernst Plassman.

THE SUN NEWSPAPER BRASS CLOCK
280 Broadway at Chambers Street • Lower Manhattan
Exterior Only

This four-sided brass clock fixed to the corner of the building at Broadway and Chambers Street is what remains of one New York newspaper, the *Sun*. The Sun Building has been repurposed to serve as the New York City Department of Buildings. Known as the Marble Palace, the building was originally designed by John B. Snook for the mid-nineteenth century A.T. Stewart Dry Goods Store, which catered to women. It is a National Historic Landmark.

GREELEY SQUARE AND HERALD SQUARE
Broadway and 6th Avenue, 34th to 35th Streets • Manhattan/Garment District

Each of these squares is actually a triangle, forming respectively the southern half and the northern half of a "square." The two great rivals, Horace Greeley of the *New York Tribune* and James Bennett Jr. of the *New York Herald*, share geography in perpetuity. And after the death of Bennett

Jr., the *New York Herald* and the *New York Tribune* merged to become the *New York Herald Tribune*, which published from 1924 to 1966. The *International Herald Tribune*, today the *International New York Times*, was an offshoot of the *New York Herald Tribune*. There is a statue of Horace Greeley by Alexander Doyle in the southern triangle. Horace Greeley is buried in Green-Wood Cemetery in Brooklyn.

In 1894, the *New York Herald*'s offices and publishing plant moved from Printers Row to what would become known as Herald Square. The new Herald Building, designed by McKim, Mead & White, was a magnificent version of an Italian palace. The Herald Building, like the newspaper, is long gone.

The imposing Bennett clock, named for the *New York Herald* publisher James Bennett Jr., once stood on top of the building. Since 1940, the clock has been incorporated into a forty-foot-tall monument to the Bennetts and the *New York Herald*, designed by Aymar Embury II. The monument features a ten-foot-tall figure of Minerva, the Roman goddess of wisdom, and two seven-foot-tall blacksmiths who strike a large bell on the hour. The sound actually comes from an internal striking mechanism. Even busy New Yorkers will pause in Herald Square to watch the blacksmiths mark the passage of time. The two blacksmiths have long been known affectionately as "Stuff" and "Guff."

Herald Square is the home of Macy's flagship department store. The store, built in 1902, covers an entire city block. It is the largest department store in the United States. There is a very helpful visitor center on the mezzanine level with maps and information on key New York City sites. The annual Macy's Thanksgiving Parade ends in Herald Square in front of a large reviewing stand. Macy's is a National Historic Landmark.

The Daily News Building
220 East 42nd Street at Lexington Avenue • Manhattan/Midtown

The *New York Daily News* was founded in 1919. It continues today as the *Daily News*. Originally headquartered near Park Row in Lower Manhattan, it moved to a new headquarters building on East 42nd Street in 1929. This landmark building, designed by Raymond Hood, has beautiful Art Deco details on its exterior. The building is recognizable as the headquarters of the fictitious *Daily Planet* in the *Superman* movies filmed in the 1980s. The lobby has an enormous, rotating globe that is not, however, updated to reflect

current national boundaries. The *Daily News* moved its operations back to Lower Manhattan in 1995. This building now houses offices. The *Daily News*, with the fourth-largest circulation of any newspaper in the United States, is famous for its headlines. One of the best known is the headline from October 30, 1975: "Ford to City: Drop Dead." President Gerald Ford never actually spoke these words, although he did oppose federal aid to New York City at a time when it was struggling to avoid bankruptcy. The building is a National Historic Landmark.

THE TIMES TOWER
1 Times Square • Manhattan/Midtown

The Times Building at 1 Times Square became known as the Times Tower in 1942, when a newer headquarters at 229 West 43rd Street took the name of the Times Building. The New York Times Company sold 1 Times Square in 1961. There is nothing left of the building's original distinctive exterior. It was stripped off by one of its owners to "modernize" the building. Number 1 Times Square is now covered with a series of large electronic billboards. However, under all those billboards remains the building that gave Times Square its name. It is from the top of this building that the ball drops each New Year's Eve. The crowd in Times Square joins in the fun by chanting the countdown.

TIMES SQUARE
42nd to 47th Streets at Broadway and 7th Avenue • Manhattan/Midtown
www.timessquarenyc.org

With its blazing electric billboards, illuminated theater marquees, jumbotrons, restaurants and hotels, Times Square is the biggest single tourist attraction in New York City. Its nickname is the "Crossroads of the World." Note that Times Square is not a traditional square at all but a large wedge of blocks between Broadway and 7th Avenue from 42nd to 47th Streets. The website lists attractions, events and stores in Times Square and offers tips on transportation. The website also gives helpful information on celebrating New Year's Eve in Times Square.

The Maine Monument

Central Park at West 59ᵗʰ Street near Columbus Circle • Manhattan/Midtown
www.centralparknyc.org/things-to-see-and-do/maine-monument

When the Brooklyn Navy Yard–built USS *Maine* battleship exploded in Havana Harbor, Cuba, on February 15, 1898, 260 American sailors died. Cuba's occupying power, Spain, got the blame, whether or not that country was actually at fault. William Randolph Hearst used his *New York Journal* to rally American public opinion to support war against Spain and also to raise funds to build this memorial, which has been in this location since 1913. The gilded bronze figures topping the monument are sea creatures and the female figure Columbia. The sculptor was Attilio Picarelli.

The Pulitzer Prize and Columbia University Low Memorial Library

2960 Broadway at 116ᵗʰ Street • Manhattan/Morningside Heights
212-854-4900 • www.pulitzer.org • www.visitorscenter@columbia.edu • Free

Joseph Pulitzer, as publisher of the *New York World*, strove to inform and educate the public and fight for reform. One of his dreams was to found a school of journalism in New York to improve the craft he had diligently practiced for many years. He finally convinced Columbia University in New York City to accept a financial gift to start a journalism school and recognize outstanding American journalists and writers each year. Though both the Journalism School at Columbia (1912) and the Pulitzer Prize (1917) began after his 1911 death, the crusading spirit of Hungarian-born Joseph Pulitzer lives on in his beloved American homeland.

Each year, the awarding of the prestigious Pulitzer Prizes is announced from the school. If you watch the televised ceremony, you will note that the backdrop is a stained-glass window showing the image of the Statue of Liberty and the banner of Joseph Pulitzer's *New York World* newspaper. The window was created for the headquarters of the *New York World* at 99 Park Row, since demolished. It recognizes the newspaper and the role it played in the Statue of Liberty going on display in New York Harbor. Joseph Pulitzer (1847–1911) is buried at Woodlawn Cemetery in the Bronx.

While it is not possible to enter the Columbia University Graduate School of Journalism, visitors can do a self-guided tour of the Columbia University campus. The university provides visitors with a map of the campus. The visitor center is on the second floor of Low Memorial Library. The

beautiful Low Memorial Library, a Neoclassical design by Charles McKim of McKim, Mead & White, was completed in 1897. The Low Memorial Library, patterned after the Pantheon in Rome and the Daniel Chester French statue *Alma Mater* in front of the library are symbols of Columbia University. Columbia moved to Morningside Heights in Manhattan from Midtown Manhattan in 1897. The Low Library, no longer a functioning library, is named for Seth Low, the Columbia University president from 1890 to 1901, who presided over the university's move to its Morningside Heights campus. Founded as King's College in 1754 in Lower Manhattan, it is the oldest college in New York. The Low Memorial Library is a National Historic Landmark.

CBS CORPORATE HEADQUARTERS
51 West 52nd Street at 6th Avenue • Manhattan/Midtown
Exterior Only

CBS Founder William S. Paley commissioned architect Eero Saarinen to design this structure, which looks as though it were built in 2015, not 1965. The exterior surface of black Canadian limestone and its minimalist appearance gave the building its nickname "Black Rock."

THE PALEY CENTER FOR MEDIA
25 West 52nd Street between 5th and 6th Avenues • Manhattan/Midtown
212-621-6600 • www.paleycenter.org • Admission Fee

With branches in New York and Los Angeles, the Paley Center's mission is to build appreciation for the role of television, radio and other media in American life. It offers guided tours of the center, rotating exhibits and online access to its extensive collection. Panel discussions with notable television stars who provide behind-the-scenes insights to live audiences is one of its many educational outreach programs. The center is named for William S. Paley (1901–90), the longtime former CEO of CBS who made the Columbia Broadcasting System into a leading U.S. television and radio network.

CBS Broadcast Center
524 West 57th Street • Manhattan/Midtown

This is the headquarters for CBS News and CBS Sports. William S. Paley—the son of Samuel Paley, a Ukrainian Jewish immigrant who was in the cigar business in Philadelphia—took a small group of radio stations his father purchased and built the popular Columbia Broadcasting System, known as CBS. Moving to New York, he forged ahead in radio and then in television and is considered the pioneer of modern television network news.

The Late Show with Steven Colbert
1697 Broadway between West 53rd and West 54th Streets • Manhattan/Midtown
www.cbs.com/shows/late_show • Free

There is an online application form for free tickets to the CBS late night show. Minimum age requirements and other information is on the website above. David Letterman put this show on the map. He retired in 2015. Steven Colbert is now the host.

Tours of the NBC Studios at 30 Rockefeller Plaza
30 Rockefeller Plaza at the Avenue of the Americas between 49th and 50th Streets • Manhattan/Midtown
www.thetouratnbcstudios.com • Admission Fee

The approximately one-hour tour of the NBC production studios at 30 Rockefeller Center includes visits to the NBC Broadcast Operations Center and at least two NBC Studios. The exact studios may vary depending on program taping. This provides visitors with a real behind-the-scenes look into television production. There is also the opportunity to "produce" a show and download it to keep.

The Today Show
NBC Studio 1A on 48th Street between 5th and 6th Avenues • Manhattan/Midtown
www.visittoday.com • Free

The easiest NBC show to visit is *The Today Show*, which airs weekday mornings at 7:00 a.m. The public is invited to gather on the plaza right outside the large windows that look into the Rockefeller Center studio. The show's stars and visitors, including notable musical performers, often interact with the viewing audience outside.

The Tonight Show with Jimmy Fallon/Late Night with Seth Meyers

www.nbc.com/tickets-and-nbc-studio-tour • Free

NBC offers free tickets to live shows filmed in the NBC Studios at Rockefeller Center, including the *Tonight Show with Jimmy Fallon* and *Late Night with Seth Meyers*. Information on how to obtain these tickets is on the website above. Tickets release month by month. The demand is extremely high. There are minimum age restrictions and other requirements. In some cases, there are same-day standby tickets. Standby tickets do not necessarily guarantee entry to the taping of the shows.

Saturday Night Live

Studio 8H Rockefeller Center • Manhattan/Midtown
www.nbc.com/tickets-and-nbc-studio-tour

Tickets to *Saturday Night Live* on NBC in Studio 8H are the most difficult of all these shows to obtain. A lottery is held annually in August, with no more than two tickets per household provided for an SNL show on a random date. Instructions on how to enter the lottery for these tickets are on the above website.

ABC's Times Square Studios

44ᵗʰ Street and Broadway, Times Square • Manhattan/Midtown
www.abcnews.go.com

Visitors are welcome to come to the ABC Studio location in Times Square each weekday beginning at 7:00 a.m. to view *Good Morning America* through the large glass windows. The show's anchors and guests will sometimes exit the building and join the onlookers outside in Times Square. The ABC late night show with Jimmy Kimmel is filmed in Los Angeles.

The Daily Show with Trevor Noah

733 11ᵗʰ Avenue
www.showclix.com

Trevor Noah took over as host of the *Daily Show* on Comedy Central in the fall of 2015. Jon Stewart retired as host that summer. Follow the procedures on the website for tickets.

A performer in the subway. *Courtesy of James Maher.*

LEISURE TIME IN THE BIG APPLE

YES, NEW YORKERS CAN RELAX

A shorter workday in the latter part of the nineteenth century gave Americans more leisure time. As people moved to the city, they missed the physical activity of country life. To fill the activity gap, many Americans turned to sports—as participants or as spectators.

Americans had many choices for sports. Lawn tennis arrived in this country from Bermuda in 1874, hockey from Canada in 1895 and lacrosse, a game first played by Native Americans, from Canada in the 1880s. The first permanent golf course in the United States was named St. Andrew's in honor of the home of golf in Scotland. The American St. Andrew's opened in Yonkers in the Bronx in 1888. It is still in operation as a private club. Van Cortlandt Golf Course in the Bronx, which dates to 1895, was the first municipal golf course in this country. It remains open to the public today. The first athletic club in the country, the private New York Athletic Club, was founded in New York City in 1868.

Bareknuckle boxing drew crowds in the nineteenth century. Boxing gloves were introduced in 1892. The first indoor World Championship Heavyweight Boxing Match was held on Coney Island in 1899. Jim Jeffries knocked out Bob Fitzsimmons to win. Roller rinks multiplied around the country after wealthy New Yorkers summering in Newport, Rhode Island, took up roller skating in the 1860s. The bicycle high wheeler, with its enormous front wheel and a small rear wheel, was a hit when it was introduced in the 1870s. However, the real breakthrough in bicycling came after John Kemp Stanley, an Englishman, introduced the bicycle with two

wheels of the same size in 1887. In 1888, 50,000 men and women in the United States were cycling; two years later, over 1.8 million cycled. Today, more than 100 million Americans ride bicycles, with more than 9 million of them riding every day.

The Triple Crown of horse racing—the Kentucky Derby, the Preakness and the Belmont Stakes—originated in this period. The Belmont Stakes was the first to run. It dates to 1867. The Belmont, named for August Belmont Sr., moved from Jerome Park, New York, to Morris Park in the Bronx in 1890 and to its current Belmont Park, New York location in 1905.

Baseball has strong New York roots. The members of the Knickerbockers Baseball Club of New York, founded in 1845, were the foremost advocates of the New York–style game, which played a significant role in the evolution of baseball from English cricket. The virtues of "the New York Game" and "the Massachusetts Game" were the subject of hot debate in the nineteenth century, with each having its advocates. Baseball today is most similar to the New York game except for two Massachusetts contributions: a small, hard ball and pitchers throwing overhand.

One of the original Knickerbockers was Alexander Cartwright. Many consider Cartwright to be the father of baseball. Cartwright codified the rules of the game. He established that three strikes made an out and three outs retired the side. The Knickerbockers, white-collar workers, began playing baseball in their free time in Madison Square. Other baseball clubs also organized in the New York area, establishing regular schedules for inter-club play. These clubs formed a National Association of Baseball Players in 1857. Despite the term "National," the clubs were all from Manhattan and Brooklyn.

The Civil War, from 1860 to 1865, gave great impetus to baseball's popularity. The war brought together young men from different parts of the country. Between deadly battles, the soldiers had long periods of slow time. They used this time to distract themselves with games of baseball. Baseball quickly took off and became firmly entrenched as "our national pastime." William Commeyer built this country's first enclosed baseball field in Brooklyn in 1862. This enabled him to charge admission. Commeyer also started the tradition of playing "The Star-Spangled Banner" before each baseball game. The National League was founded in 1876 and the American League in 1901. In the first World Series, in 1903, the American League Boston Red Sox beat the National League Pittsburgh Pirates for the title.

The American League New York Yankees, also known as the Bronx Bombers because of their location, began in 1903. Until 1913, they were called the New York Highlanders. From 1913 to 1957, the Brooklyn Dodgers

played at Ebbets Field, named for Charles Ebbets, the team's owner. The Dodgers took their name from their fans, who had to cross a number of trolley tracks and "dodge" speeding cars to reach the stadium. The Brooklyn Trolley Dodgers became the Dodgers. The Dodgers left New York in 1957. Although now in Los Angeles, they remain the Dodgers. The Giants were another New York baseball team. They also left the city in 1957, moving to San Francisco. To counter the loss of these two teams, the National League New York Mets started playing ball in 1962. Notably, the office of the commissioner of baseball is located in New York City.

Although the origins of football and basketball are not directly associated with New York, both the National Football League Headquarters and the National Basketball Association Headquarters are located in New York City. Neither headquarters building is open to the public.

The Downtown Athletic Club began in 1930. Its legacy is the Heisman Trophy, named for football player and coach John W. Heisman. First awarded in 1935 to the best collegiate football player in the United States, the prestigious annual award continues, notwithstanding the 2002 bankruptcy of the Downtown Athletic Club. The award ceremony is nationally televised from New York City.

Not all Americans played or even watched sports. Many turned to other diversions to fill their leisure time. Amusement parks, circuses and the theater grew rapidly as important public distractions. Early Dutch settlers had called the seaside area of Brooklyn Conyne Eiland, or Rabbit Island, after the many rabbits that lived there. Anglicized, this became Coney Island. Its development as a resort for the wealthy began in 1829. With improved public transportation, Coney Island became accessible to the middle and even lower middle classes, who could escape the city heat for a day to enjoy the beach or the growing number of activities found there. In 1903, several amusement parks opened, including the famed Luna Park and Steeplechase Park, making Coney Island the largest amusement park area in the United States.

The Coney Island Boardwalk dates to 1923. The first boardwalk in the United States was built in Atlantic City, New Jersey, in 1870. The boardwalk was named for its creator, Alexander Boardman, as well as for the fact that it was a walk made of boards. The boardwalk allowed ladies in their long skirts and intricate footwear, as well as children and gentlemen, to walk along the beach without getting sand all over them. The boardwalk, however, quickly became much more than a practical invention, as merchants and other attractions set up business along its way.

The first modern roller coaster, the earliest carousels and multitudes of electric lights made Coney Island a unique and wondrous destination. Sadly, one by one, these great amusement parks closed. Dreamland burned to the ground, Luna Park closed in 1946, Steeplechase Park closed in 1964 and Astroland closed in 2008. The City of New York, with the determined backing of many boosters, revived the amusement tradition of Coney Island when it opened a new Luna Park in 2010. The 1927 Cyclone roller coaster and the 1906 B&B Carousel are now operated by Luna Park. Luna Park offers many additional rides and amusements. The 1918 Wonder Wheel is part of Deno's Wonder Wheel Amusement Park. The Parachute Jump that made its debut at the New York World's Fair of 1939 no longer operates but stands on the Coney Island Boardwalk in tribute to adventures past, present and future.

The golden age of the circus occurred during the late nineteenth century and continued until the 1929 Depression. The genius who put together the special combination of animal acts, music and bizarre attractions that became "the circus" was Phineas Taylor Barnum. In 1841, P.T. Barnum purchased Scudder's American Museum, a collection of oddities on display in New York City at Broadway and Ann Street. Understanding the appeal of the exotic to the public, Barnum made the museum a great hit. The collection of freaks of nature, such as the "seven foot tall woman," and fabricated oddities, including a "mermaid," drew enormous crowds. His greatest success came in 1843, when he introduced General Tom Thumb to the American public. The General was actually a five-year-old midget named Charles S. Stratton. Barnum fabricated a wonderful history for the General that included a British military record. When Tom Thumb later fell in love with another midget, Lavinia Warren, Barnum staged a grand wedding celebration for the happy couple, complete with a little carriage pulled by white ponies. Barnum even arranged to have General Tom Thumb presented to Queen Victoria at court. Barnum's American Museum in New York City was a big attraction until the building burned to the ground in 1865.

Barnum started his Grand Traveling Museum, Menagerie, Caravan and Circus in 1870. He called it "The Greatest Show on Earth." One of the most popular attractions was Jumbo, the elephant Barnum brought to New York in 1882 to great acclaim. A year later, Jumbo demonstrated the safety and strength of the Brooklyn Bridge by walking across it. It was the popularity of this enormous elephant that added the word *jumbo*, Indian in origin, to the American vocabulary to mean "something very large." In 1880, Barnum merged his circus with that of James Bailey to create the Barnum & Bailey Circus. This circus merged with the Ringling Brothers Circus in 1907.

Vaudeville was a great attraction in nineteenth-century New York. Vaudeville was fun-filled song-and-dance routines and comedy that provided clean entertainment for the entire family. While the opera and the legitimate theater catered to a wealthy clientele, vaudeville appealed to second-generation New Yorkers and the middle class. Vaudeville began in New York in 1881 in Tony Pastor's New 14th Street Theater. Vaudeville continued as a theater tradition through the first part of the twentieth century, until competition from radio and movies and the hard times of the Depression did it in.

In contrast to vaudeville, theater in New York City continues and thrives. In the years right after the Civil War, the theater district was concentrated around Union Square. As the audience moved uptown, so did the theater. By the 1880s, the theater district had moved to the Madison Square area. Around the turn of the twentieth century, the theater district would find its permanent home in New York City in the district then known as Longacres. Longacres had been home to the horse trade and carriage shops. In 1900, the horse and buggy were beginning to give way to the automobile. There was space available in the area for new ventures such as theaters. After 1904 and the opening in Longacres Square of the New York Times building, Longacres Square became Times Square. Broadway Avenue running through Times Square gave its name to the theater district. Many of the most beautiful Broadway theaters date to the early twentieth century. Architects such as Herbert Krapp and Henry Hertz became known for their elaborate theater interiors that helped pack in audiences.

Not only were Americans going out for entertainment in the second half of the nineteenth century, but home life also became idealized during this time. The celebration of many family holidays dates to this period. In the 1870s, Congress authorized four federal holidays: George Washington's Birthday, Independence Day, Thanksgiving Day and Christmas Day. At first, the holidays were only for federal workers in the District of Columbia. In 1885, these holidays were offered to all federal employees across the country. In 1888, Decoration Day, later called Memorial Day, was added to this list. It expanded again in 1894 with Labor Day. In 1938, Congress authorized Armistice Day to remember those who served in World War I; Armistice Day became Veterans Day in 1954 to recognize veterans of all wars. The last federal holiday created by Congress was in 1983 in honor of Dr. Martin Luther King Jr.

New York is a wonderful place to celebrate holidays. New Year's Eve in Times Square is the ultimate celebration. Easter, with its wacky "parade" up 5th Avenue; the Fourth of July, with dazzling fireworks off barges in the East

River near the Brooklyn Bridge; and Thanksgiving, with its famed parade, are exciting and special. Christmas, in particular, has a unique historical tie with New York City.

The concept of gift giving at Christmas has existed for a very long time. St. Nicholas, an Orthodox Christian bishop in fourth-century Turkey, gave gifts. St. Nicholas wore a bishop's traditional red cape. He had a long, flowing white beard. Other religions and countries formulated their own versions of St. Nicholas. The French called him "Père Noël" and the English called him "Father Christmas." The Dutch named him "Sinter Klaas." In the seventeenth century, the Dutch brought Sinter Klaas with them to New York, where he would be their patron saint. In New York, his name took an American form: Santa Claus.

For centuries, Santa Claus remained a gift giver but otherwise a rather vague fellow. It was nineteenth-century New Yorkers who gave him definition and an endearing image. The first to contribute significantly to our concept of Santa Claus was Clement C. Moore. Moore, a New York landowner and scholar, published his 1823 poem "A Visit from St. Nicholas." This beloved poem, now more commonly known by its opening line "'Twas the Night before Christmas," describes Santa as a rotund, jolly old elf. Santa laughed as he went about his business filling the stockings the children had laid out with such great care. He went up and down the chimney and he traveled from house to house by sleigh and reindeer. Moore's Santa firmly caught the public imagination, never to be displaced. There is a plaque on the building that now stands at 420 West 23rd Street to remember where Moore wrote this cherished poem.

Thomas Nast, a New York cartoonist, contributed further to Santa's image. Nast, born in Germany, came to New York with his family in 1848. In 1862, Nast landed a job with *Harper's Weekly*, considered the preeminent American magazine. Before television and radio, publications with a national following were influential trendsetters. For a December 1862 issue of *Harper's*, Nast drew a picture "Santa Claus in Camp," showing Santa as a kind-looking, white-bearded gentleman in a fur-trimmed suit. In the cartoon, Santa was passing out presents to Union soldiers. Nast's image of Christmas struck a responsive chord with many during the difficult winters of the Civil War. It was so popular that Nast began drawing pictures of Santa Claus annually for *Harper's*: Santa decorating trees, making toys, giving gifts. The image Americans and many around the globe associate with Santa Claus today derives from the pen of Thomas Nast in the pages of *Harper's Weekly*.

And it was a New York newspaper, the *Sun*, that reaffirmed for children everywhere that Santa Claus really does exist. In 1897, an eight-year-old girl wrote to the *Sun* that friends told her there was no Santa Claus. She wrote a letter to the *Sun* because her father told her if the *Sun* says something is true, then it must be. The *Sun* printed its answer to the little girl on its editorial page, entitling it: "Yes, Virginia, There Is a Santa Claus." The editorial stated, "He exists as certainly as love and generosity and devotion exist." Francis P. Church wrote the editorial. It is one of the most famous editorials ever written in any newspaper. The *Sun* reprinted the editorial yearly at Christmastime until the newspaper stopped publishing.

Part of the Christmas celebration is the decorated tree. Germans who settled in this country in the eighteenth century brought the Christmas tree tradition with them. Yet the Christmas tree did not become popular in this country until the mid-nineteenth century. In 1846, an image appeared in the *Illustrated London News* of Queen Victoria and her husband, Prince Albert, with their children gathered around a decorated Christmas tree. Queen Victoria was not only a trendsetter in England but also in the United States among the middle and upper classes. Following Victoria's lead, Americans made the decorated tree a Christmas tradition here.

British and European Christmas trees were tabletop size. In America, large trees were plentiful. Christmas trees here came off the table and went onto the floor, often reaching the ceiling. Americans decorated their trees with toys and homemade pictures and sweets. Sensing commercial opportunities in Christmas tree decorations, F.W. Woolworth of Woolworth's Five & Dime Department Stores, headquartered in New York City, began importing German glass tree ornaments to sell in this country in 1880. The glass ornaments caught on quickly. An associate of Thomas Edison's, Edward Johnson, created the first string of electric Christmas tree lights for his own tree in New York in 1886.

The outdoor decorated tree has become an important part of public celebrations at Christmas. The first community Christmas tree lighting ceremony occurred on December 24, 1912, in Madison Square Park in New York City. A crowd gathered around a seventy-foot-tall tree with electric lights provided by Thomas Edison. This annual tradition in Madison Square Park occurs to this day. The most famous outdoor Christmas tree in the world is the one at New York City's Rockefeller Center in Midtown Manhattan. In 1931, construction workers at the site decided to put up a decorated tree to bring cheer to their surroundings during the depth of the Depression. Today, the Rockefeller Center tree lighting is a highly anticipated event attended by thousands and watched by millions on television.

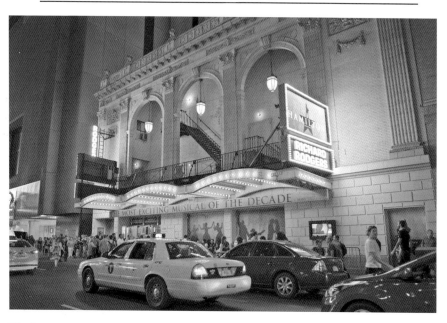

The Richard Rogers Theater. *Courtesy of James Maher.*

Bike Share in NYC
www.citibikenyc.com • Admission Fee

Thousands of bicycles are at hundreds of stations around the City of New York. Details on how to access the bicycles and where to find the stations are on the website.

New York City Cycling Map
www.nyc.gov/bikemap.com

This website is a handy guide to where to find the best and safest bicycling routes in New York City.

Summer Streets
www.nyc.gov/summerstreets • Free

On several Saturday mornings each August, New York City closes Lafayette Street at the Brooklyn Bridge and Park Avenue to Central Park to motor vehicles. Seven miles of roadway are open to pedestrians and bicyclists to enjoy fully. There are art installations, music and rest stops along the route.

New York City Marathon
www.tcsnycmarathon.org • Registration Fee • Free to Spectators

This marathon is the largest in the world, with over fifty thousand runners and two million spectators. It occurs annually on the first Sunday in November. The only year since its first year in 1970 when there was no New York City Marathon was in 2012, when super storm Sandy flooded parts of New York. The marathon did occur in 2001 as a testament to the resiliency and determination of New Yorkers after the September 11 terrorist attack on the World Trade Center. The first marathon had 127 entrants who ran laps around Central Park in Manhattan. Fewer than half of the runners finished. In 1976, a revamped New York City Marathon route included all five boroughs to celebrate the diversity of the city. The New York City Marathon begins at Fort Wadsworth Park on Staten Island. It crosses the Verrazano-Narrows Bridge, continues through Brooklyn, into Queens and then Manhattan, briefly

touches the Bronx and reenters Manhattan to finish in Central Park. There is also a highly competitive wheelchair marathon. The New York Road Runners have been a key partner in the marathon since its inception. Information on entering the marathon and related events is on the website.

Fort Wadsworth Park is part of the vast Gateway National Recreation Area that encompasses land from three New York City boroughs as well as the state of New Jersey. www.nps.gov/gate.

Madison Square Garden
4 Pennsylvania Plaza at 7th and 8th Avenues, West 31st to 33rd Streets
Manhattan/Garment District
www.thegarden.com

This is the fourth Madison Square Garden. The first, in 1819, was located at Madison Square, therefore the name. It was rebuilt in 1890 on the same site before relocating to 8th Avenue at West 50th Street. This Madison Square Garden opened in 1968. It hosts the Knicks, the Rangers, the Liberty and the City Hawks, as well as concerts and circuses.

New York Rangers
Madison Square Garden
www.rangers.nhl.com • Admission Fee

Originally, it was the New York Americans that played hockey at Madison Square Garden. Hockey became so popular in 1920s New York City that a second team formed in 1926. This second team was owned by Madison Square Garden. It became known as Tex's Rangers after the president of Madison Square Garden, G.I. "Tex" Richard. Later, "Tex" was dropped. The ice hockey team simply became known as the Rangers.

New York Knicks
Madison Square Garden
www.nba.com/knicks • Admission Fee

The New York Knickerbockers or Knicks, a professional basketball team, play in the Atlantic Division of the Eastern Conference of the National

Basketball Association. Founded in 1946, the earliest team uniforms featured Father Knickerbocker, the creation of New York author Washington Irving in 1809 that took hold as a nickname for all New Yorkers. Changes and updates to the uniforms have occurred many times since.

The New York Yacht Club
37 West 44th Street • Manhattan/Midtown
www.nyyc.org • Exterior Only

Founded in 1844, the private New York Yacht Club is housed in a 1901 Beaux-Arts building designed by Warren & Wetmore. The yacht club building is landlocked. In 1851, the yacht *America*, representing the New York Yacht Club, defeated a British yacht in a race off the coast of England to win the beautiful silver trophy and bring it to New York City. *America*'s owners decided to donate the trophy to the NYYC to be awarded annually to the yacht and nation that won the America's Cup, named in honor of that first victorious yacht. For 132 years, the America's Cup trophy remained in New York until an Australian team successfully challenged the United States in 1983 to take home the most prestigious trophy in yachting. Since 1983, the United States has again won the cup, which has also gone to victorious teams representing New Zealand and Switzerland. The yacht club owns an exceptional collection of sailing ship models that are occasionally loaned to other institutions for public display. The building is a National Historic Landmark.

National Basketball Association Flagship Store
545 5th Avenue at 45th Street • Manhattan/Midtown
866-746-7622 • www.nba.com

The NBA is opening a New York City flagship store at a new location in 2016 to replace a previous one.

The Brooklyn Nets

620 Atlantic Avenue • Brooklyn
www.barclayscenter.com • www.nba.com/nets • Admission Fee

The Brooklyn Nets play in the Atlantic Division of the Eastern Conference of the National Basketball Association. They play at Barclays Center in Brooklyn. Established in 1967 in the American Basketball Association as the New Jersey Americans, the team moved to Long Island in 1968 and became the New York Nets. In 1976, the ABA and the NBA merged. Since 2012, the team has played at the Barclays Center as the Brooklyn Nets. The Barclays Center also plays host to top musical performers and entertainers.

New York Islanders

620 Atlantic Avenue • Brooklyn
www.barclayscenter.com • www.newyorkislanders.com • Admission Fee

Newly arrived at the Barclays Center, the New York Islanders hockey team plays in the Metropolitan Division of the Eastern Conference of the National Hockey League. The franchise began in 1972.

New York Mets

120–01 Roosevelt Avenue • Corona, Queens
www.newyork.mets.mlb.com • Admission Fee

Visit the website for information on schedule, tickets, transportation and parking. The Mets Hall of Fame and Museum is located adjacent to Citi Field, the park where the Mets play. It is open on game days or accessible through the Citi Field tour. Special exhibits include the 1969 and the 1986 World Series Trophies, Mets Defining Moments and Hall of Fame Plaques. Founded in 1962, the Mets—short for the Metropolitans—were intended to replace two New York baseball teams that left the city in 1957: the Dodgers to Los Angeles and the Giants to San Francisco. Several times a season, the National League New York Mets play the American League New York Yankees in the Subway Series. The Mets were the 2015 National League Champions, playing in the World Series against the American League Kansas Royals, who won the title.

A huge Red Apple sits in the Mets Stadium Center Field and pops up whenever a Mets player hits a home run. New York is sometimes called

"the Big Apple." The nickname became popular as part of an advertising campaign to lure tourists to New York City during the doldrums of the 1970s. Its origins date to the 1920s, when a city sportswriter named John J. FitzGerald describing horseraces referred to New York as "the big Apple." Apples are a favorite treat for horses.

United States Open
Flushing Meadows–Corona Park • Flushing, Queens
718-760-6200 • www.usopen.org • Admission Fee

The United States Open is an international tennis event that is the final major of the four majors that compose the Grand Slam. It takes place over a two-week period in late August to early September each year. Its history dates to 1881, when the United States National Championship was held at Newport Casino, a sports facility in Newport, Rhode Island, commissioned by *New York Tribune* publisher James Bennett Jr. The women's championship began in 1887. In 1915, the championship moved to Forest Hills, New York. In 1978, it relocated again, this time to Flushing Meadows. Since 1976, the open is played at the Billie Jean King National Tennis Center in Flushing Meadows–Corona Park in Queens. This is a tournament of the United States Tennis Association, a not-for-profit organization.

The Belmont Stakes
Belmont Park, 2150 Hempstead Turnpike • Elmont, New York
516-488-6000 • www.belmontstakes.com • Admission Fee

The Belmont Stakes horse race, first run in 1867, is named for August Belmont Sr., a nineteenth-century New York banker and racing enthusiast. His son, August Belmont Jr., continued the racing tradition and served as head of New York's first Racing Commission and as chairman of New York's famed Jockey Club. The Belmont Stakes is the third event in the prestigious Triple Crown of Racing, which begins with the Kentucky Derby in early May, continues to the Preakness in Maryland and then culminates in New York in June. For tickets to the Belmont Stakes or other racing events at Belmont Park, go to www.ticketmaster.com.

New York Yankees
1 East 161st Street • The Bronx
646-977-8687 • www.newyork.yankees.mlb.com • tours@yankees.com • Admission Fee

Information on purchasing game tickets, pre-game tours or individual and group tours of the stadium is on the website. Hands on History is a special tour of the New York Yankees Museum presented by the Bank of America. Those on this tour may, for a significant fee, hold Babe Ruth's 1922–23 bat, Derek Jeter's jersey from his 3,000th hit in 2011 or one of the many, many World Series trophies won by the Yankees. What is included in the tour varies between the season and the off-season.

New York Giants
MetLife Stadium, 1 MetLife Stadium Drive • East Rutherford, New Jersey
www.giants.com • Admission Fee

The New York Giants football team, founded in 1925, is one of the original five National Football League teams still in existence. Today, the team plays in the National Football Conference Eastern Division. The extensive website provides information on schedules, tickets and the history and glory moments of the team.

New York Jets
MetLife Stadium, 1 MetLife Stadium Drive • East Rutherford, New Jersey
800-469-5387 • www.newyorkjets.com • Admission Fee

The Jets' schedule and ticket information are on the website. The American Football League New York Titans were founded in 1959. After bankruptcy, the Titans became the New York Jets in 1963. In 1969, the Jets became a success story when they won the Super Bowl under the flamboyant and brilliant leadership of quarterback Joe Namath.

Coney Island Boardwalk

The Coney Island Boardwalk runs from West 37th Street to Corbin Place. Since 1923, the Coney Island Boardwalk has been improved many times,

and the beach has been widened. Landfill has turned Coney Island into a peninsula. Crowded, with a "honky-tonk" atmosphere, Coney Island is not for everyone. However, its attractions are famous the world over. Coney Island's association with food, fun and frolic lives on.

Luna Park in Coney Island
1000 Surf Avenue • Brooklyn
718-373-5862 • www.lunaparknyc.com • Admission Fee

This amusement park has a multitude of rides, games, eateries and shops to keep visitors entertained all day and all evening long. The legendary wooden Cyclone roller coaster, which opened in 1927, offers drops and speeds up to sixty miles per hour that are not for the faint of heart. It is now joined by the new Thunderbolt roller coaster with speeds and sharp turns for only the most adventurous.

The first carousel on Coney Island arrived in 1876. The B&B Carousel in Luna Park is the last of the great Coney Island carousels still on Coney Island. Built in 1906, it has fifty hand-carved wooden horses. There are thirty-six "jumpers" (ones that go up and down) and another fourteen "standers" (ones that are stationary). The horses, carved by Charles Carmel, are in the Coney Island style—they are extremely stylish and spirited with large, animated faces and bared teeth that make them appear aggressive. Their manes and tails are flowing. Charles Carmel, Marcus Charles Illions, Solomon Stein, Harry Goldstein, W.F. Mangels and Charles Loof had all been trained as woodcarvers in Germany and Eastern Europe. After they immigrated to New York, they made late nineteenth- and early twentieth-century Coney Island and Brooklyn the center of the carousel industry in the United States.

Deno's Wonder Wheel Amusement Park
1025 Boardwalk at West 12th Street • Brooklyn
718-372-2592 • www.wonderwheel.com • Admission Fee

The flag piece of this amusement park with its many rides for children is the Wonder Wheel. The Wonder Wheel, the invention of Charles Hermann, opened on Memorial Day 1920. The Wonder Wheel stands 150 feet tall. It has twenty-four individual cars for passengers. In 1983, Denos Vourderis bought the Wonder Wheel. It has been in the Vourderis family ever since.

Nathan's Hot Dog Eating Contest
www.nathansfamous.com/contest

Coney Island is known for its hot dogs. The hot dog was invented by Charles Feltman after he arrived on Coney Island from Germany in 1871 and put a frankfurter on a long bun. Feltman's was the place to go for food and fun, whether inside the restaurant or outside in the beer garden. Nathan Handwerker, a Polish immigrant with a special recipe, opened a hot dog stand on Coney Island in 1916. A hot dog cost five cents. The original Nathan's still exists on the Coney Island Boardwalk. The popular hot dog–eating contest occurs every year on the Fourth of July. It is nationally televised.

The Mermaid Parade
www.coneyisland.com/programs/mermaid-parade

This Coney Island parade, at the opening of each beach season, is the largest in the country celebrating seaside culture. Floats, antique cars and marchers in sea creature costumes make this an artsy and fun way to welcome the summer.

The New York Aquarium
602 Surf Avenue at West 8th Street • Brooklyn
718-220-5100 • www.nyaquarium.com • Admission Fee

The New York Aquarium is the oldest aquarium in continuous operation in the United States. It opened in Castle Garden in the Battery in 1896. It has been at its current fourteen-acre site on the Coney Island Boardwalk since 1957. In recent years, the aquarium has undergone extensive renovation and enlargement with new exhibits and experiences, including the popular sea otter feedings. The aquarium is part of the Wildlife Conservation Society, which is also responsible for the zoos in the Bronx, Brooklyn, Queens and Central Park in Manhattan. Its mission is to conduct research on aquatic life in addition to public education.

Ringling Brothers and Barnum & Bailey Circus
www.ringling.com

P.T. Barnum had an eye for what would appeal to the public. Born in 1810 in Bethel, Connecticut, Barnum got his real start when he was twenty-five. He paid $1,000 to obtain the "rights" to a woman, Joice Heth, who claimed to be 161 years old and the former nurse to President George Washington. Crowds of people bought tickets to see Joice Heth only to learn after she died that she was probably no more than 80. Barnum claimed to be tricked too. The public forgave him, and he went on to find other crowd pleasers. This circus extravaganza plays around the country and regularly in New York City.

Big Apple Circus
Damrosch Park, Lincoln Center • Manhattan/Upper West Side
888-541-3750 • www.bigapplecircus.org • Admission Fee

Created in 1977 by Paul Binder and Michael Christensen, who were juggling partners, this classical-style, award-winning, nonprofit circus first made its home in the Battery in Manhattan. Today, it pitches its tent around the country. When in New York City for the fall to winter season, it performs under the big top at Damrosch Park, Lincoln Center. Many consider this the "big-hearted" circus as it features rescue animals and devotes considerable time and resources to entertaining hospital-bound children. Its acts include performers from all over the world. "Big Apple" is a reference to one nickname for New York City.

Broadway Theaters

Although many of the beautiful Broadway theaters built in the early years of the twentieth century fell on hard times, went into decline and were even demolished, in recent years, quite a few have undergone restoration and a return to elegance. Today, the theaters play to a full house. The earliest, the New Amsterdam Theater, dates to 1903. Many others were built from 1910 to 1927. It is inspiring to stand on West 44th or West 45th Street near Broadway and see a row of brilliantly illuminated theater marquis and know that theater is alive and well in New York City.

Broadway Theater Information
www.broadway.org

This is the official site of the Broadway Theater League. Access it for up-to-date information on shows, openings, closings, locations of theaters and the online purchase of tickets.

TKTS Discount Booths
www.tdf.org

The Theater Development Fund, a nonprofit organization, supports theater productions and enables a more diverse population to attend Broadway shows through discounted ticketing. Same-day tickets at greatly reduced prices are available at TKTS. If you are willing to be flexible about what show you see and are able to stand in line, this is a good deal. The location of the three TKTS booths are on the website. One is in Times Square, one is at South Street Seaport and the third is in downtown Brooklyn.

Beacon Theater
2124 Broadway at West 74th Street • Manhattan/Upper West Side
212-465-6500 • www.beacontheatre.com

The Beacon Theater, designed by architect Walter Ahlschlager, opened in 1929. Its beautiful 2,600-seat theater plays to major musical acts. It is on the National Register of Historic Places.

Kings Theatre
1027 Flatbush Avenue • Brooklyn
718-856-5464 • www.kingstheatre.com

Built as a movie theater in 1929, Kings Theatre fell on hard times and closed its doors in 1977. After many years, the city and the public worked to save the French Baroque–style building, designed by Rapp and Rapp. After a complete renovation, it reopened in 2015. Go for one of the varied musical or theatrical performances at Kings Theatre if only to enjoy the splendid, lush interior.

Steinway & Sons Piano Showroom and Factory Tours
1 Steinway Place, Long Island City • Queens
718-721-2600 • www.steinway.com • info@steinway.com • Free

Steinway & Sons Piano was founded by German immigrant Heinrich Engelhard Steinweg in 1853 in a building on Varick Street in Manhattan. While once there were many piano manufacturers in the United States, now Steinway is the only one. Most consider Steinway to be the preeminent manufacturer in the world. The factory offers two-hour tours once a week from September to June that cover the entire process of making a piano. It is important to sign up well in advance for these very popular tours.

The Easter Parade
5th Avenue from 49th to 57th Streets • Manhattan/Midtown

Each year on Easter Sunday, from 10:00 a.m. to 4:00 p.m., 5th Avenue between 49th and 57th Streets is closed to vehicular traffic. The Easter Parade in New York City, which began around 1890, is really a "stroll." Anyone may participate. Individuals enjoy wearing their Easter finery of fancy outfits and elaborate hats. Many parade with their pets attired in coordinated costumes. You do not have to dress up, but it is more fun if you do. On 5th Avenue, you will see many an Easter bonnet "with all the frills upon it," as New Yorker Irving Berlin wrote in 1933 in his song "Easter Parade." Berlin was inspired by the New York parade. Irving Berlin had come to New York City as a child late in the nineteenth century with family members who were fleeing Russia and pogroms against Jews. He was one of the many who came through Ellis Island. Easter is a Christian holiday falling on a Sunday in March or April. St. Patrick's Cathedral, St. Thomas Episcopal Church and 5th Avenue Presbyterian Church along the parade route hold Easter Sunday services.

The Fourth of July
www.social.macys.com/fireworks

The largest Fourth of July fireworks display in the United States takes place each year in New York City. Fireworks are set off from barges in the East River near the Brooklyn Bridge. The twenty-five-minute-long pyrotechnic spectacular uses more than fifty thousand fireworks to celebrate the nation's

birthday. There are also musical performances by major stars. Macy's department store sponsors the festivities, which are televised nationally on NBC. The website is helpful for the best viewing locations.

Labor Day

The origins of Labor Day and the parade are described in Chapter 10.

Halloween

The largest Halloween parade in the world is in New York City. Please see Chapter 8 for details.

Thanksgiving Day Parade
Manhattan
www.social.macys.com

The annual Thanksgiving Day Parade in New York City, sponsored by Macy's department store, has been part of our national holiday celebration since 1924. Millions watch on television each Thanksgiving morning as the large helium balloons, floats and marching bands pass down Central Park West to Columbus Circle and then down Broadway to the parade's end point at Macy's on Herald Square. Early risers get the best opportunity for frontline positions along the parade route, arriving by 6:00 a.m. for a spot along Central Park West between 75th Street down to 59th Street. The Herald Square area is not optimal, as it is almost completely blocked by television equipment and reserved grand stand seating. Some prefer to watch the balloon inflation on the Wednesday afternoon and evening before the parade at 79th Street and Columbus Avenue near the Museum of Natural History.

New Year's Eve in Times Square

The origins and details of this celebrated tradition are described in Chapter 11.

Christmas in New York

Christmas in New York is a magical experience. Roasted chestnuts are sold on street corners during the winter months, adding a wonderful aroma to the city scene. Store windows beckon with elaborate moving displays. Lights dazzle. Even Patience and Fortitude, the stone lions in front of the New York Public Library on 5th Avenue, get into the act with their large, red, festive bows. There are many special Christmas events, sights and sounds to experience in New York City. Descriptions of some of the highlights of Christmas in New York follow.

Major Department Store Window Decorations

No city does it like New York. Take a walk up 5th Avenue to see the fantastic Christmas displays in the windows of stores like Lord & Taylor (424 5th Avenue at West 39th Street), Saks Fifth Avenue (611 5th Avenue at East 50th Street), Cartier's (651 5th Avenue) and Tiffany's (727 5th Avenue at East 57th Street). Even if you do not have a child by the hand when you see these elaborate and moving delights, you will rediscover your own inner child. The very first Christmas displays in store windows were at the old Lord & Taylor's beautiful cast-iron building at 901 Broadway Avenue, which still stands today.

The Christmas Tree at Madison Square
5th to Madison Avenues from East 23rd and East 26th Streets • Manhattan/Gramercy
www.madisonsquarepark.org

The first public Christmas tree in the United States was here in Madison Square in 1912. This tradition continues with an annual tree illumination in December that offers music and other festivities.

The Empire State Building Light Show
www.esbnyc.com/explore/tower-lights

The website above includes a calendar of the Empire State Building Tower light displays visible throughout the city. Since 1976, the signature Empire State Building white lights have given way to other hues on holidays such

as Christmas (red and green), Hanukkah (blue and white), St. Patrick's Day (green) and the Fourth of July (red, white and blue) to enhance the city's celebratory mood. In 2012, the installation of a new LED lighting system permitted more colors and rapidly changing light displays. These lights honor organizations such as the American Red Cross and the American Cancer Society, as well as major sporting and other events.

The Morgan Library and Museum
225 Madison Avenue at 36th Street • Manhattan/Midtown
212-685-0008 • www.themorgan.org • Admission Fee

J. Pierpont Morgan acquired the original manuscript of the English novelist Charles Dicken's *A Christmas Carol* in the 1890s. The Morgan Library and Museum displays the manuscript each Christmas season. Charles Dickens helped popularize the notion of Christmas with *A Christmas Carol*, published in 1843, not long after a visit to the United States, during which he spent one month in New York City. Some believe that nineteenth-century New York City, with the grimmest slums in the world, served as the inspiration for the book's scenes of extreme poverty and illness.

Christmas Train Display at the New York Transit Museum Gallery Annex
Grand Central Station at 89 East 42nd Street • Manhattan/Midtown
www.grandcentralterminal.com • Free

During an extended holiday season, Lionel model trains run on tracks that go in and out of a small-scale Grand Central Terminal. Lionel Trains were founded in 1900 very near City Hall in New York City. Their creator was Joshua Lionel Cowen, whose family had immigrated to New York City after the Civil War. His father was a hat maker on the Lower East Side. The first Lionel trains went on display in a New York City department store window in 1901. The train's movement was intended to catch the eye of passing shoppers, who would then enter the store and make a purchase. But it was the small trains themselves that caught the attention of children, who put them on their Christmas wish list. Soon, Lionel Trains became big business in the United States. A lasting association began between Lionel Trains and Christmas. They went under the tree and into holiday displays everywhere.

The Christmas Tree at Rockefeller Center
30 Rockefeller Plaza • Manhattan/Midtown
www.rockerfellercenter.com/rockefeller-center-Christmas-tree-light • Free
www.therinkrockcenter.com • Admission Fee

Tens of thousands attend the annual tree-lighting ceremony in Rockefeller Center, while millions more watch on television. The exact date in early December changes annually. Information is on the website. It is a thrill to be one of the 150 skaters on the winter ice rink at Rockefeller Center, passing under the iconic golden statue of Prometheus by Paul Manship and the beautiful Christmas tree. Bring your own skates or rent them here.

Radio City Christmas Spectacular
1260 Avenue of the Americas between West 50ᵗʰ and West 51ˢᵗ Streets •
Manhattan/Midtown
212-247-4777 • www.radiocitychristmas.com • Admission Fee

The ninety-minute no-intermission show is indeed a fabulous spectacle. The amazing precision dancers, the Rockettes, appear in the holiday season Parade of the Wooden Soldiers. The show also includes a living nativity with a live menagerie.

www.radiocity.com

Radio City Music Hall opened in 1933. It owes its name to David Sarnoff, the head of NBC Radio, who partnered with John D. Rockefeller Jr. to make Rockefeller Center a reality during the height of the Depression. Radio City Music Hall has the world's largest indoor theater with the largest stage in the world. Its nickname is the "Showplace of the Nation." Radio City also features the massive "Mighty Wurlitzer" organ, which has played here since 1932. The Radio City website has information on tours of the facility, including the Stage Door Tour and the Art Deco Tour, featuring the architecture of the beautiful entertainment complex designed by Donald Deskey. Movie premieres and musical acts are among the performances in this majestic venue.

The Nutcracker at Lincoln Center for the Performing Arts
10 Lincoln Center Plaza • Manhattan/Upper West Side
212-875-5456 • www.nycballet.com • Admission Fee

From the end of November through December of each year, the New York City Ballet performs the holiday favorite *The Nutcracker*. The ballet has music by Russian composer Peter Tchaikovsky and choreography by George Balanchine. *The Nutcracker of George Balanchine* made its New York City debut in 1954. This ballet for young and old tells the tale of the young girl Maria, who is transported from her family's living room at Christmastime to a fantasy world with a wooden nutcracker who comes alive, mischievous king-sized mice and beautiful sugar plum fairies. The sets include a Christmas tree that grows from twelve feet to forty feet. Fabulous costumes and ninety incredible dancers transport the audience to a magical world in a span of two hours.

The Christmas Tree at the Metropolitan Museum of Art
1000 5th Avenue at 82nd Street • Manhattan/Upper East Side
212-535-7710 • www.metmuseum.org • Admission Fee

Each holiday season, the Metropolitan Museum of Art displays a magnificent Christmas tree and eighteenth-century Neapolitan nativity. Fifty terra-cotta, silk-robed angels alight on the branches of the tree. At the base of the tree is a large nativity from eighteenth-century Naples, Italy. Adoring magi, shepherds with their flocks of sheep and other animals surround Mary, Joseph and baby Jesus in the manger. In all, there are more than two hundred figures and decorative buildings. First displayed at the Met in 1957, the Christmas tree and Neapolitan nativity scene command large crowds. Information on the exact dates of the annual display and how to obtain timed entry tickets to avoid waiting in line are on the Metropolitan Museum website.

The Park Avenue Tree Lighting Ceremony
Brick Presbyterian Church, 1140 Park Avenue at 91st Street • Manhattan/Upper East Side

More than forty blocks of Park Avenue from 54th to 97th Streets put on a display of illuminated Christmas trees in the center divider that separates

the northbound and southbound lanes. The tree lighting occurs on the first Sunday evening in the month of December in front of the Brick Presbyterian Church. This annual holiday tradition began in 1945, when a few families living on Park Avenue wanted a way to thank the returning United States servicemen who had served in World War II.

New York Botanic Garden Holiday Train Show
2900 Southern Boulevard • The Bronx
718-817-8700 • www.nybg.org • Admission Fee

The New York Botanic Garden visit is described in Chapter 7. During the Christmas season, the Haupt Conservatory at the NYBG houses the Holiday Train Show. Visitors experience the magic of New York in miniature as model trains wind their way along a track that takes them by 150 tiny versions of famous New York landmarks, such as the Statue of Liberty, St. Patrick's Cathedral and the Empire State Building. Most impressive is that, in keeping with the garden, the miniatures are all made of leaves, bark, twigs and other natural materials.

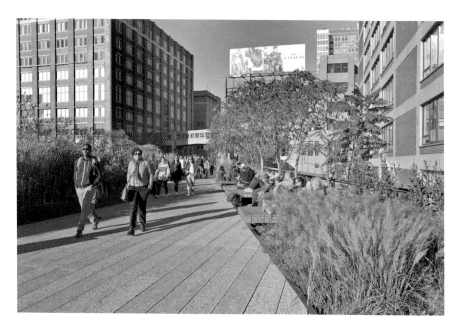

The High Line. *Courtesy of James Maher.*

THE CITY OF GENIUS

PROGRESS AND MORE PROGRESS

Even as New Yorkers amused themselves, they took the business of progress very seriously. They were eager to discover, to create, to advance. To do this required genius. New Yorkers recognized genius.

Thomas Alva Edison was a genius. As a young man, he had worked as a telegrapher, tapping and receiving messages in a small office. Edison appreciated the significance of the invention of the telegraph to America but recognized that it needed improvement. He saw that telegraph lines could transmit multiple messages simultaneously and transmit them faster.

Edison solved these problems, attracting the attention of the New York Vanderbilts. Supported by their financial backing, he established an industrial research laboratory in Menlo Park, New Jersey, a convenient railway commute from New York City. In December 1879, at Menlo Park, Edison demonstrated his latest invention: the electric light bulb. Awe over Edison's remarkable creation quickly inspired investment schemes among his financial backers—J.P. Morgan, the Vanderbilts and Henry Villard. They made plans to electrify New York City.

Within three years, Edison had implemented these plans. In an enormous undertaking, Edison supervised the installation of power lines below the streets of Lower Manhattan to carry electricity to New York's financial and manufacturing center. On September 4, 1882, Thomas Alva Edison, standing with J.P. Morgan in the Drexel Morgan Building, at the corner of Wall and Broad Streets, illuminated eight hundred lights to make New York City the first electrified city in the world. Soon, electricity was no longer a

novelty; it was a necessity. The New York Stock Exchange was electrified in 1883. New York office buildings installed their own power generators. Not surprisingly, J.P. Morgan was the first individual in New York City—and the world—to electrify his home. Other millionaires followed his example.

Lights transformed the city. Stores, hotels, restaurants and theaters all lit up, drawing people out in the evening hours. New York became a night city, a city ablaze. Soon, advertising signs lit up. To attract further attention, they blinked. The Great White Way—Broadway between 23rd and 34th—earned its name from its serious concentration of lights. Even after the introduction of colored lights, the Great White Way retained its nickname.

The Edison General Electric Company, formed by J.P. Morgan and presided over by Henry Villard, made Thomas A. Edison a wealthy man. He rented a home in fashionable Gramercy Park. Edison was not a great businessman, however. The company financiers soon eased Edison out of the company. Edison General became the General Electric Company.

New York quickly embraced other Edison inventions. Edison worked with Alexander Graham Bell, who came to New York City in 1877 to demonstrate his new invention: the telephone. Early in 1879, after a year of creative cooperation with Thomas Edison, Bell put the telephone to commercial use. In 1879, this country's first telephone exchange opened in New York City with several hundred customers. Within a few years, hundreds of customers became thousands as businesses and private individuals clamored for the new device, which quickly became an indispensable part of everyday life. The next step was to connect New York City to other cities. The first line was from New York to Boston in 1884. New York to Philadelphia went through in 1885. The more distant Chicago was hooked up to New York in 1892.

Edison also invented the phonograph, demonstrating this new marvel in New York City in 1877. Moving pictures, aided by Edison inventions, caught on rapidly. The first commercial motion picture house in the United States opened in New York City on April 14, 1894. The Holland Brothers Kinetoscope Parlor, at 1155 Broadway, used the Edison-developed technology to display a series of moving pictures. This was, however, little more than a peep show viewed by one person at a time looking into a little box.

The excitement of an audience sharing the experience of watching a flickering image on a screen in a theater first occurred in New York City in April 1896 at Koster and Bial's Music Hall, at Broadway and 34th. This location is where Macy's department store now stands. From the 1890s until World War I, New York was the capital of the young United States film industry until it left the East Coast for Hollywood, California.

However, many movies and television shows today are filmed on location in New York City.

Advances in technology were beneficial to transportation. As New York grew, so did the congestion. Getting around the city was never convenient. It often took hours to go from 42nd Street to Wall Street. The horses that pulled the transport carriages left behind a filth that was difficult to contain. In the 1870s, New York City constructed elevated railroads along 2nd, 3rd, 6th and 9th Avenues. These Els—often three stories above the city streets—were a great advance in transportation within the city, though their drawbacks were significant. The trains that ran along these tracks were noisy and extremely dirty, spewing smoke and soot.

Cable cars and trolley cars ran on city streets late in the nineteenth century and on into the 1930s and '40s. However, when a March 1888 snowstorm brought New York City to a complete halt, demands grew for an underground transportation system that would be impervious to the weather. It took a few more years of wrangling before city leaders reached the decision to go forward and work could begin. Between 1900 and 1904, over seven thousand workers—more than forty of whom would die in the process—excavated below city streets and laid the underground track for the Interborough Rapid Transit, the IRT. August Belmont Jr. founded the IRT.

The track began at City Hall. The opening day ceremonies in 1904 generated great excitement and some real trepidation. To descend underground, enter a subway car and emerge moments later at a different location was a novel experience and just a little frightening to some. The subway, however, quickly became an absolutely essential element of New York life and expanded throughout the city. There were several privately operated lines, including the IRT and the IND. In the 1940s, the city assumed control and ownership of the lines of transportation.

Today, the New York City subway system—operated by the MTA, or Metropolitan Transit Authority—is the largest in the world. It runs twenty-four hours a day to accommodate two billion passengers annually. The subway has run everyday in New York City since its inception except for one. On January 27, 2015, the subway was shut down in anticipation of a major snowstorm that did not occur.

YOUR GUIDE TO HISTORY

Grand Central Terminal. *Courtesy of James Maher.*

Subway and Bus Maps and Information
www.mta.info

This website provides a full range of information on the New York subway and bus system with maps, fare and schedule updates.

Subway Stop at City Hall

This was the original subway station at the southern end of the first line of the IRT. City Hall Station, no longer in use, dates to 1904. Heins & LaFarge were the architects for this beautiful Romanesque-style station that has brass chandeliers and colored-glass tile. To get a peek at the station, stay on at the last stop on the southbound Local 6 to Brooklyn Bridge as the train loops around and continues northbound. The New York Transit Museum also offers tours of the station.

Astor Place Subway Station
Astor Place at Lafayette Street • Manhattan/Greenwich Village

This is the original 1904 station restored. There is a bronze tablet to commemorate the Interborough Rapid Transit, the first subway in the United States. The subway cast-iron kiosk is a replica of the original. There are images of beavers on the walls inside the station in reference to the beaver trade that first made John Jacob Astor wealthy after he came to the United States in 1784. This is a working station on the MTA Lexington line.

The High Line
Gansevoort Street to 34ᵗʰ Street between 10ᵗʰ and 12ᵗʰ Avenues •
Manhattan/Meatpacking District to Chelsea
www.thehighline.org • Free

Visit the website for the exact location of stairs and elevators that provide access to the High Line. On former elevated rail tracks, the High Line is a diverse pathway offering lounge chairs, water features, covered passages and wonderful views of New York City north and south, including broad vistas through the Meatpacking District. The Chelsea Thicket is a two-block walk through an ornamental tree forest. In warmer months, there are public programs and a variety of tours, including a general tour, a tour of the artwork on the High Line and a tour of the plants and flowers found there. There are also public activities for children. The High Line was created by a

design team of James Corner Field Operations, landscape architectural firm Diller Scofidio + Renfro and planting designer Piet Oudolf.

Beginning in the 1870s, elevated tracks allowed trains to traverse safely a busy part of the city without endangering pedestrians, cars and street activity. In 1980, the trains stopped running. Many in New York hoped the tracks would go away as well. Others enthusiastically supported neighborhood activists Joshua David and Robert Hammond, who had the vision to turn the abandoned Els into a park. Their vision became a reality when the first segment of the High Line opened in 2009. The last part of the revitalized trail, now 1.45 miles long, opened in September 2014. The High Line has quickly become a favorite destination for New Yorkers and tourists.

New York International Auto Show
655 West 34th Street • Manhattan/Garment District
800-282-3336 • www.autoshowny.com • Admission Fee

The New York International Auto Show occurs one week each spring at the Jacob Javits Convention Center on West 34th Street. New York City, in 1900, hosted the first automobile exposition in the United States. The show has occurred every year since, becoming the largest in the world. On August 31, 1903, a Packard car left San Francisco to make the first cross-country car trip to New York City.

Grand Central Terminal
89 East 42nd Street at Park Avenue • Manhattan/Midtown
917-566-0008 for private tours • www.grandcentralterminal.com •
www.MAS.org to purchase tour tickets • Admission Fee

Visit Grand Central to marvel in its glory, even if your means of transportation do not require it. Note that it is Grand Central Terminal, not "station" like Penn Station. That is because trains terminate here and do not pass through en route to another destination. Once at the terminal, there are circular tracks to redirect the trains out of the terminal. In 1854, New York banned trains from running south of 42nd Street, keeping their sooty steam from the most populated areas of the city. As the city grew, the railroad tracks went underground in 1875, allowing Park Avenue to become a fashionable residential address.

The Municipal Art Society of New York offers a daily tour of the architecture and history of the beautiful Grand Central Terminal, including Vanderbilt Hall, with anecdotes that bring the terminal alive. Go to the GCT Tours window on the main concourse. There are also self-guided audio tours for a fee.

Cornelius Vanderbilt constructed a terminus for his newly merged New York Central Railroad in 1871. The growth of the railroad soon made this facility obsolete. A new rail depot was necessary. This was Grand Central Terminal, a 1913 Warren & Wetmore Beaux-Arts building that is a beautiful tribute to the days when the railroad was king. Grand Central today is dedicated to commuter lines. Longer routes to Boston, Philadelphia and Washington, D.C., go in and out of Penn Station.

Grand Central Terminal is testimony to the power and grandeur of the railroad, one of America's great nineteenth-century achievements. There is a statue of Cornelius Vanderbilt on the southward-facing exterior of Grand Central—the boy from Long Island who built a railroad empire from his first business venture in the Staten Island Ferry and Hudson River shipping. Cornelius Vanderbilt forever remained "the Commodore," even as he branched into railroads, merging one railroad line after another to make the New York Central Railroad one of the great lines of the late nineteenth and early twentieth centuries. Vanderbilt Hall next to the main concourse inside the terminal is named for the Commodore.

Note the impressive, grand stairways of marble patterned after the stairway in the Old Paris Opera House, the 125-foot-high vaulted ceiling of the main concourse, with its lighted zodiac design of 2,500 stars (although astronomers note that the constellation is actually backward), the arched windows with catwalks and the elegant Seth Thomas clock with its four faces of precious opal that sits atop the information booth. The large American flag has hung in the main concourse since a few days after September 11, 2001. Atop the 42^{nd} Street exterior entrance is a large Tiffany clock depicting Roman gods, including Mercury, who represents speed.

After the 1963 demolition of Penn Station to build the fourth rendition of Madison Square Garden, Jackie Kennedy and the Municipal Art Society of New York worked to save Grand Central Terminal. The 1903 Beaux-Arts Penn Station, by architects McKim, Mead & White, was the single most beautiful building in New York. New York's loss and shame over the demolition of Penn Station turned to anger and action, spurring the population to fight to save many landmarks, such as Grand Central Terminal, from disfiguration and destruction. Grand Central is the largest train station in the world by the number of tracks and platforms. It is a National Historic Landmark.

The New York Transit Museum Annex

Grand Central Terminal, 89 East 42ⁿᵈ Street • Manhattan/Midtown
www.transitmuseum.org

This small annex of the New York Transit Museum has changing exhibits on the history of transportation in New York City. It is a teaser and will certainly convince you to visit the home museum on Boerum Place in Brooklyn.

The New York Transit Museum

Boerum Place at Schermerhorn Street • Brooklyn
718-694-1600 • www.transitmuseum.org • Admission Fee

Housed in a 1936 IND, or former Independent Subway, station in Brooklyn, this museum focuses on the history of public transportation in New York City and on the subway in particular. In the winter months, the transit museum offers rides on "nostalgia trains," which provide visitors with the opportunity to experience subway cars in use from the early 1930s to the mid-1970s. The New York Transit Museum periodically offers the chance to see the original City Hall Station that dates to 1904. This very special station was the design of architects George Lewis Heins and Christopher Grant LaFarge.

Intrepid Sea Air Space Museum

Pier 86, West 46ᵗʰ Street and 12ᵗʰ Avenue • Manhattan/Midtown
212-245-0072 • www.intrepidmuseum.org • Admission Fee

The USS *Intrepid*, an aircraft carrier that saw service in World War II, is berthed on the Hudson River at Pier 86. Entrance to the museum includes tours of the *Intrepid* and a guided-missile submarine. The Space Shuttle Pavilion houses the space shuttle *Enterprise*. The USS *Intrepid* is a National Historic Landmark.

Statue of Charles Lindbergh

Rockefeller Center, 630 5ᵗʰ Avenue Entrance • Manhattan/Midtown

At the turn of the twentieth century, the possibilities of air flight generated great excitement. In a landmark event, Wilbur Wright flew an airplane over New York City in 1909. Charles Lindbergh took off in his single-engine airplane the *Spirit of St. Louis* from Roosevelt Field on Long Island to fly to Paris in his famous 1927 transatlantic voyage. Lindbergh returned to the United States as an American hero, revered around the globe. There was a ticker tape parade in New York City in his honor. The statue of Charles Lindbergh by Paul Fjedle celebrates his achievements.

The International Center of Photography
250 Bowery • Manhattan/The Bowery
212-857-0000 • www.icp.org • Admission Fee

The museum is moving to its new location at 250 Bowery in 2016. This museum, founded in 1974 by Robert Capa and Cornell Capa, focuses on photography that documents the human condition.

New York Film Festivals
www.nyc.gov/film_festivals

This New York City website provides a helpful calendar of the many film festivals occurring each year. The New York Film Festival, now over fifty years old, shows the work of prominent and up-and-coming filmmakers for two weeks each fall. It is sponsored by the Film Society Lincoln Center. Another popular film festival is the Tribeca Film Festival. Its website is www.tribecafilm.com.

Museum of the Moving Image
36-01 35th Avenue • Queens
718-777-6800 • www.movingimage.US • Admission Fee

Everything you would want or need to know to understand how movies are made is provided in the core exhibit Behind the Screen. Film, television and digital media are featured and explained in the museum, which also shows hundreds of films each year. This area was home to film studios, including one long affiliated with Paramount Pictures. The first two Marx Brothers movies were filmed here. Episodes of the children's television series *Sesame Street* were also filmed here. The campus is the only film back lot in New York City.

New York Hall of Science
47-01 111th Street, Corona • Queens
718-699-0005 • www.nysci.org • Admission Fee

The last of the three World's Fairs held in New York City was in 1964–65. The New York Hall of Science is one of the few buildings from that fair surviving to this day. Since the fair closed, the hall has served as New York's science and technology museum. This is a hands-on museum that encourages visitors to see, touch and listen to learn about science, technology and math in the more than 450 exhibits. This is an especially good museum for children. An outdoor exhibition space displays rockets provided by the National Air and Space Agency (NASA) to the World's Fair.

The 1964 New York World's Fair chose as its theme "Peace through Understanding." It focused on technological achievements both past and anticipated. Displays of early computer components gave visitors a real peek into the future. The Ford Motor Company first displayed its new Mustang automobile at this fair. The fair was not a commercial success. After its conclusion, many of the buildings were demolished. A few elements have endured.

A large panorama of the City of New York from the original New York City Pavilion is now on display, updated, in the New York Hall of Science. The fair's large Unisphere, intended to represent Earth in the space age, still stands in Flushing Meadows–Corona Park. This park hosts the United States Tennis Association Billie Jean King National Tennis Center and the Arthur Ashe Stadium where the United States Open tennis tournament is played each September. Adjacent to the park is Citi Field, home to the New York Mets baseball team.

THE ALICE AUSTEN HOUSE
2 Hylen Boulevard • Rosebank, Staten Island
718-816-4506 • www.aliceausten.org • Donation

Alice Austen (1866–1952) is recognized as a female pioneer of photography as documentary art. Her home, Clear Comfort, is today a museum of her work and her times. Originally built in 1690 as a one-room Dutch farmhouse, Alice's grandfather significantly expanded the home after he purchased it in the mid-nineteenth century. Alice spent much of her life here until financial problems forced her to give up the home in 1945. In addition to its collection of Alice Austen photographs, the museum has rotating exhibits, musical and dance programs and self-guided tours. It is a National Historic Landmark.

NEW YORK CITY FIRE MUSEUM
278 Spring Street between Varick and Hudson Streets • Manhattan/Soho
212-691-1303 • www.nycfiremuseum.org • Admission Fee

Vintage fire engines and the history of the Fire Department of New York (FDNY) are the focus of this museum, which is housed in a 1904 fire station once home to FDNY Engine Company Number 30. There is a moving section that details the response of the New York Fire Department to 9/11, the heroism of the firefighters and the loss. Three hundred and forty-three firemen died on 9/11.

New York City Police Museum

www.nycpm.org

This museum is currently closed. It does plan to reopen in order to continue its mission to inform the public about the history of the New York City Police Department, including individual stories, historic uniforms and artifacts. One focus is how the police as first responders played a heroic role after the September 11, 2001 terrorist attack on the World Trade Center. Information about its status is on the website.

Cooper Union

30 Cooper Square • Manhattan/Greenwich Village
www.cooper.edu

The Cooper Union is an educational institution particularly for art and design. It hosts exhibitions and symposiums in its several galleries and auditoriums. Many are free, as noted on the website. Peter Cooper was a genius. He turned his genius to his great advantage, rising from his beginnings as the son of a poor storekeeper to make a fortune in iron. Cooper owned rolling mills in New Jersey that produced much of the wrought iron that went into nineteenth-century building construction in New York City. Cooper also designed the first American locomotive, the Tom Thumb, which made its trial run on the Baltimore to Ellicott City, Maryland track in 1830.

Peter Cooper's practical and technical innovative approach to nineteenth-century advances inspired him to endow one of the earliest free institutions in this country dedicated to teaching students a trade. The school, built in 1859, was also remarkable in that it was racially integrated and coeducational. Abraham Lincoln chose the auditorium of the Cooper Union in 1860 to make one of his great speeches—a campaign speech, "Right Makes Might," in opposition to the spread of slavery to new American territories—that helped propel him to the presidency.

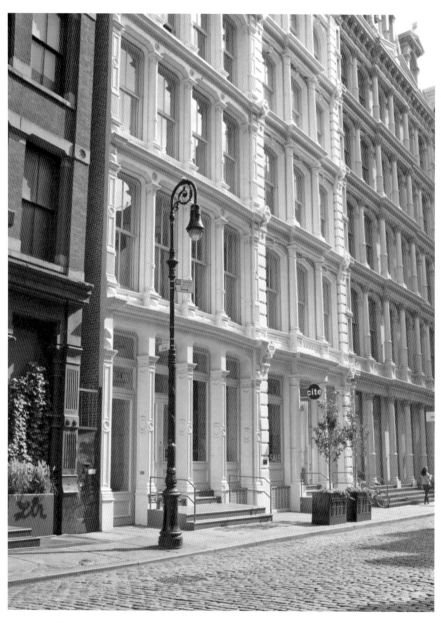

The Soho Cast Iron Historic District. *Courtesy of James Maher.*

A CITY OF SKYSCRAPERS

REACHING HIGHER AND HIGHER

New York has always had skyscrapers—the spires of its churches. Until 1890, the tallest structure in Manhattan was the 280-foot-high steeple of Trinity Church. But in the late nineteenth century, the reach to the sky had a secular purpose: to provide commercial interests with office space. No one is quite sure when and where the term "skyscraper" originated, but its meaning is clear. In the late nineteenth century, buildings went higher and higher until they appeared to "scrape the sky." Chicago is credited with having the very first skyscraper. This was the Home Insurance Building, designed by William Le Baron Jenney and completed in 1885.

But it was New York that quickly seized on the skyscraper, building it taller and better. New York and the skyscraper became synonymous. The relatively small confines of Manhattan Island created a scarcity of real estate. The demand for land accelerated in the nineteenth century, driving prices up astronomically. The skyscraper, offering more space per site, was the solution. Manhattan's geology helped. The geological foundation at the tip of the island and in Midtown is solid rock; this provides the necessary support for skyscrapers. When you look at New York today, you will note that the greatest concentration of tall building towers is downtown and in Midtown, reflecting the island's geological base.

The skyscraper was a symbol of power and a statement of presence. Built as much for its visual impact as for its office space, the skyscraper climbed higher and higher. Technological advances during this time made this new

skyscraper possible. The Bessemer process for steel, invented in 1855, allowed man to build strong structures whose walls did not have to be as thick as their height. Electricity and the elevator facilitated the ease of movement up and down tall buildings. The light bulb illuminated their interiors.

A precursor to the skyscraper was the cast-iron structure. For a building to rise more than two or three stories above its plot of land, structural materials had to be sufficiently strong to support it. In the mid-nineteenth century, builders developed cast-iron structures that were both strong and lighter than the traditional stone and brick. Cast iron was part of the nineteenth century search to produce cheaply and in mass quantities what once only the wealthy could afford. Wrought iron had long been admired, but it had to be hammered out by hand one piece at a time. Wrought iron required expert craftsmen, attention to detail and time, making it very expensive. Cast iron is molten metal cast in molds. Heavy ornamentation could, as a result of this process, be produced relatively quickly and economically. The strength of cast iron also permitted larger windows that were attractive and practical as they flooded building interiors with light.

One of the first buildings to use the cast-iron structure was the 1857 Haughwout Building on Broadway. It housed the store where Edver V. Haughwout sold china, silverware and crystal to the wealthy of New York. The Haughwout Building was also the first building in New York to have a key 1853 invention that helped make the skyscraper possible: the elevator. Elisha Otis, the inventor of the safety elevator, himself installed the elevator in the Haughwout Building.

The first building in New York City to rise above the 280 feet spires of Trinity Church and, therefore, to be considered a true skyscraper was the 1890 New York World Building. At 309 feet, the New York World Building on Newspaper Row, designed by architect George Browne Post, was the world's tallest building from 1890 to 1894. The New York World Building served as the headquarters of the newspaper of the same name, one of the most popular and respected in New York City at the end of the nineteenth century. Joseph Pulitzer purchased the *New York World* in 1883, intending to make a statement with this building, which housed his office. The *New York World* ceased to exist as an independent newspaper in 1931. The building was demolished in 1955.

At 386 feet, the Manhattan Life Insurance Building, designed by architects Kimball & Thompson, held the title of the world's tallest skyscraper from 1894 to 1895. This building was demolished in 1930.

The Singer Building, designed by architect Ernest Flagg as the headquarters for the Singer Sewing Machine Company, was completed in 1908. Located at 149 Broadway, it stood 612 feet tall and held the title of tallest for one year only. The lovely Beaux-Arts-style building was demolished in 1967.

Metropolitan Life, at seven hundred feet tall, took the tallest skyscraper in the world title from the Singer Building in 1909 and held it until 1913. By 1909, the Metropolitan Life Insurance Company was the largest insurance company in the world with a business base in New York's immigrant community. Its commercial success was demonstrated through its fifty-story tower patterned after the Campanile of the Piazzo San Marco in Venice, Italy. Over time, the building has lost some of its charm, but the great clocks, twenty-six and a half feet in diameter, designed by architect Napoleon LeBrun & Sons, remain. And they still tell accurate time.

In 1913, Metropolitan Life would lose the title of world's tallest skyscraper to a building that would remain forever one of the most distinctive and beautiful, even if not the tallest in perpetuity: the Woolworth Building. The Woolworth Building is an outstanding example of the power and symbolism of the skyscraper and of the importance attached to holding the title of "tallest." During the official opening of the Woolworth Building on April 24, 1913, it was President Woodrow Wilson sitting in the White House in Washington, D.C., who pushed a button to signal that it was time to turn on the eighty thousand lights in the building. The Woolworth Building would remain the tallest skyscraper in the world from 1913 to 1930.

The Woolworth Building was the dream of Frank W. Woolworth. He had risen from the position of stock boy in a store in Watertown, New York, to become the head of a multimillion-dollar retail empire with over three hundred stores. It had been Woolworth's genius to open a new type of store—one that sold items that cost a nickel or less. He broke tradition by running his first store on a cash-and-carry basis and by displaying all the goods on open counters so that customers could touch them. When Woolworth added to his inventory items that cost ten cents, his stores became known as "the five and dime."

Like many others who had made their fortune elsewhere, Frank Woolworth opened a central office in Manhattan in 1886. He would fulfill his dream twenty-seven years later of owning the tallest building in the world. Woolworth chose Cass Gilbert as the architect and asked

for a building reminiscent of the Gothic style. Rising 792 feet above the pavement, the skyscraper has spires, gargoyles and flying buttresses. These distinctive architectural features have caused some to liken the building to a cathedral—a "Cathedral of Commerce." There are whimsical details in the lobby that include carved figures representing Cass Gilbert and others responsible for the creation of the building. Frank Woolworth is depicted counting his nickels and dimes. And, in fact, Woolworth paid in cash the $13.5 million it cost to build the skyscraper! It is ironic that the luxuriousness of the lobby with its marble, mosaics and rich ornamentation was for a company that made its fortune in selling cheap at high volume.

While the 1915 Equitable Building never held the title of tallest skyscraper, it had a great impact on New York architecture. This building, known for its sheer mass, occupied an entire city block and could accommodate office space for twelve thousand people. It sides went straight up forty stories and 515 feet, casting dark shadows on its surroundings and blocking the view of the sky. Before 1916, New Yorkers imposed no restrictions on skyscrapers. However, once they experienced the long, dark shadows of the Equitable Building, they took a stand. They passed the New York City Zoning legislation of 1916. New Yorkers wanted to preclude their city streets becoming dark canyons between tall buildings that blocked all sunlight. The new law required all buildings to have a setback: a tower of unlimited height would be permitted on one-quarter only of each site. There would be height restrictions on the remaining three-quarters of the lot. With this legislation, the pyramid style of skyscrapers became the norm in New York and elsewhere.

The Manhattan Company building, completed in 1930, very briefly held the title of tallest building. How the Manhattan Company lost the title is a fascinating story underscoring the significance attached to a skyscraper holding the title of "tallest." The announced height of the Bank of Manhattan Company Building was 927 feet. After the Bank of Manhattan Company's Building completion, the architect of the Chrysler Building—under construction at the same time—secretly arranged to have the Chrysler spire lifted in one piece to the top of the building. With that surreptitious sleight of hand, the Chrysler Building had a height of 1,048 feet, beating out the Manhattan building for "tallest" by more than 120 feet.

But there is much more to the Chrysler Building than height. This Art Deco building, designed by architect William Van Alen, is surely

one of the world's most beautiful. Often cited as a favorite by New York architects, residents and visitors, it is noteworthy for its dramatic use of geometric shapes and innovative display of rich woods and stainless steel. The famous Chrysler spire is a progression of sunbursts leading to the pinnacle. Much of the building ornamentation recalls the automobile: car wheels, fenders, hood ornaments and the sleek lines of a roadster.

The only skyscraper in New York City to rival the Chrysler Building as a sentimental favorite is the Empire State Building. The Empire State took the title of the world's tallest building from the Chrysler Building in 1931 and held that title until 1971. Construction of the Empire State building began in 1929 at a time of great prosperity and high hopes. Within weeks, the stock market crashed, and the general outlook for the country had vastly diminished. Construction continued, however, and even moved ahead briskly. It took only one year and forty-five days, at a cost of $41 million, to complete the Empire State Building. Because of the desperate economic circumstances, much of the building's office space remained unrented for years, earning it the nickname "Empty State." What saved the building from being a complete financial disaster were the millions of visitors who thronged to the Empire State for views of New York from its observation decks. Giving the public the opportunity to experience the thrill of ascending to the top of the world's tallest building reaffirmed the importance of the skyscraper and provided it with a more inclusive significance.

The top of the Empire State, whether at sunset, at night when the city lights twinkle or at any time of day, is a place of legend. It was here that King Kong met his tragic end as he attempted to show his love for the actress Faye Wray in the 1933 film classic while other lovers, both Hollywood and real, have chosen it as their special rendezvous point. These may be the best views of any in New York City.

The next and last in New York City to hold the title of world's tallest were the Twin Towers in the World Trade Center. Standing at 1,350 feet, they enjoyed a reign as the world's tallest skyscraper from 1971 to 1974. Since 1974, the world's tallest building has stood beyond the perimeter of New York City. From 1974 to 1997, the Sears Tower in Chicago owned the title of world's tallest skyscraper. In 1997, the title passed overseas. Since then, various countries around the globe seeking prestige and recognition have built the tallest skyscrapers.

The World Trade Center began as an instrument of urban renewal in Lower Manhattan. In a complex of sixteen acres and seven buildings,

two identical towers, which would become known as the Twin Towers, formed the centerpiece. A single floor of each building covered one acre. Each tower was originally to be 88 stories tall. However, their height was deliberately increased to 110 stories to ensure that they would take the title of the world's tallest skyscrapers from the Empire State Building. The popular observation deck on the 110th floor of the South Tower afforded a 360-degree view of New York City. On a clear day, it was possible to see the limb of the earth—the earth's curvature.

The World Trade Center was a deliberate name. Its office space housed some of the most important international business enterprises. The WTC made the statement that New York City was the financial and trade capital of the globe. Trade not only grew wealth, but it also encouraged communication and understanding. The architect, Minoru Yamasaki of Troy, Michigan, described the World Trade Center as a monument to peace and humanity. The Twin Towers became familiar landmarks on the New York horizon.

It is tragic that not all shared Minoru Yamasaki's view of the World Trade Center. Terrorists identified it as a primary target to destroy. The first attempt to bring down the Twin Towers occurred on February 26, 1993. Al-Qaeda-trained terrorists drove a truck with a concealed bomb into the parking garage of the North Tower. They detonated the bomb, which was intended to bring the North Tower down on top of the South Tower, thereby destroying both and causing maximum loss of life. In this attack, 6 people died and 1,042 were injured. While the bomb caused extensive damage to the garage, shut off power in the World Trade Center and sent smoke throughout both towers, the towers survived.

Eight years later, on September 11, 2001, terrorists hijacked American Airlines Flight 11 and flew it into the North Tower at 8:46 a.m. In a coordinated attack, terrorists flew hijacked United Airlines Flight 175 into the South Tower at 9:03 a.m. Within 102 minutes, both towers had collapsed. Victims of these horrific acts included many who were in the Twin Towers and immediate area; the firefighters, police and other first responders who rushed in to help; and the crew and passengers of the two airliners. Damage to the other five buildings in the World Trade Center complex was so extensive that they had to be demolished.

Osama bin Laden, the leader of al-Qaeda, would claim responsibility for these attacks and two others on September 11: American Airlines Flight 77, which terrorists flew into the Pentagon in Washington,

D.C., and United Flight 93, which targeted the United States Capitol but crashed in Shanksville, Pennsylvania, when passengers fought and overcame the terrorists. In all, almost three thousand people died on September 11, 2001. More than ninety countries, in addition to the United States, lost citizens that terrible day.

The Twin Towers and the lives lost in 1993 and on September 11, 2001, remain forever inscribed on our collective memory.

Your Guide to History

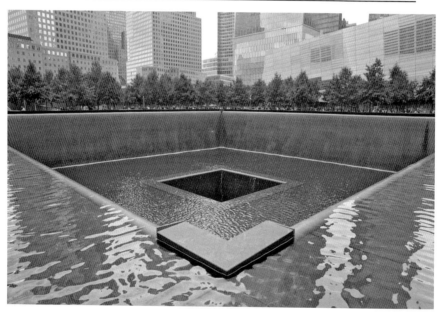

The 9/11 Memorial. *Courtesy of James Maher.*

The Skyscraper Museum

39 Battery Place at First Place • Lower Manhattan
212-968-1961 • www.skyscraper.org • Admission Fee

This museum offers a loving look at the skyscraper as a fixture of New York since the nineteenth century. To appreciate the desire to reach the sky and how the city climbed to its vertical destination, the museum offers an impressive collection of photographs, architectural drawings and historical commentary, as well as educational outreach, special events and private tours. Its online resources are extensive.

New York by Frank Gehry

8 Spruce Street • Lower Manhattan
Exterior Only

Completed in 2011 and originally known as Beekman Tower, this is the tallest residential building in the United States at 870 feet and seventy-six floors. The stainless steel exterior undulates from ground to sky in the style of noted American architect Frank Gehry that is termed "Deconstructivism." Well reviewed by most architectural critics, it is deemed a worthy neighbor to the famous Woolworth Building nearby.

The Bank of Manhattan Company Building

40 Wall Street • Lower Manhattan
Exterior Only

This building, completed in 1930, very briefly held the title of tallest building in the world before losing the title to the Chrysler Building.

The Equitable Building

120 Broadway between Nassau, Cedar and Pine Streets • Lower Manhattan
Exterior Only

This 1915 building, a National Historic Landmark, never held the title of tallest skyscraper. Its size rather than its height made it noteworthy. Stand outside this building and feel its massive impact and you will understanding why it was instrumental in the development of laws that required building setbacks.

Park Row Building
15 Park Row • Lower Manhattan
Exterior Only

At 386 feet, this was the world's tallest skyscraper from 1899 to 1908. The twin-towered Park Row Building was designed by architect R.H. Robertson. It was no longer the world's tallest skyscraper after the completion of the Singer Tower in 1908. Number 15 Park Row now houses apartments.

The Woolworth Building
233 Broadway between Park Place and Barclay Street • Lower Manhattan
203-966-9663 • www.woolworthtours.com • Admission Fee

The Woolworth Building is an office building with security that precludes walk-ins off the street. Visit the website above to reserve a place on one of several guided tours offered that feature the important architectural details and the cultural significance of the building. The Woolworth Building was the tallest skyscraper in the world from 1913 to 1930.

Frank Woolworth grew up poor in New York State. He experienced setbacks in the retail world before his business succeeded, and he owned more than three hundred Woolworth stores. Standing in the lobby, it is easy to understand why this Gothic-style building was called "the Cathedral of Commerce." The marble lobby is three stories high with Byzantine and Christian motifs, as well as strong Gothic overtones. Visitors' eyes are drawn toward impressive marble stairs at the back of the lobby that lead up to a bank—almost like an altar in a church. In the lobby, sculpted heads in the likeness of Frank Woolworth, Cass Gilbert and others instrumental to the building's creation add a whimsical touch. The mezzanine level has bizarre gargoyle heads similar to a Gothic church, as well as a painted triptych of Commerce that has the qualities of the adoration of the Madonna. In recognition of the significance of the Woolworth Building, President Woodrow Wilson participated in its dedication. The president sent a telegraph message from the White House to a worker in the Woolworth basement who flipped the switches to illuminate more than eighty thousand lights in the building. For many years, the Woolworth Building had an observatory deck popular with the public. It was closed during World War II for reasons of national security and never reopened.

In an indication of the real estate market in today's New York City, the upper floors of the Woolworth Building are being converted to residential use. A penthouse with a separate entrance from the office lobby is purportedly to go on the market for over $100 million. It is a National Historic Landmark.

The Soho Cast Iron Historic District

Soho, an area south of Houston Street, has the largest concentration of cast-iron buildings in the United States. The Soho Cast Iron Historic District is made up of twenty-six blocks between Canal Street, 6th Avenue, Houston Street and Crosby Street. This district has five hundred historic buildings, many of which are cast iron. It is important to look up above more recently adapted ground floor spaces to see the detailed repeat ornamental patterns that characterize the cast-iron building. The fashion was to paint the cast iron so that it looked like stone. Do not be fooled! The intersection of Greene and Prince Streets is particularly appealing.

The E. V. Haughwout Building
488 Broadway at Broome Street • Manhattan/Soho

The 1857 Haughwout Building, designed by John P. Gaynor, was built to house Eder Haughwout's store for fine merchandise. It is remarkable not only for its beautiful Venetian-style façade but also for the fact that it is the first building that used a structural metal frame rather than a brick frame. It is considered the most outstanding example of a cast-iron building in the United States. The five-story building is also notable in that it had the first passenger elevator. Elisha Graves Otis, who founded Otis Elevator, installed the elevator. The Haughwout Building is again a store.

The Little Singer Building
561 Broadway • Manhattan/Soho
Exterior Only

The Singer headquarters, which became known as the Little Singer Building, was never the tallest. Designed by New York architect Ernest Flagg, this 1903 building was for Isaac Merritt Singer and his Singer Manufacturing

Company, which made and marketed the most popular sewing machine for home use. The pattern of glass and steel in the façade—it has row after row of windows interspersed with deep green, wrought-iron balconies—made this building a true precursor of the mid-twentieth-century skyscraper. The Little Singer Building is now a mixed-use building with residential and commercial components. In 1908, the Singer Company moved to a new and larger headquarters at Liberty Street and Broadway, which stood forty-one stories and 612 feet tall. The older Singer Building became known as the Little Singer Building while the new building was referred to as the Singer Tower. The Singer Tower held the title of the world's tallest building for one year. It was demolished in 1967.

THE DUCKWORTH BUILDING
28–30 Greene Street • Manhattan/Soho

This is the most notable of a row of cast-iron buildings in the Soho Cast Iron Historic District. Combined with the brick street, it transports visitors to the nineteenth century. Constructed between 1872 and 1896, it was designed by Isaac F. Duckworth. Today, the first floors of many of these cast-iron buildings are luxury stores. Stroll down Greene Street to experience the beauty of nineteenth-century New York City.

THE FLAT IRON BUILDING
175 5th Avenue at 23rd Street • Manhattan/Gramercy
Exterior Only

Though never holding the distinction of being the tallest skyscraper, this noted landmark of New York stands 312 feet tall. Originally known as the Fuller Building after its owner and builder in 1902, the Fuller Construction Company, this was one of the first skyscrapers to use a steel frame. It became known as the Flat Iron Building because of its distinctive shape, which adapted to its triangular-shaped lot at 23rd Street where 5th and Broadway Avenues cross. The building bears a resemblance to the old flatirons in use before the days of electric irons. It is a National Historic Landmark.

Metropolitan Life Insurance Building
11 Madison Avenue between 24th and 25th Streets • Manhattan/Gramercy

At seven hundred feet tall, Metropolitan Life took the tallest skyscraper in the world title from the Singer Building in 1909 and held it until 1913. Note the tower, which was patterned after the Campanile of the Piazzo San Marco in Venice, Italy, and the great clocks, designed by the architect Napoleon LeBrun & Sons, that still tell time. It is located near Madison Square Park and is a National Historic Landmark.

New York Life Insurance Building
51 Madison Avenue at 26th Street • Manhattan/Gramercy

This massive 1928 Gothic Revival building by architect Cass Gilbert has a beautiful pyramid roof covered in gold-leaf tiles. The site itself has had a distinguished history in great part because of its proximity to Madison Square across the street. Prior to 1928, tenants included circus impresario P.T. Barnum's Hippodrome and the first two Madison Square Gardens.

Stanford White of the prominent architectural firm McKim, Mead & White designed the second Madison Square Garden, which stood here from 1890 to 1925. Stanford White was as famous for his womanizing and outrageous behavior as he was for his beautiful buildings. In June 1906, in the rooftop garden of Stanford White's Madison Square Building, the jealous husband of the beautiful actress Evelyn Nesbit shot and killed the architect in a scandal that rocked the city. It is a National Historic Landmark.

The Empire State Building
350 5th Avenue at 34th Street • Manhattan/Midtown
www.esbnyc.com • Admission Fee

Observation decks with protective barriers are on the open-air 86th floor and also on the fully enclosed 102nd floors of the building. Both decks offer 360-degree views of New York City. From the top floor, visitors can see eighty miles in good weather. Online ticketing is a timesaver. Employees in red jackets are in front of the building to answer any questions and to direct visitors. Enter the building through the lobby and note the eight wall panels of the Seven Wonders of the World plus one—the eighth being the Empire State Building.

To reach the eighty-sixth floor takes one minute by elevator. For the past forty years, the Empire State Building management has sponsored a February charity run up the 1,576 stairs to reach the eighty-sixth floor. This highly competitive event invites the public to apply to participate. The form is on the website. However, only a very few will be selected to attempt the 1,050-foot vertical course. The men's record is nine minutes and thirty-three seconds and the woman's record is eleven minutes and twenty-three seconds.

If you are in New York at holiday time, look up to note the lights on the Empire State Building tower, which are green for St. Patrick's Day; red, white and blue for the Fourth of July; blue and white for the first day of Hanukah; and red and green for Christmas. A lighting calendar to anticipate and explain the colors is on the website above. It is a National Historic Landmark.

THE CHRYSLER BUILDING
405 Lexington Avenue at East 42nd Street • Manhattan/Midtown

By subterfuge, the Chrysler Building won the title of world's tallest skyscraper when completed in 1930. The spire—a progression of sunbursts leading to the pinnacle—is the feature that earned this building the title of tallest skyscraper in the world from 1930 to 1931. Architect William van Alen kept the spire and its height a secret until he erected it on top of the building at the very end of its construction. There is no observation deck. The Art Deco lobby is well worth a visit. While the Chrysler Building has not been the tallest in the world for many years, it remains a favorite of New York architects, residents and visitors. Looking for that fabulous spire, whether from the streets of New York or from skyscraper observation towers, is extremely satisfying. It is a National Historic Landmark.

THE SEAGRAM BUILDING
375 Park Avenue at 52nd Street • Manhattan/Midtown
Exterior Only

Designed by famed architect Mies Van der Rohe, this is the only one of his buildings in New York City. It is a landmark modern tower in the International style coupled with a low rectangular building in glass and bronze. Completed in 1958, this building served as the headquarters for the

distiller Seagram & Sons. Two large pools of water with fountains in front of the building soften the street noise. A massive statue, *Big Clay #4* by Urs Fischer, stands in front of the building.

LEVER HOUSE
390 Park Avenue at 53rd Street • Manhattan/Midtown

While never holding the title of tallest skyscraper, this 1952 landmark building of low and tall intersecting glass and steel rectangles determined the way people and cities would look at skyscrapers for the next forty years. Lever House, by Skidmore, Owings & Merrill architects; Gordon Bunshaft; and Natalie de Blois created the International style of commercial architecture. It remains a beautiful building on the New York horizon today. To appreciate the building, walk into the outdoor open atrium to look up to see the tower.

SONY PLAZA
550 Madison Avenue at 55th Street • Manhattan/Midtown

Designed by celebrated American architect Philip Johnson for the AT&T Corporation to serve as its headquarters, the south-facing roof has the distinctive silhouette of a rounded notch referred to as "Chippendale." Now the Sony Plaza, there is a covered atrium with tables and seating open to the public.

GROUND ZERO MUSEUM WORKSHOP
420 West 14th Street • Manhattan/Chelsea
212-209-3370 • www.groundzeromuseumworkshop.com • Admission Fee

The mission of the workshop is to provide vivid images of the horrific events of September 11, 2001, and of the heroism of that day. Many of the photographs in the collection are of the firefighters who bravely served and gave so much. Ground zero is the point on the earth's surface closest to the detonation of a bomb or to a major cataclysmic event. Television news reporters first used the term "Ground Zero" to describe the devastation at the World Trade Center on September 11, 2001.

9/11 Tribute Center
120 Liberty Street • Lower Manhattan
866-737-1184 • www.tributewtc.org • Donation

The five galleries of the Tribute Center focus on the stories of those who lived through the two attacks on the World Trade Center in 1993 and 2001. The Tribute Center also offers walking tours of the nearby 9/11 Memorial.

9/11 Memorial
Liberty to Vesey Street and Church to West Street • Lower Manhattan
www.911memorial.org

Guided tours of the 9/11 Memorial are available through the National September 11 Memorial Museum. Visitors may choose to tour the memorial on their own. The open-air memorial has two pools of water, the North Pool and the South Pool, that trace the original footprints of the North and the South Twin Towers. In each, water flows down into the pools that represent a permanent void where the towers once stood.

The names of those who died are engraved on panels around the pools. The names of the six who died in the 1993 terrorist bombing of the World Trade Center are included and inscribed on panel N-73 of the North Pool. Those lost on September 11 are listed together on the panels according to where they were and worked in the buildings. There is a place on the panels for the first responders who died that day. The 9/11 Memorial is a testimony to the value of the individual, to bravery and sacrifice and to the courage to continue. It acknowledges the life, as well as the passing, of each person by placing a birthday rose on the engraving of each name. The overwhelming impression to visitors is of a strong sense of caring. Michael Arad was the architect of the memorial, called *Reflecting Absence*, and Peter Walker was the landscape architect. The dedication of the memorial was on September 11, 2011, the tenth anniversary of the attack. Each year, on September 11, the memorial and museum project into the sky for twenty-four hours blue lights that represent the former outlines of the World Trade Center Twin Towers. It is possible to see this remembrance from any point in New York City.

The National September 11 Memorial Museum
180 Greenwich Street • Lower Manhattan
212-312-8800 • www.911memorial.org/mus • Admission Fee

Tours of the museum are guided or self-guided. Audio tours are also available. The museum offers extensive public programs and talks. Visitors enter the Museum Pavilion, designed by the international architectural firm SNØHETTA, and then descends a ramp into the museum that was designed by Davis Brody Bond, also known as DBB. The ramp takes visitors to the foundation level of the World Trade Center. Some of the most impressive exhibits include structural columns from the Twin Towers and the slurry wall that held, preventing the Hudson River from flooding Lower Manhattan and causing an even greater tragedy. The Vesey Street stairs that survived allowing hundreds to escape are on display. The damaged Ladder Company 3 Truck of the New York Fire Department that rushed to the scene to rescue survivors and fight fires is among the very moving exhibits. There is a room devoted to the memory of those who died with individual photographs and remembrances by family members and friends. The museum focuses on life in the Twin Towers prior to 9/11, to the events of 9/11 and loss of life and to the rebuilding of the site. It is a relief that nowhere in the museum is there any video of American Airlines Flight 11 and United Airlines Flight 175 flying into the Twin Towers. The museum focuses not only on the events in New York but also on those at the Pentagon in Washington, D.C., and on Flight 93, which passengers flew into the ground in Shanksville, Pennsylvania, resisting the terrorists' intent to strike the United States Capitol. The dedication of the National September 11 Memorial Museum was on May 15, 2014. President Barack Obama was present for the dedication.

New Yorkers are known for their toughness and their resilience. This they showed on September 11, 2001, and in the years that have followed. New Yorkers stood up, dug out and rebuilt. Yet what also impresses visitors to this museum is the tenderness on display in safeguarding the memory of those who were lost. In a city so large and seemingly impersonal, you will sense the will to recognize and honor the individual—the lives and spirit of those who died, the commitment of those who loved and remember them, the bravery and self-sacrifice of the first responders and the determination of a city to look back and reflect as it rebuilds and moves forward.

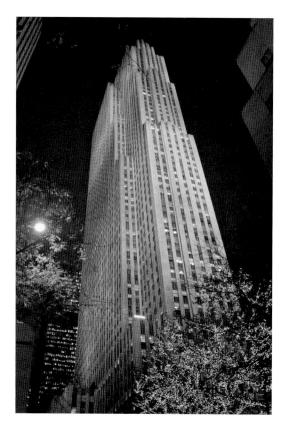

30 Rockefeller Plaza. *Courtesy of James Maher.*

GLOBAL FINANCIAL CAPITAL

WALL STREET TO THE WORLD

Those who built skyscrapers were captains of industry and finance. To build their fortunes, they turned to Wall Street. In the nineteenth century, Wall Street became the financial capital of America. By the twentieth century, it had become the financial capital of the world, a position it retains today.

In 1792, twenty-four men in New York City who had informally traded shares of companies signed an agreement to regulate the buying and selling of stocks and bonds. This was "The Buttonwood Agreement" because they concluded the deal under a buttonwood tree at 68 Wall Street. Wall Street has been New York City's financial center ever since.

At the beginning of the nineteenth century, it was, however, Philadelphia that was home to the largest American banks and to the Second Bank of the United States, a federal institution. The business of Wall Street was on a smaller scale. Its focal point was the Tontine Coffee House at the corner of Wall and Water Streets. Many considered trading in stocks to be shady. This changed after the War of 1812, when the fast-paced construction of canals and railroads required large infusions of capital. Financing these enormous projects provided real impetus to the stock market. New York brokers were determined to take advantage of this situation to become number one in the country. Accordingly, in 1817, they reorganized more formally into the New York Stock and Exchange Board. They also moved into new and larger quarters at 40 Wall Street.

President Andrew Jackson (1829–37) then indirectly aided New York when he ended Philadelphia's national financial leadership. Our seventh

president despised the Bank of the United States, viewing it as a tool of the moneyed classes against the little guy. In 1836, Jackson disbanded the Bank of the United States and closed the Second Bank in Philadelphia.

Technological advances also helped make Wall Street the preeminent stock market in the country. After Samuel Morse demonstrated the telegraph in 1844, New York stock prices could be quoted anywhere almost instantaneously. Telegraph lines quickly radiated from New York City to Philadelphia, Boston and points west. A young Western Union employee named Edward Calahan realized he could enhance the use of the telegraph to transmit stock prices. On November 15, 1867, in New York City, Calahan demonstrated a printer that conveyed stock prices in real time through a system of letters and numbers rather than the Morse code of the telegraph. The machine made a ticking sound. The strip of paper it printed became known as ticker tape. Improved variations of ticker tape machines continued to operate until computers took over the function of transmitting stock prices in the 1960s.

The ticker tape machine led to a New York City institution that has endured to this day: the ticker tape parade. The first use of ticker tape in a parade occurred in 1886. Enthusiasm spontaneously erupted during the parade celebrating the dedication of the Statue of Liberty. Workers in the offices on the Broadway parade route used ticker tape as confetti to throw down on the marchers. After the ticker tape machine retired, workers along the parade route were provided with regular confetti to use for these parades.

New York's financial importance to the country in the nineteenth century also resided in the United States Custom House. Until the Sixteenth Amendment to the Constitution in 1916 imposed the federal income tax, the United States relied on customs duties on imported goods to generate revenue. Customhouses were at every port. New York was the country's largest port in the late nineteenth and early twentieth centuries and, accordingly, the largest source of federal revenue. The beautiful Alexander Hamilton U.S. Custom House, today the Smithsonian Museum of the American Indian, is a reminder of the importance of customs duties and the New York role in funding the federal government.

Throughout the nineteenth century, there were financial highs and lows, panics and recoveries. Overspeculation in railroad stock and bank failures triggered the Panic of 1873. New York City bank reserves dropped significantly, contributing to a crisis in this country that lasted six years. In another panic, in 1893, United States Treasury gold reserves sank

alarmingly low. The result was the worst depression of the nineteenth century. The president of the United States, Grover Cleveland, turned to New York banker J.P. Morgan and his associates in 1895 to ask for a loan to keep the country financially afloat. To restore confidence in the Treasury and the American economy, J.P. Morgan personally signed a note lending the United States government $65 million in gold. Morgan thereby guaranteed the solvency of the federal government and demonstrated the power of Wall Street. Morgan's actions helped calm United States financial markets and stave off a downward economic spiral.

Not all were happy with the success of Wall Street and the role of J.P. Morgan. On September 16, 1920, a bomb exploded in a wagon outside the New York Stock Exchange. The bomb killed thirty-three people and injured more than four hundred others. Many thought it the work of anarchists, though the identity of the perpetrators was never uncovered. It is still possible to see marks from the bomb in the exterior façade of the New York Stock Exchange and of the Morgan Building at 23 Wall Street.

The 1920s in the United States were the Roaring Twenties. Relief over the conclusion of World War I—the War to End All Wars—was palpable. There was also excitement about the shiny automobile that took over American roadways, the unconstrained growth of business and the roaring bull market of Wall Street that brought an exhilarating sense of prosperity to many Americans. All but a few chose to ignore the warnings of potential economic disaster. New York financier Paul Warburg had expressed concern: too many were buying stocks on margin and credit. Investors were heavily borrowing money to speculate in the stock market, assuming the market would continue to climb. Often these buyers were new to the stock market, not understanding what they were doing or the huge risks they were taking.

Then, the very institution that formed the basis of New York's economic power failed not only the city but also the country. On Monday, October 29, 1929, the stock market crashed. The crash came suddenly. For most, it was unexpected. They were unprepared. Vast fortunes were lost. The market went from giddy highs to great depths in less than twenty-four hours. Fortunes of millions of dollars became thousands. But the market would go lower yet in the days and weeks that followed. Within a few months, the stock market had lost $40 billion in value. The financial market that had served the country so well now brought ruin to many. Millionaires and members of the middle class lost heavily. There were some highly publicized instances of the former leaping out of their New York skyscrapers. Most, however, suffered the consequences and lived out their days in severely reduced circumstances.

The stock market crash—Black Monday, as it has been forever after known—came at a time when drought in the West left farms dry and barren. Banks foreclosed on farms. Banks then failed. Even those Americans who had prudently saved instead of speculating found that when they tried to withdraw funds from their bank accounts, there was nothing there. The country and the world at large entered the Great Depression, bleak economic years that lasted from 1929 to the late 1930s. In the United States, unemployment reached 25 percent as factories closed and construction stopped. Breadlines and soup kitchens proliferated.

Herbert Hoover, elected president in 1928, watched the buoyant American economy deflate, hopes evaporate and spirits sag. It was not that he responded indifferently. This was an era of more limited government and more circumspect federal intervention. Hoover's solution was to urge the state governments to act. But the problems were too large and too widespread for individual states to be able to cope effectively. Hoover's presidency foundered with the economy. In response, in 1932, the country elected the forty-fourth governor of the state of New York, Franklin Delano Roosevelt, to be the thirty-second president of the United States. Roosevelt responded to the crises facing the country by building up the power of the federal government and using that power to regulate financial markets to avoid future crises like the 1929 stock market crash.

Notwithstanding the 1929 crash and the ensuing Depression, some retained their belief in the underlying strength of the American economy and New York City's role in it. One of these was oilman John D. Rockefeller Jr., the richest man in the country. In 1930—the height of the Depression—Rockefeller took on the development of a parcel of Midtown real estate with the understanding that a new Metropolitan Opera House would be its centerpiece. The Metropolitan Opera, strapped for funds, withdrew from the project. It looked as though the real estate project was doomed to failure and financial loss. Nevertheless, John D. Rockefeller Jr. pushed ahead. The oil titan turned to architect Raymond Hood and others to develop a city within a city that became known as Rockefeller Center.

Rockefeller Center is testimony to the American faith in a better future. A complex of twenty-one buildings, Rockefeller Center occupies the city blocks between West 48th and West 51st Streets from 5th to 6th Avenues. The focal point is the seventy-story, 850-foot-tall Comcast Building, 30 Rockefeller Center, that was formerly the General Electric Building and originally the RCA Building completed in 1933.

The Depression would last until 1940. Federal efforts in the 1930s to turn around the country economically and to spur growth provided some relief. However, it was World War II that fired up the engine of American industry, leading to recovery, greater employment and an improved standard of living.

New York City contributed to the World War II effort. In addition to the many who served in the United States military, some of whom made the ultimate sacrifice, patriotism was strong in the city. Times Square went dark, and lights dimmed in the city's many skyscrapers. Workers at the Brooklyn Navy Yard, one of the country's most important, toiled overtime to build the United States Navy. The Brooklyn Navy Yard built both the USS *Arizona*, attacked and sunk by the Japanese at Pearl Harbor on December 7, 1941, and the USS *Missouri*, on which the Japanese totally and unconditionally surrendered to the United States and its allies on September 2, 1945.

At the end of World War II, Times Square was the scene of major jubilation. Photographer Alfred Eisenstaedt took the iconic photo of an American sailor kissing a nurse in Times Square on August 14, 1945, the day World War II unofficially ended. Crowds poured into Times Square to celebrate as the electronic billboards blasted the happy news.

The last sixty-five years have been mostly good ones for New York City. The exception was a period during the 1970s when the city's finances failed. Government overspending and the departure of industry and jobs to cheaper areas hurt New York as a place to live and work. High unemployment and escalating crime, rampant drug use and inadequate public services left garbage piling up on street corners and graffiti on buildings and subway cars. New York City was a difficult place to live. Population numbers declined—not until the 2000 census did the population exceed what it had been in 1950. A citywide power blackout in 1977 symbolized the city's fate. The future looked dark.

At its depths, New York City appealed to the federal government for financial aid to avoid bankruptcy. The administration of President Gerald Ford denied the aid. The *New York Daily News* paraphrased the president's position in its famous October 30, 1975 headline: "Ford to City: Drop Dead." Despite the fact that the Ford administration reversed itself within a few months and offered federal loan guarantees to New York City, Ford narrowly lost the state of New York to Democratic nominee Jimmy Carter in the 1976 presidential election. Jimmy Carter went on to the White House to become our thirty-ninth president. Gerald Ford blamed this headline for costing him the election.

New York City, with the help of New York State, labor unions and Wall Street, did avoid bankruptcy. It began a recovery that accelerated in the 1980s and '90s and continues today. Neighborhood restoration efforts have reclaimed areas that had been crime-ridden and failing. In Manhattan, the Meatpacking District, Chelsea, Soho, Tribeca and the Bowery became areas for art and community living rather than centers of distress. Activists ensured the preservation of many historic buildings that otherwise would have suffered demolition. Contemporary New York is an attractive and exciting place to live and to visit. It is the most visited tourist destination in the United States.

At One World Trade Center, the Freedom Tower rises up as an exhilarating expression of rebirth and confidence in the future. Gleaming, it is the defiant face of American determination and refusal to bend to terrorism. Freedom Tower is 1,776 feet tall in honor of the year of American Independence. It will continue to serve as a reminder to us all of the importance of preserving our liberty and human dignity and demonstrating strength, resilience and compassion in the face of adversity. Riding the elevator to the observation deck, visitors get a look back at the New York of 1609, witnessing the city's progression to the present day, as images flash up the elevator walls while they shoot higher into the sky. With history instructed and reaffirmed, we know where we have been and who we are.

Twenty-first-century New York City owns many superlatives: the most populous city in the United States, the tallest skyscraper and the largest museum in the Western Hemisphere and the largest subway system and train station in the world. With eight hundred spoken languages, New York is the most linguistically diverse city on the globe. The tolerance of our Dutch forbearers, the determination of our immigrant ancestors, the contributions of the many and the excellence of the few combine, blend and stand out in New York City to make it, the United States and the world a better place.

Whether together we celebrate the New Year in Times Square or express our collective sorrow over the lives lost on September 11, 2001, we share an understanding of our history and a vision of our future with New Yorkers.

YOUR GUIDE TO HISTORY

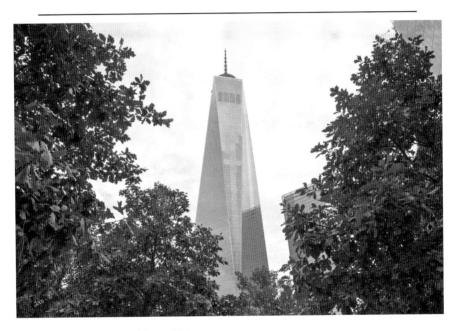

Freedom Tower. *Courtesy of James Maher.*

ALEXANDER HAMILTON U.S. CUSTOM HOUSE

1 Bowling Green across from the Battery • Lower Manhattan
212-514-3700 • www.nmai.si.edu • Free

The Alexander Hamilton U.S. Custom House building is on the site where the Dutch Fort Amsterdam once stood. It is one of the most beautiful Beaux-Arts buildings in New York City. It dates to 1907 and is the work of famed architect Cass Gilbert. Sculptor Daniel Chester French designed the massive exterior statues representing the continents of America, Africa, Asia and Europe, signifying the importance of global trade. The building is named for Alexander Hamilton, a New Yorker. He was the first secretary of the treasury of the United States, serving under President George Washington. Hamilton is credited with creating the national banking system. When it operated as a customhouse, it was the greatest source of revenue for the United States government, especially before the 1916 institution of the federal income tax.

It is a National Historic Landmark. The Alexander Hamilton U.S. Custom House houses the Smithsonian Institution's National Museum of the American Indian New York branch and the New York branch of the National Archives described in Chapter 2.

CHARGING BULL

On Bowling Green at Broadway and Morris Streets • Lower Manhattan
www.chargingbull.com

This magnificent bronze statue by sculptor Arturo DiModica has attracted tourists in its current location since 1989. DiModica originally placed his statue without permit or permission in front of the New York Stock Exchange after the 1987 stock market crash. He felt the city needed the encouragement of the bull, the symbol of stock market optimism. The city felt otherwise, and the police moved to impound the statue. Public outcry and demands for the statue to be restored to a public site led to its relocation to Bowling Green near Wall Street.

When prices on the stock market are expected to rise, leading to profits and prosperity, we say it is a "bull market." When prices decline and investors lose money, we say it is a "bear market." The apparent underlying reason for the names relates to the way the two animals fight their enemies. A bull thrusts his horns up while a bear slashes downward with his paws. The ubiquitous

cartoonist and social commentator Thomas Nast depicted millionaire banker J.P. Morgan as a bull in a 1901 cartoon, thereby cementing this terminology. This is a popular attraction. Expect lines to pose for a "selfie" with the bull, including his impressive back end.

Ticker Tape Parades
Broadway from the Battery to City Hall • Lower Manhattan

Silver stars in the sidewalk along both sides of lower Broadway commemorate the more than two hundred ticker tape parades that have occurred over the past 125 years. Each star notes who was honored and on what day. The parade traditionally makes its way up Broadway from the Battery to City Hall, where the mayor extends his welcome. Street signs on this part of Broadway designate it as "the Canyon of Heroes."

The first ticker tape parade was spontaneous. During the dedication of the Statue of Liberty on October 28, 1886, the excitement of workers leaning from their windows in the tall financial district buildings led them to shower the parade below with ticker tape. Paper from the ticker tape machine, invented in 1867 to record telegraphed stock quotes, made great streamers.

The parades became more regularized after World War I, when returning United States military veterans received a hero's welcome. The most famous ticker tape parade was that honoring Charles Lindbergh on June 13, 1927, to celebrate the first nonstop transatlantic solo flight. Widely published photographs of "lucky Lindy" proceeding up Broadway made the New York City Ticker Tape parade a beloved and coveted event. During the twentieth century, the honor was bestowed on generals, astronauts and foreign dignitaries, including some who were later condemned for despotic practices.

Increasingly, in the twentieth century, the ticker tape parade has honored the many New York City champion sports teams, including the New York Giants football team, the New York Yankees and New York Mets baseball teams and the New York Rangers hockey team. As modernity phased out the ticker tape machine, replacing it with electronic and digital devices, the city provided confetti to the Broadway officeworkers to throw down on the parade honorees.

The New York Stock Exchange

11 Wall Street • Lower Manhattan
www.nyse.com • Exterior Only

The iconic façade of the New York Stock Exchange, recognizable around the world, is not on Wall Street but at 18 Broad Street. The New York Stock Exchange moved into 18 Broad Street in 1903. The architect of this symbol of financial power in the Classical Revival style was George B. Post.

The New York Stock Exchange, also known as "the Big Board," is the leading global exchange for buying and selling shares of stock in publicly traded companies. Over fifteen million shares on average are traded daily, and the combined value of the twelve thousand listed securities is over $28 trillion. The Intercontinental Exchange or ICE, an American holding company, owns the NYSE. The NYSE closed for four trading sessions after 9/11. While it is no longer possible to tour the New York Stock Exchange, there are often scenes of its activities on television. The opening bell is rung at 9:30 a.m. to signal the start of the day's business, and the closing bell to signal its end is rung at 4:00 p.m. To stand on the podium overlooking the trading floor and ring the opening bell is an honor. This honor goes to large companies and to new companies joining the stock exchange. After 9/11, first responders rang the opening bell. While once the trading floor was a scene of frenetic activity with buyers and sellers of stock waving paper about and screaming stock prices, computerized trading has led to fewer people and more machines. It is a National Historic Landmark.

Museum of American Finance

48 Wall Street • Lower Manhattan
212-908-4110 • www.moaf.org • Admission Fee

Financial education is the mission of this museum. It accomplishes this objective through its exhibits on how the Federal Reserve System works, speakers on special topics and tours and events such as the annual celebration of Alexander Hamilton's birthday. Hamilton, a New Yorker, was the first American secretary of the treasury in the cabinet of President George Washington. There is a Hamilton Room at the Museum of Finance in honor of him.

Federal Reserve Bank

33 Liberty Street • Lower Manhattan
212-720-6130 • www.newyorkfed.org • Free

Visitors enter at 44 Maiden Lane between Nassau and William Streets. It is worth the effort to go online early in the morning thirty days in advance of a requested Federal Reserve Bank Museum and Gold Tour date to obtain a ticket. While the museum itself is minimal (though there are plans to upgrade it), the overall tour and visit to the bank's vault to see gold bars is fascinating. It offers an entertaining education on the American financial system for adults and mature children.

This is the only Federal Reserve Bank in the United States that holds gold. There is more gold here than in any other one place in the world. Most of the gold belongs to other governments. There is very little American gold here. The New York Fed holds over $380 billion worth of gold bars from more than forty different governments. Each gold bar is worth about $500,000 to $700,000, depending on the market value of gold. Each gold bar weighs twenty-eight pounds. Think of the Fed as a bank for banks. Legislation in 1913 created the Federal Reserve in response to multiple bank panics and bank runs in prior years. The president appoints and Congress approves the seven members of the Board of Governors plus the chair, each for fourteen-year terms. There are also four presidents of American banks who serve on the Fed on a rotating basis. The Fed sets the prime interest rate in the United States on the basis of its assessment of the overall state of the American economy. This has a major impact on mortgage rates, savings rates and the stock market.

If you look at a one-dollar note, it will say "Federal Reserve Note" across the top. To the left of George Washington is a circle with a letter. If it is the letter "B," that bill came from the New York Federal Reserve Bank (though printed at its facility in New Jersey). "B" equates to the second letter or "two" for the Second District Federal Reserve Bank, which is New York. A one-dollar bill has a life expectancy of about twenty-two months. If ripped or damaged, it is taken out of circulation, shredded at the New York Fed and a new bill is authorized by the Bureau of Engraving and Printing in Washington, D.C.

Visitors descend into the gold vault that was built prior to the Federal Reserve Bank building itself. The vault was cut one hundred feet deep into the New York bedrock. A 90-ton cylinder within a 140-ton frame rotates to close the vault door. Visitors will see but are not allowed to touch a sample

of gold bars that are safely in a metal compartment. The Federal Reserve Bank of New York, designed by the architectural firm of York and Sawyer, resembles, appropriately and deliberately, a fort with massive blocks of stone and openings near the top that look like gun turrets.

FREEDOM TOWER
285 Fulton Street • Lower Manhattan
800-416-7192 • www.oneworldobservatory.com • Admission Fee

There is a range of tickets for One World Observatory in Freedom Tower at One World Trade Center. Varying prices reflect the degree of convenience for the visit, including take your chance, timed entry or the ability to go to the head of the line at any time on a certain day.

Freedom Tower acknowledges the past and represents the future. Designed by David M. Childs of the architectural firm Skidmore, Owings & Merrill, it stands 1,776 feet high, symbolic of the 1776 founding of the United States of America and American freedom. The building is a dominant and luminescent presence on the New York City skyline. Rounding a corner in Lower Manhattan often brings the Freedom Tower into view in an exhilarating and uplifting experience. With 104 stories overall, Freedom Tower has public observation decks called One World Observatory on the 100th, 101st and 102nd floors. The decks offer 360-degree views of Manhattan with some of the best elevated views available of the Statue of Liberty. On a clear day, visitors can see out to a range of fifty miles. Passenger elevators take visitors to the observatory in less than sixty seconds and provide a quick summary of New York City history since the sixteenth century.

With the addition of several more planned skyscrapers for the World Trade Center site, the complex promises to restore the location to its preeminence as the focal point for global trade.

THE MORGAN LIBRARY AND MUSEUM
225 Madison Avenue at 36th Street • Manhattan/Midtown
212-685-0008 • www.themorgan.org • Admission Fee

While the home of J. Pierpont Morgan no longer exists, the extraordinary library designed by Charles McKim of McKim, Mead & White, completed in 1906, stands as testimony to the wealth and power of its owner. The

Tennessee marble exterior and the lush interior of four breathtaking rooms are in the style of the Italian Renaissance. It is no accident that the red silk wall covering in Morgan's study is imprinted with the insignia of the Chigi, the great fifteenth-century Sienese banking family. It was in this very study that Morgan and other New York financiers helped solve the 1907 economic crisis in the United States.

Morgan admired more than financial acumen. He collected the art and manuscripts of the Italian Renaissance now on display here. In the beautiful Rotunda, there are murals by American artist Henry Siddons Mowbray of the ancient world, the Middle Ages and the Renaissance. These epochs are represented in works in the collection of the Morgan Library. These rooms give visitors the feel for the silence in New York City that only the very wealthy could afford. The museum is a more recent and modern addition to the Morgan rooms and permits a broader exhibition space. As noted in Chapter 11, at Christmastime, the Morgan Library and Museum puts on display the original manuscript of Charles Dickens's *A Christmas Carol*. The museum is a National Historic Landmark.

NASDAQ MarketSite
43rd and Broadway in Times Square • Manhattan/Midtown
Exterior Only

The seven-story MarketSite Tower provides a twenty-four-hours-a-day electronic display that offers up-to-date financial information to passersby. It is a popular Times Square feature. Inside the tower are broadcast studios for many financial news programs, including CNBC, Fox Business Network, Reuters and CNN Money.

Rockefeller Center
5th Avenue to 6th Avenue, West 48th to West 51st Streets • Manhattan/Midtown
212-698-2000 • www.topoftherocknyc.com • Admission Fee

Timed entry tickets for the Top of the Rock Observation Deck and for seventy-five-minute guided tours of Rockefeller Center are available online and at the box office on 50th Street between 5th and 6th Avenues. Since 2005, two million visitors annually have enjoyed access to the Top of the Rock at 30 Rockefeller Plaza. The elevator takes visitors to the sixty-seventh floor,

with escalators to the sixty-ninth to seventieth floors. The outside spaces have high glass walls, reassuring to those who do not like heights. The views of New York City are breathtaking.

The tour of Rockefeller Center includes visits to famous sculptures, including *Atlas* by Lee Lawrie in front of 636 5th Avenue, the dramatic limestone relief sculpture of Jehovah representing wisdom on the façade of 30 Rockefeller Plaza and the Paul Manship statue of Prometheus that backstops the skating rink on Rockefeller Plaza. Also included are works of art by Carl Milles, Jose Maria Sert, Attillio Piccirilli, Diego Rivera, Isamu Noguchi and many, many others.

Between 1 Rockefeller Plaza and 45 Rockefeller Plaza and accessible from 5th Avenue is open space that is appealing and functional. It includes the lovely Channel Gardens, so named because, like the English Channel, they separate the French from the British. In this case, the gardens separate La Maison Française from the British Empire Building. The Channel Gardens lead toward a sunken area that is the skating rink in the winter and an outdoor café in summer, with the magnificent large statue of Prometheus by Paul Manship looking down over it all. The Rockefeller Center is a National Historic Landmark.

SELECTED BIBLIOGRAPHY

Websites

The websites of all the places visited in the book were of great help. It is good to check the websites for hours, closings and special exhibitions or instructions.

Books

Alden, John R. *A History of the American Revolution*. New York: Alfred A. Knopf, 1969.

Bailey, Thomas A. *The American Pageant*. Boston: D.C. Heath and Company, 1956.

Breiner, David M. *Stone Street Historic District Designation Report*. New York: New York City Landmarks Preservation Commission, 1996.

Burrows, Edwin G., and Mike Wallace. *Gotham: A History of New York City to 1898*. New York: Oxford University Press, 1999.

Freebert, Ernest. *The Age of Light, Electric Light and the Invention of Modern America*. New York: Penguin Books, 2014.

Goodwin, Doris Kearns. *The Bully Pulpit: Theodore Roosevelt, William Howard Taft and the Golden Age of Journalism*. New York: Simon & Schuster, 2013.

Halberstam, David. *The Powers That Be*. New York: Alfred A. Knopf, 1979.

Hamill, Pete. *Downtown, My Manhattan*. New York: Little, Brown and Company, 2004.

Kisling, Vernon N., Jr. "The Origin and Development of American Zoological Parks to 1899." In *New Worlds, New Animals: From Menagerie to*

Zoological Park in the Nineteenth Century, edited by R.F. Hoage and William A. Deiss. Baltimore, MD: Johns Hopkins University Press, 1996.

Lepore, Jill. *New York Burning: Liberty, Slavery, and Conspiracy in Eighteenth-Century Manhattan*. New York: Alfred A. Knopf, 2005.

McCullough, David. *The Great Bridge: The Epic Story of the Building of the Brooklyn Bridge*. New York: Simon & Schuster, 1972.

———. *Mornings on Horseback*. New York: Simon & Schuster, 1981.

Miller, Donald L. *Supreme City: How Jazz Age Manhattan Gave Birth to Modern America*. New York: Simon & Schuster, 2014.

Pritchard, Evan T. *Native New Yorkers: The Legacy of the Algonquin People of New York*. San Francisco: Council Oak Books, 2007.

Rybcznyski, Witold. *A Clearing in the Distance: Frederick Law Olmsted and America in the Nineteenth Century*. New York: Scribner, 1999.

Schlereth, Thomas J. *Victorian America: Transformation in Everyday Life*. New York: Harper Collins, 1991.

Schlesinger, Arthur. *The Rise of the City, 1878–1898*. New York: MacMillan Company, 1933.

Shorto, Russell. *The Island at the Center of the World*. New York: Vintage Books, 2005.

Taylor, Alan. *American Colonies*. New York: Viking, 2001.

Traxel, David. *1898: The Tumultuous Year of Victory, Invention, Internal Strife, and Industrial Expansion That Saw the Birth of the American Century*. New York: Alfred A. Knopf, 1998.

ARTICLES

Cool, Carol R. "Unbored Walk." *Traveller* 7, no. 2 (Summer 1999).

Gopnik, Adam. "The Man Who Invented Santa Claus." *New Yorker*, December 15, 1997.

The website of photographer James Maher is www.jamesmaher photography.com.

INDEX

ABOUT THE AUTHOR

Alison Fortier lived with her family at 15 West 72nd Street next to the famous Dakota Apartments. Alison is the author of *A History Lover's Guide to Washington, D.C.: Designed for Democracy* published by The History Press in May 2014. She has a BA from the College of William & Mary and an MA in history from the University of Michigan. She is the widow of Donald Robert Fortier and the mother of Graham and Merrill Fortier.

Courtesy of Merrill Fortier.